# MAKING PICTURES

*Also by Julian Calder*

**The 35mm Photographer's Handbook**
with John Garrett

**Keepers of the Kingdom**
with Mark Cator and Alastair Bruce

**A Year in the Life of the London Regiment**

**Horse Gunners**
with Henry Dallal

# MAKING PICTURES

*Vision, Imagination, Skills*
*& Techniques in Photography*

JULIAN CALDER

MACMILLAN

First published 2004 by Macmillan
an imprint of Pan Macmillan Publishers Ltd
Pan Macmillan, 20 New Wharf Road, London N1 9RR
Basingstoke and Oxford
Associated companies throughout the world
www.panmacmillan.com

ISBN 0 333 90762 0

1 3 5 7 9 8 6 4 2

A CIP catalogue record for this book is
available from the British Library.

Designed by Louise Millar

Colour Reproduction by Aylesbury Studios (Bromley) Ltd.

Printed and bound by Butler and Tanner, Frome

# Contents

**INTRODUCTION**     **8**
An historical perspective     10

**Chapter 1 – SEEING THE PICTURE**     **14**
Using the viewfinder     16
Composition     18
How the eye reads pictures     20
Scale, shape and detail     22
Colour     24
Seeing in black and white     28

**Chapter 2 – THE  CAMERA IN YOUR  HANDS**     **30**
Exposure     32
Shutter     34
What the aperture can do     37
Autofocus     38
Lenses – the range     40
What a lens can do     42
Special lenses     44
Perfect lenses     46
The art of lensing     48
Different cameras for different pictures     50

**Chapter 3 – DIGITAL PHOTOGRAPHY**     **62**

**Chapter 4 – FILM AND PRINTS**     **68**
Negative/Transparency     68
Black and white     70
Special films     72
Cross-processing     74

Film effects 76
Polaroid proofing 78
Polaroid film and effects 79
Polaroid cameras 81
Black and white papers and printing 82
Print effects 84
Digital manipulation 90

**Chapter 5 – LIGHT** **92**
Types of daylight 92
Natural light 94
Difficult light 96
Camera-mounted  flash 98
Mixed lighting 104
Studio and location lighting 106

**Chapter 6 – CONTROLLING THE PICTURE** **110**
Filters 110
Creating movement 114
Tripods, releases and remotes 116
Controlling light 118
Useful everyday objects 120

**Chapter 7 –MAKING PICTURES** **122**
Introduction 122
Favourite pictures 124
Portraits 130
Lighting 132
Controlled portraits 134
Candid portraits 136
Groups 138
Children 139
'Make me look better' 141
Digital capture 142
Computer-enhanced portraits 144

Portrait masterclass                    146
Family                                  148
Nude                                    152
Nude in landscape                       154
Landscape                               156
Landscape masterclass                   162
Travel                                  164
Travel masterclass                      170
Expeditions                             172
Cities                                  174
City masterclass                        178
Architecture                            180
Interiors                               184
Architecture masterclass                186
Nature                                  188
Gardens                                 190
Flowers                                 193
Wildlife and pets                       194
Safari                                  196
Wildlife masterclass                    198
Close-up                                200
Still life                              202
Sport                                   206
Sport masterclass                       211
Photojournalism                         212
Photojournalism masterclass             218
Street photography                      220
At work                                 222
Photostory                              224

**Chapter 8 – WORKING IN DIFFICULT CONDITIONS      230**

Photographers' biographies              236
Index                                   238
Acknowledgements                        240

# INTRODUCTION

I started taking pictures seriously for a living in the early 1970s, having been an assistant to photographers working in advertising, fashion, cars, people and travel over a period of five years. I had wanted to be a photojournalist from the age of fourteen, but it would have been considerably more difficult without that long and varied apprenticeship. My first jobs were for British and American magazines. I was happy to work with available light and simple camera equipment but, after a few years, just taking pictures was no longer enough. Photographing in colour, where cropping was not advisable because of the loss of image quality, and working for the more demanding American magazines, I had to start making pictures, exercising much more control over the subject matter. Living in Britain, with its unreliable weather, meant I had to learn to light all sorts of subjects, but this wasn't a limitation in any way. In fact, it was quite liberating, for there are endless ways to make a picture. In my time as an assistant I'd watched hundreds of models posing, and now I can make almost anyone look good in a picture. Ever since that time, I've had an ongoing, expensive love affair with camera kit and photographic techniques.

Photographers learn from the work of other photographers. My main influences have been Henri Cartier-Bresson's 'The Decisive Moment', Eugene Smith's photo stories in *Life* magazine, portraits by Richard Avedon and the consistent high quality of Annie Leibowitz's work, the black and white work of Sebastiao Salgado, the awesome images of *National Geographic* photographers James Stanfield, Jodi Cobb, William Albert Allard and others, and Walter Iooss's pictures in *Sports Illustrated*. Every week we see great pictures in books, magazines and adverts and most people take them for granted. The great photographers all have their imitators: for example, there are still young photographers wanting to be Cartier-Bresson and there are many who emulate the hard-flash portraits of Martin Parr. But for serious photography it is essential to establish and maintain a personal identity.

'Take inspiration from wherever you find it. But constantly copying others will take you nowhere.'

Good photography is 5 per cent intuition and 95 per cent application of learned skills. As with all skills, it takes time to learn the basics, and the purpose of this book is to turn the photographer – as opposed to the camera owner – into a skilled craftsman. Once technical matters are second nature to you, you have the freedom to express your creativity.

The pictures in the book, the majority of which were taken by commercial photographers working to a commission, are representative of all kinds of photography. They may not always be the finest images and some are even clichés, but they are all here to demonstrate specific techniques or the range and capabilities of a particular piece of equipment. Most of the pictures in the book were taken on film, but every one of them could just as easily have been taken digitally. This book is primarily about creating successful pictures; the equipment they are taken on can be incidental.

Technique can be applied to all types of photography. If a subject does not engage you emotionally then you can maintain your own interest – and make a good picture – by applying technique and craft. It's when emotional involvement and technique come together that the resulting picture can be something special.

Why bother to push yourself to make good pictures? Photographic equipment is now so sophisticated it can do a lot for you. But quality is more than sharpness, exposure and all the other basics. It is that particular look that a perfect Velvia transparency has; the crispness of a picture taken on an IFED wide-aperture lens at f2; the black and white tonal range of a picture taken with a Leica and a 28mm lens; the out of focus merging colours when using a wide lens with only the subject sharp; the perfect white background on a full-length fashion photo; perfect skin in a beauty shot; a selenium- and gold-toned lith print, the huge range of tones in a digital image and the wonders of Photoshop. The combination of content and quality is thrilling, and always striving for this, learning new ways of achieving it, and applying a range of techniques, marks the difference between a photographer and a camera owner.

My closest friends are photographers and I have used some of their pictures in this book. Professional photography is extremely competitive, but there is a great camaraderie. If you appreciate a picture, the photographer is generally only too happy to tell you how they achieved it, and conversations with friends form the basis for some of the work in the book. For professional photographers, photography is not only a job it's a hobby. Some of the best pictures I have seen have been done by commercial photographers working on self-generated, self-financed projects that can take anything from a few weeks to several years to complete. These projects give the photographer satisfaction and can often lead to commercial commissions, so they are worth the investment. O. Winston Link was a commercial photographer in New York in the 1950s. His hobby was photographing steam trains at night, with flash. His prints of trains have long out-lived his commercial work and a single print now sells for in excess of $20,000.

Working on your own projects gives you the freedom to develop your style and increases your confidence. You can experiment in your own time and at your own expense – if you think a picture will turn out half decent, take it, because you will often be surprised how good the outcome can be. But remember, you must always be your most severe critic.

The opinions expressed in this book are mine and have been formed over many years shooting pictures, for myself as well as for picture editors, art directors, writers and designers (when these relationships work well they can be creatively stimulating). I have photographed all over the world and have gone to places I'd have had no reason to go to, other than that somebody wanted a picture. I have photographed hundreds of people and never tire of looking at all sorts of photographs. I hope that, even if you don't agree with the opinions, the facts in this book will help you develop your own vision and that you may get as much pleasure from photography as I have.

> 'To take good pictures consistently, you cannot divorce the technical from the aesthetic.'

> 'If you have to apologize for a picture, don't show it.'

# An historical perspective

Photography has often been moved forward by someone mastering a new piece of technology in order to make a picture their own. It was the cut-throat competition in the world of sports photography that inspired many key modern developments. American sports photographers in the 1960s were competing with television. TV images were instant. *Sports Illustrated* was on the news-stands the following week. Sports photographers demanded bigger and faster lenses so they could get to the heart of the action. They were shooting colour, which meant that they had to fill the frame with their subject, not crop later. Until then, most news photographers had been shooting in black and white. Picture editors could then crop into the print, using as much of it as they wanted. But with colour, you have to shoot the whole frame. If you cut into it, you risk losing quality.

> ‘Photography is everywhere in our lives.’

The 1990s were boom years for football across Europe because of the onset of satellite television. Late kick-offs and weekday evening matches became the norm, which meant newspapers demanded colour pictures on the back pages the next morning to keep up. Using film was just too slow, so sports sections became a proving ground for digital photography. Then came the Afghan war. There were no processing labs for thousands of miles. Those who shot on film had to carry their own colour processing chemicals, something that news photographers had done when shooting black and white, but it was too slow when competing with today's electronic news-gathering possibilities. Naturally photographers chose to shoot and transmit digital pictures for use on the front pages. Digital photography now dominates news and sports coverage. Camera manufacturers still announce new equipment to coincide with an Olympics or the football World Cup.

Digital photography itself has its roots in the desktop publishing technologies that transformed the publishing industry two decades ago. The DTP revolution led to a proliferation of new magazines and newspaper supplements hungry for picture stories; new magazine launches continue apace, offering an ever-wider range of opportunities for image-makers. Ease of reproduction, however, is no guarantee of quality, and all too often the people commissioning pictures have limited knowledge of the photographic craft. These days, companies commission photography for their annual reports, but few companies use the opportunity creatively. Instead of using photography to showcase the company, its workforce and whatever it manufactures, most pictures in annual reports are used purely for decoration. Even commissioners with a good eye are frequently constrained by time and money restrictions as the bean-counters strive for ever-greater efficiency. Despite the new outlets for their pictures, independent photographers can have a hard time making a living – although a good agent or a picture library can make a world of difference in terms of showcasing an existing portfolio and in expanding the life of an image or story via syndication.

Of course you can still use older equipment and produce fresh, exciting images. In recent years one of the most celebrated photographers has been Sebastiao Salgado, who shoots many of his pictures in black and white on a Leica rangefinder – a camera that has only been marginally updated since the 1930s. As the new technology improves and becomes accessible for everybody, it doesn't replace the old but adds to the sum of the whole photographic arsenal. The pendulum may swing one way, with the latest equipment, but there is also a swing in the oppo-

site direction, and people look again at old techniques. A striking recent example is the huge increase in popularity of black and white photography just when colour film has became foolproof and digital imaging has arrived on the scene as the serious professional alternative.

To see where visual and photographic style is going in future, you need to look at the emerging technological developments. Where once it was considered sacrilege to retouch a photographic image, today's digital technology encourages manipulation, with the taken image often heralding the start of the picture-making process.

Every day we are bombarded with media images – posters, newspapers, magazines, packaging. There is a camera in almost every household and people take photographs much more readily than ever before. The commissioned photographic portrait is seen as a badge of success and people who reach a certain position in their working lives are willing to pay to be photographed by a professional. People in the public eye give signed photographic portraits as tokens of thanks. Many media and sports stars are so concerned about their image that they control the release of the 'right', or flattering, pictures of themselves.

Photography can play an important part in making people more aware of world problems – and what there is to protect. News weeklies, natural history and travel magazines have all contributed to making the world a smaller place. Television news and documentaries may have more immediate impact, but you can ponder a still picture in a book or magazine. You can refer back to it, and read more into it than you get from a fleeting news item.

As a professional photographer I feel I have a responsibility not to concentrate on the downside of life, as news film tends to. I think young photographers are attracted to the extremes of the human

condition, to showing famine, war – situations as different as possible from home. But as I get older, I become more interested in showing the whole of life, even in apparently mundane features on lifestyle. As long as you are passionately involved in the photography I don't believe it really matters what the subject is. The pictures in magazines such as *Hello!* are often scorned, but perhaps in a hundred years' time people will see them as social documents.

There are certain classic images that work photographically. Such iconic pictures retain their power. More than fifty years ago Willy Ronis took a picture of his wife washing in the morning. It is a simple picture but one that contains much that we all recognize and respond to – the warm summer morning, a relaxed atmosphere, a romantic holiday mood.

Great images can inspire. Your photography is influenced by what you have seen, by the bank of visual images in your memory. There is a visual heritage in our culture, just as there is a literary one.

Photographs don't have a constant value. Their importance changes as time passes and the viewer's perspective on them alters. Frank Sutcliffe documented the Victorian fishermen of Whitby. They are wonderful pictures of the ordinary life of the time, but today other aspects also interest us such as the way the boats were rigged and what the fishermen's clothing looked like. The patterns of their sweaters have been copied by a knitwear company.

Of the news pictures of today, some will come to represent this period of history for future generations, just as certain key images of the Second World War or the Vietnam war symbolize those times. You may find your photographs gain importance and even become symbolic of their time when you look at them years later. It is important to photograph what is happening around you, your life. Photograph what is of interest to you and trust your instincts.

> '**Take heart that the demand for photographic images is ever-increasing.**'

'You don't take a photograph, you make it.' ANSEL ADAMS

'Taking pictures is like panning for gold. You do it again and again, and sometimes you find a nugget.' RAGHUBIR SINGH

'You can take a good picture of anything.' GARY WINGRAND

'All I know is that within every man and woman a secret is hidden, and as a photographer it is my task to reveal it if I can.' YOUSUF KARSH

'A photograph is a secret about a secret. The more it tells you the less you know.' DIANE ARBUS

'All photographs are accurate. None of them is truth.' RICHARD AVEDON

'If your pictures aren't good enough, you're not close enough.' ROBERT CAPA

'No matter how mundane the assignment may be, there is always one good picture to be taken and possibly a great one.' HARRY BENSON

'Good photography requires: organization and negotiation, tact and assertiveness, punctuality and patience.' MICHAEL DUNLEA

'F8 and be there!' PHOTOJOURNALISTS' MANTRA

'When we engage with the landscape, we are surely enriched and stimulated by a greater force; perhaps we take a step closer to the source of things.' CHARLIE WAITE

'The camera is an instrument that teaches you to see without a camera.' DOROTHEA LANGE

'I believe in technique only as a way of getting
where I want to go artistically.' ALBERT WATSON

'The best zoom is your legs.' ERNST HAAS

'I try not to go anywhere with pictures in my head.
What you see is what you get.' WILLIAM ALBERT ALLARD

'Think about the photograph before and after, never during.
The secret is to take your time. You mustn't go too fast. The subject
must forget about you. Then, however, you must be very quick.'
HENRI CARTIER-BRESSON

'When I say I want to photograph someone, what
it really means is that I'd like to know them. Any-
one I know I photograph.' ANNIE LEIBOWITZ

'I have been a witness. The events I have recorded should not be
forgotten and must not be repeated.' JAMES NACHTWEY

'I only use a camera like I use a toothbrush.
It does the job.' DON McCULLIN

'You're only as good as your last set of pictures.' DAVID BAILEY

'Don't bruise the already bruised.'
EUGENE SMITH                    'The camera cannot lie, but it can-
not help being selective.' ANON

'What you look for is a symbol of something in everyone's life.'
MARY ELLEN MARK

'Nothing happens if you sit at home. I always carry
a camera with me at all times.' ELIOT ERWITT

'If I knew how to take a good photograph,
I'd do it every time.' ROBERT DOISNEAU

# 1: SEEING THE PICTURE

In any photographic situation, the first step is to see the picture. Be receptive to the possibilities in front of you, even if you already have a strong idea of the image you want to take. Absorb the atmosphere, get to know your subject – and look. Study the dominant shapes, the graphic power of colour and the relationship of foreground to background. In a three-dimensional scene there is not always a discernible relationship between foreground and background. On a flat piece of film there is a relationship, even though the two may be far apart.

Think about what it is that excites you about the scene. It may be movement, the relationship between two people, the strong lines of a building, a dramatic juxtaposition of colours, a silhouette, a particular light – a thousand things. Think about the angle of view. The view from eye level is what everyone sees. Getting higher or lower can give a picture an unexpected slant.

The technical decisions you make – about film, aperture, shutter speed, lens and filters – should all be designed to enhance your subject. Simplicity is all-important. When you look through the viewfinder you are trying to eliminate the 'rubbish' and clarify the picture. No one looking at the photograph should be in any doubt as to its point and purpose.

Robert Capa famously said that if your pictures aren't good enough, you're not close enough. Simplify the picture, move closer and fill the frame. As you become more involved with your subject, you may find yourself going closer and closer in and finding pictures you had not realized were there. Photography's unique feature, compared with most other art forms, is that you can see things in isolation. When you're hunting for pictures look at the overall view but also look at the details. Sometimes they can say more about a subject than the whole view. If the light, scale and texture are right, a detail can make a picture.

Sometimes, taking a successful picture needs patience and anticipation. The structure of the scene might be there, the elements in place, but the picture still needs a spark of action to give it purpose. You may have to wait and keep the camera to your eye until something happens that completes the picture – a person doing something, a car coming down the street. Photography is not just chance. There is more to it than just seeing a pretty scene, picking up the camera and clicking the shutter button.

Remember, too, that a picture doesn't have to be perfect to be worth taking. Don't dismiss something if there is only half a chance it might make a good picture. The translation of a three-dimensional scene to a flat image is sometimes quite unexpected and finished pictures often look very different from what you saw through the viewfinder.

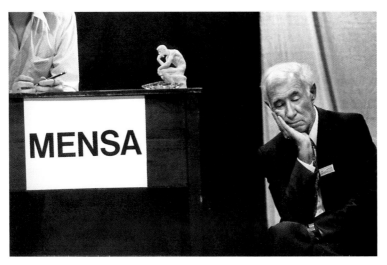

**The lucky moment**
Sitting in the front row for a *Time* magazine story, I watched as one of the guest speakers struggled to stay awake. I caught him just as he nodded off. One frame later, he was awake with a start. Keep alert and develop the skill of anticipating a picture. This is what Henri Cartier-Bresson called 'the decisive moment', a mantra for all reportage photographers.
**Mensa meeting**
*Nikon F2 50mm/Kodak Tri-X*

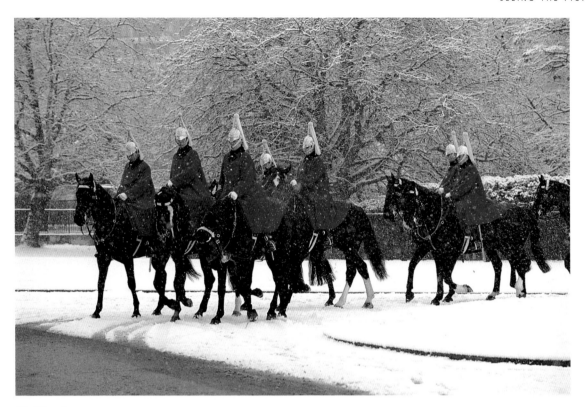

## Waiting ten years

I waited ten years for this picture. The Household Cavalry's ceremonial duties are at 11.30 a.m. every day. It doesn't snow that often in London, and certainly cannot be guaranteed on the dot of 11.30.

**Household Cavalry**
*Nikon F5 80–200/Kodak E200*

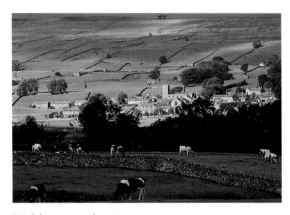

## Waiting ten minutes

I was photographing the Yorkshire Dales for a James Herriot calendar. The shadows of the clouds were scuttling across the landscape. I waited until the light was on the church in the centre of the valley. Wait for the right light – don't just click and hope.

**Yorkshire Dales** *Nikon F3 180mm/Kodachrome*

## Just come upon it

Keep your eyes open and keep it simple. Everybody sees pictures in a different way and it's often a surprise what can make a good picture. This is just a snap. All you have to do is walk round to get the best angle, the rest has been done for you.

**Cephalonia** *Nikon F4 35mm/Kodak Ektachrome*

# Using the viewfinder

When you look through the viewfinder you see pictures that were not there when you looked with the naked eye. The frame imposes relationships on the elements within the subject. By moving, you change these relationships and the dynamics of the picture. By framing tightly – cutting into the desired picture – you create a visual tension that will hold a viewer's eye. Turning the camera on an angle immediately makes a dramatic change.

It is vital to check the edges of your frame before taking a picture. There may be something that your eye has ignored but would divert from the subject if it appeared in the photograph. Look from the foreground through to the distant background to check for anything that may distract and that could be eliminated.

The shape of the format you use is important. With the oblong format of 35mm you have to think about proportion and the relative weight of one element to another. The oblong format may, of course, be shot horizontally or vertically. When you have decided what to shoot, remove everything that does not add to the picture. Only work with the essentials and the message will be much stronger and clearer. The way you organize these elements is a subjective decision that gives your picture a distinctive style. Most photographers tend to shoot horizontally. There are simply more subjects that lend themselves to a horizontal view. Perhaps our stereoscopic vision means that we look for breadth rather than height. For me, it is always a conscious decision to switch to vertical, usually dictated by the subject.

The square format, although elegant and harmonious, is much more difficult to compose on. The balance between subject and background is usually equal, rather than proportional. You are always conscious of the foreground-to-background balance, since it is more critical to get it right. A really good composition in a square can be stronger than a good 35mm composition because the balance is more satisfying. Even a portrait shot on a square format has a different feel to the same shot on 35mm. The 6 x 7

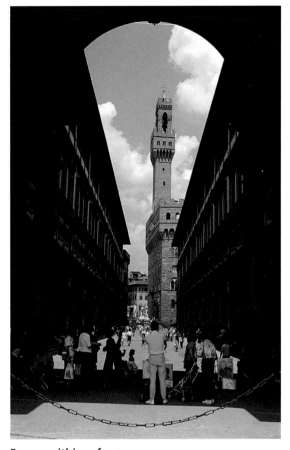

**Frame within a frame**
Using the viewfinder to crop into a natural frame adds graphic strength and doubly directs the eye to the subject.
**Palazzo della Signoria, Florence, Italy**
*Nikon F4 28mm/Kodak EPP*

format is neutral. It imposes very little on a picture, which is fine because you want to concentrate on the content of the picture.

Whatever your format, it is important to be aware of the balance of positive and negative space in the picture. Positive space is the subject of the picture. Negative space is the space surrounding the subject. The whole is contained by the frame – the format of whatever camera you are using, or the crop in the darkroom afterwards. Most modern cameras force you to look at the centre, since that is where the meter reading is taken from and where the focusing scales and autofo-

## Positive to negative space

How much space should the statue have around it? Using the zoom lens, the amount of sky can be controlled until there is a balance between the negative and positive space.

**St Peter with the key to the City of Rome**
*Nikon F4 80–200mm/ Kodak EPP*

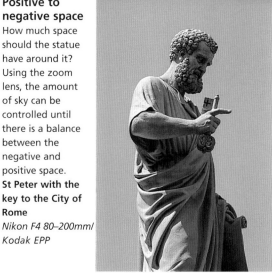

of foreground to background. The tones in the picture may all look fairly even to the eye, which can compensate for exposure values. When you press the preview button, however, you start to see the contrasts at play and get more of a feel of the shapes between dark and light.

Once you are aware of the positive and negative space in the picture, you can adjust their relationship to each other – from a feeling of harmony to one of high tension, depending on what you are trying to communicate. With black and white the relationship of the two areas is fairly straightforward, but with colour you need to allow for the emotional weights of the colours involved and their relationships to each other. Getting the balance right, especially in colour, is a question of feel. Zoom lenses are helpful here. As you look through the viewfinder, you can zoom back and forth until you feel the balance between the elements creates a harmonious picture.

Even when you think you have the picture, keep looking and adjusting. As you look through the viewfinder, assess alternative angles, adjust the f-stop a fraction. There is no limit to the number of frames or rolls it takes to get the perfect picture.

cus sensors are, but you should compose on the whole frame. If all the emphasis is in the middle of the frame the areas of positive and negative space will generally be equal, and this limits the composition.

Apply the rule of thirds. It is very balanced and pleasing to the eye. It is instinctive to most photographers and will work well for all subjects. The preview button helps our awareness of the relationship

## Filling the frame

Coming closer and cropping tightly in, the viewfinder has emphasized the random structure of this old building. The angles of the timbers contrast with the strong vertical and horizontal constraining lines.

**Lavenham, Suffolk**
*Nikon F3 80–200mm/ Kodak EPP*

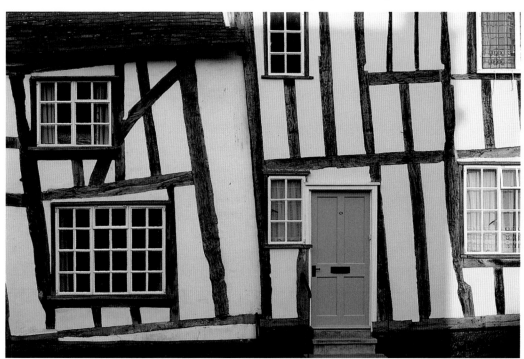

# Composition

What goes into a picture, and how, is fundamental to successful photography. The skill of composition is something that no camera, however high-tech, can help you with. I don't think there should be rules about composition because I don't believe following rules makes exciting and involving pictures.

I know what makes a pleasing composition for me and for a few other photographers. A good picture is simple and direct, so the viewer immediately understands its message. There is a balance between the elements and unnecessary information is eliminated. If there are any tension points it is because the photographer wants them to be there. Although 'good' or 'bad' composition is a matter of personal taste, if something's amiss it nags, like having a stone in your shoe. You can walk, but it's uncomfortable and irritating.

Rather than thinking in terms of rigid rules, I think it is more valuable to practise seeing the world in terms of pictures. In the end, the art of composition is something you have to work out for yourself. Analysing photographs when they are printed, and noticing what works and what doesn't, is a good way to speed the learning process. The trick is to discover what has meaning for you and do your best to convey that meaning through your photographs.

Photography translates the three-dimensional view that your eye sees into a flat image. As you look at the world, your eye automatically edits what you see, so you concentrate on the elements in the scene that interest you and ignore any non-essentials. The camera, however, records everything equally, unless you use your skill in composition to exclude distractions while retaining the interest of the picture. Translating that three-dimensional view onto film means juggling shapes and blocks of colour or light and shade to get what you want within the frame.

If you are composing pictures every day, composition becomes instinctive. Whenever you pick up a camera and look at a scene through the viewfinder you will automatically stop when the image is well

composed. It is a physical process. As you move your head, the camera moves; you drop down a little and the composition changes. Even when not holding a camera you are aware of the relationship between the elements you are looking at. Photography simply makes you crop the view within the given format.

I have always felt it is important to compose in the camera as far as possible, rather than in the dark-

room, or on the computer screen. It is an excellent discipline and more or less essential if you are shooting on transparency. I like the physical involvement with the picture that composing in the camera gives you. You may have to walk across the street, for example, to fill the viewfinder, and in doing so you may find an even better angle. A zoom lens also gives you lots of options in how you frame a picture.

**Robin Hood's Bay on August Bank Holiday**
A classic composition has foreground detail that leads the eye of the viewer to the subject in the middle. The background should not be overpowering, but a backcloth in front of which the action takes place. Your eye moves easily around the frame, taking in different details with each viewing.
*Nikon F4 85mm/Kodak EPP*

# How the eye reads pictures

There are certain instinctive reactions everyone has when they look at a picture. Understanding these can help you strengthen the impact of your photographs. The first thing anyone notices is the area of highest contrast in the photograph, because that is the most exciting part. This may often be a bright white highlight but it could equally be a touch of pink in a mainly blue picture, or black in a pale scene. Another instinctive action of the eye is to follow any strong lines in the picture, or any implied line of movement.

There is an old Hollywood saying: 'Put the money [the star] in the middle.' Putting the subject in the middle of the picture gives it emphasis, because the eye has difficulty going beyond it to the background. If the subject is to one side, the eye explores the whole frame.

The mind's eye makes assumptions about what lies beyond the borders of the picture. Going tight in on a subject can make it seem to extend further than it does. In group portraits, you don't always have to keep the knees in and certainly not the feet. The point of the picture is the group. You don't need to record that they all have legs because the imagination will assume that. Similarly, cropping off the top of the head in a portrait forces the viewer's attention to the subject's eyes. At least one of the eyes should be focused in a portrait. It is generally difficult to look at a portrait in which the eyes are blurred.

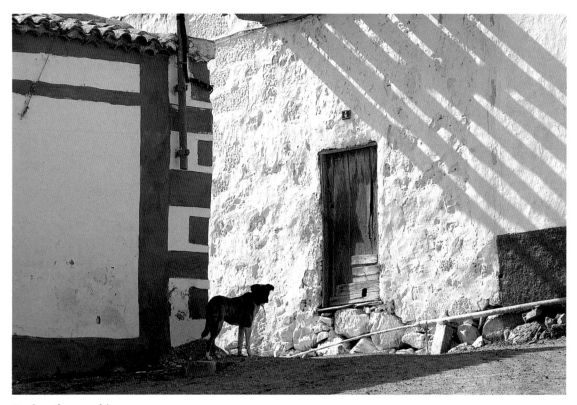

**Seeing the graphics**
The frame is divided into graphic shapes: rectangles, squares and diagonal stripes. The only irregular shape is the dog, which is positioned just off the point of the golden mean for emphasis.
**Central Spain**
*Nikon F3 180mm/Kodachrome 64*

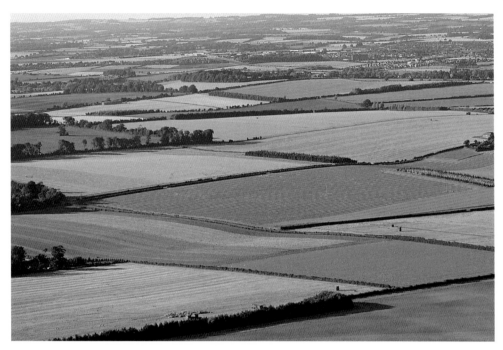

## Cropping in on patterns
Cropping into strong patterns or using zigzags within the frame can be especially effective.
**Harvest landscape, Wye Valley** *Nikon F5 300mm on unipod/Fuji Velvia*

## Concentrating on the essential
Why cut the top of the head off? It adds strength to the face and makes you concentrate on the subject's eyes. The same effect doesn't work if you cut the feet off! In that case, crop above the knees to give the body a tapered shape.
**Headshot** *Nikon F5 80–200mm/Agfa APX 100*

# Scale, shape and detail

I could go and stand on Tower Bridge today and get the whole of HMS *Belfast* on a frame. Or I could go on board and photograph one of the huge rivets that hold this huge battleship together. Both would be on a 35mm frame and both occupy exactly the same space. Which says 'big'? The beauty of photography is that you can express things in different ways. You can stand back or go in close and achieve a remarkably similar effect. I once saw a calendar in America on which the numerals for the days of the month were photographs. '1' was a numeral made by an old typewriter. '2' was a number from a huge billboard, '3' was from a car number plate – but they were all the same size on the frame. The photographer had used the format to reduce everything to the same scale; the viewer had to surmise the source.

This is one of photography's real pluses. Often, the full-frame rivet conveys the massive size of the ship bet-

**Silhouettes**
In a picture these are just shapes arranged in a certain way. Exposing for highlights turns people into silhouettes. *Nikon F3 50mm/Fuji 100D*

ter than the overall view. One way of showing scale is by comparison. Deliberately eliminating any sense of scale from a picture can make for powerful images, too.

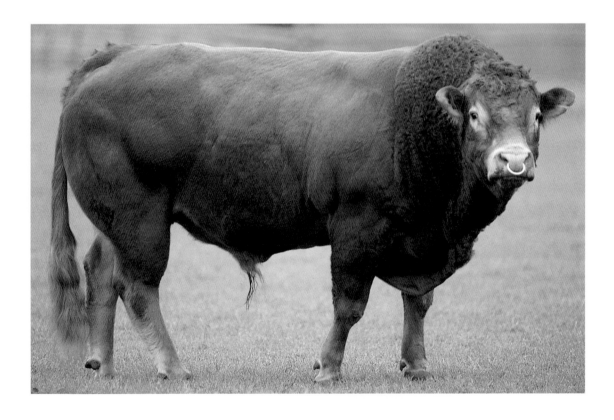

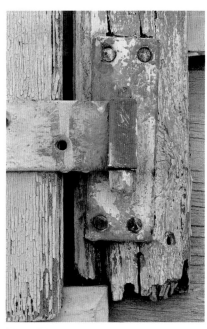

### Looking for the detail
Go in close to photograph colour, graphic shapes and texture. An isolated detail makes for a great enlargement.
**Paint and hinge**
*Nikon F5 105mm macro on tripod/Fuji Velvia*

Sitting and waiting in Milan airport, my low angle was a good vantage point to see the fleeting action of a girl adjusting the strap of her shoe. Returning home, I re-staged the picture. Look for opportunities to crop into the details of daily life.
**Heels**
*Nikon F3 300mm on tripod/Kodachrome 64*

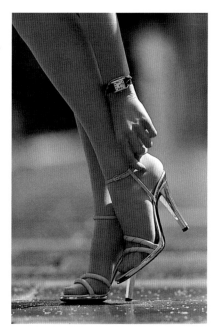

### Big – bigger
Here are two ways of showing size. The first image fills the frame with as much of the subject as possible. The positive space dominates the negative space. Another way of showing scale is to have a small detail in a big background. Finally compare the subject with something we can all relate to – a hand.
**Bull, Gloucestershire** *Nikon F4 200mm/Fuji 100*
**Plane over the North Pole** *Nikon F2 180mm/Kodachrome 64*

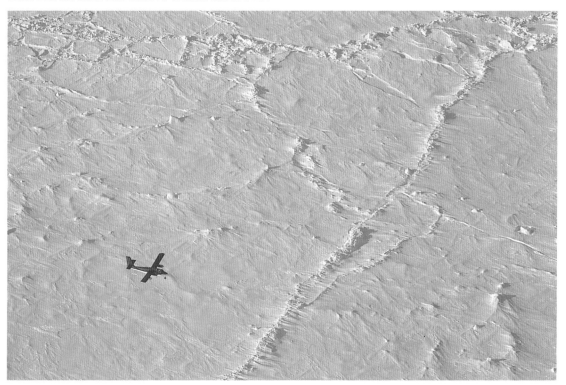

# Colour

Colour has a language of its own. It is a subject in its own right. You can take a picture of a white house, a green tree and blue sky, but you can also photograph the white, green and blue – something not every photographer understands. When working with colour, you have to be aware of the relative weights of colours in the picture. The right balance between those colours goes a long way to making a pleasing composition. Think about what colours are complementary, why there is discord between others. Look at colour around you and why certain combinations work. The Swedish flag looks good because the yellow and blue, although contrasting, complement each other. A red bridge in a Japanese garden is attractive because the red is surrounded by green, which makes it looks even redder than it is.

Colour is also part of photographic technique. A photographer can now control colour as easily as an artist controls paints on his palette. For example, if you want to exaggerate a small amount of colour in the background of a picture, open up the aperture as wide as possible. It will enlarge the colour mass of the areas that are not sharp. The Impressionists worked with their impressions of colour, not factual representations, and revolutionized attitudes. In photography, too, colour is an area in which photographers can express their own creativity. Colour can help you achieve an individual look.

The standard calendar picture of Switzerland with bright blue sky and crisp snow-capped mountains may be beautiful and technically spot on but lacks drama and emotional content. It is more interesting to be adventurous with colour and record it at the margins early or late in the day or when the weather is bad. Filtration can also create colour impact. With filtration you can go beyond what is before you and create a picture that has soul and atmosphere. Shooting digitally allows you to control colour both at the time of capture and later on the computer.

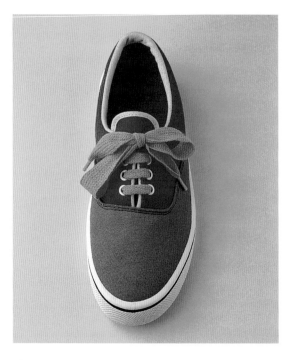

**Shoe**
Without colour this picture would be nothing. I bought these shoes for their colour, which gives them a photographic charm. The picture was taken in daylight, simply looking down on the shoe. The yellow background adds contrast and strengthens the overall colour effect.
*Mamiya RB 6 x 7 160mm macro/Fuji Velvia*

The colour wheel shows the relationship between colours. The primary colours (red, green and blue) are separated by the secondary colours (orange, yellow and violet). Colours opposite each other contrast in the most extreme way. Colours next to each other are visually harmonious. Colour has a weight in a picture, and an understanding of this helps make for successful photographs. For example, there only needs to be a small red detail in a landscape for your eye to lock on to it. The Impressionists discovered that if you put blue and orange together, both colours are heightened.

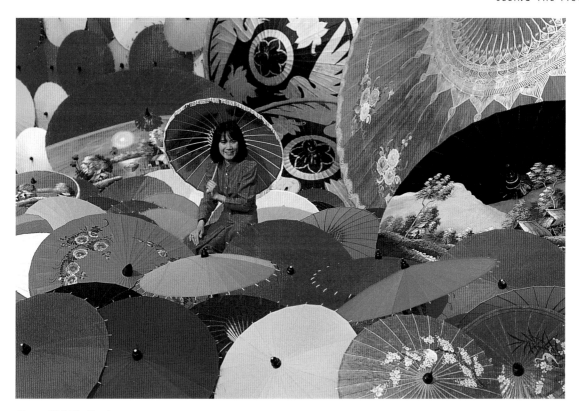

**Chang Mai, Thailand**
I asked the boss of an umbrella factory if I could photograph a sea of colourful umbrellas. The next day we set up the picture, choosing to keep it predominantly red and yellow. The direct morning sunlight enriches the colours, which are further saturated by the Velvia film. The girl, one of the skilled painters, was there to give the picture scale.
*Nikon F3 135mm on tripod/Fuji Velvia*

**Mexican wall**
In the dazzling morning light the colours on this Mexican hotel building looked amazing and their juxtaposition makes the photograph. The colours are the subject here, demonstrating photography's ability to make something out of nothing. I had to turn the camera on its side to get the angle to balance the colours. The red and yellow are the walls of the hotel and the blue of the sky is seen as just another colour. I exposed for the highlights, which has slightly darkened the blue. A medium telephoto lens has foreshortened the perspective, flattening the image.
*Nikon F4 80–200mm zoom/Fuji 100*

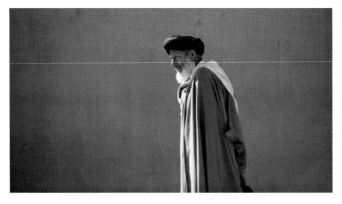

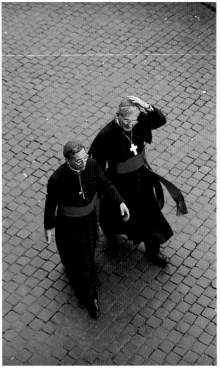

## Complementary

Pink and grey are a harmonious combination. These two pictures demonstrate their use in opposite ways. In the picture of the Moroccan in Fez there is much more pink than grey, but because it is such a subtle shade a balance is achieved. Touches of white in the scarf and long beard heighten the contrast and help hold your eye in the picture.

The pink in the picture of cardinals in Rome is much brighter, so less of it is needed. The small amount of intense colour is just enough to balance the darker areas of the picture and its position in the middle of the picture keeps the eye on the figures.

**Fez:** *Nikon F2 85mm/Kodachrome 64*
**Rome:** *Nikon F4 80–200mm zoom/Fuji 100*

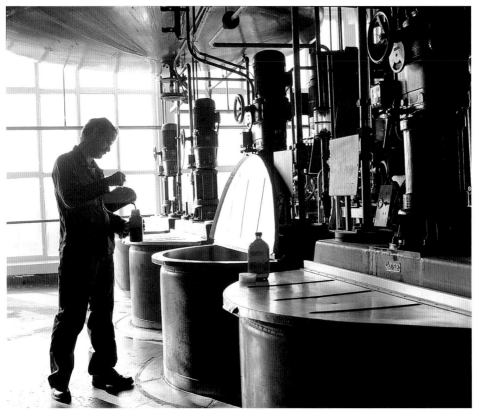

## Power of red

Strong back-lighting from the windows of a dye workshop has washed most of the colour out in this picture and turned it to shapes, but picks out the red in the bottles. The eye goes straight to the red dye, while the man pouring it becomes only a shape.

**Dye Works, Ciba, Basel**
*Mamiya 7 80mm/ Fuji Provia*

As a general rule, the fewer the colours in the picture the stronger the impact. Colour in the wrong area of the frame can be extremely disruptive. Look at a picture of a man in a dark suit with a white handkerchief in his pocket. The white is distracting. Red has the power to attract the viewer's attention and can provide just the focus needed in a picture, but a red highlight in the background of a picture can lead the eye away from the subject. Be aware of the positive and negative effects of colour. On occasion clashing, irritating colour can also be the point of the picture.

Exploit pre-conceived ideas about colour. For instance, blue is usually thought of as a cold colour. This can be exploited photographically. If you underexpose a snow scene, it will have a blue cast, looking colder than white snow. Conversely, by accentuating a blue sky and a blue sea with a polarizing filter in a summertime Mediterranean scene, you are adding to the feeling of warmth – exactly the opposite effect!

### Contrasting

The direct sunlight made the blue of the new storage tanks really 'zing' out and, as luck would have it, the men working wore bright orange overalls. The perfect colour combination. Orange clothing is used in many industrial locations because it is so visible.

**Molasses tanks, Dublin** *Nikon F5 35–70mm/Fuji Provia 100.*

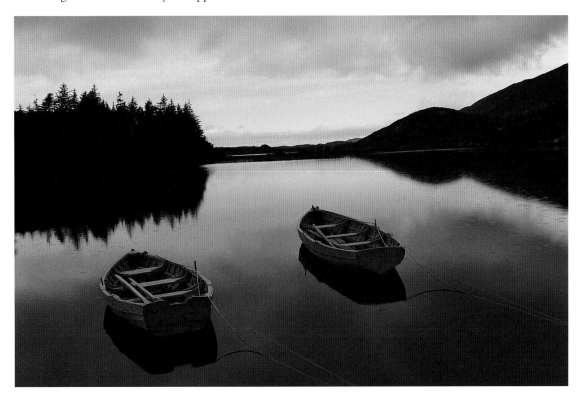

### Minimal colour

It is the very lack of colour that makes this picture. Even at the height of summer in coastal areas, the weather can change abruptly. Here the dark clouds of a passing thunderstorm have dulled any colour in the landscape, leaving just a hint of pale blue in the western sky. **Ballynahinch Castle, Galway** *Nikon F4 35–70mm on tripod/Kodachrome 64*

# Seeing in black and white

Why shoot in black and white when the world is in colour? Black and white photography established itself well before colour, which was not reliable until the late 1960s. Nearly all the great photographic themes are perfect in greyscale, and – in part because it's been around longer – most memorable photographs are monochrome.

A perfectly rendered colour print is never quite as satisfying as black and white. Stripped bare of the distraction of colour, you are left with the graphics, the leading lines and the structure of the picture. The texture and form are in the tones. When the mundane scene of the fence in a field is turned into black and white, it becomes another type of image. The hard, straight lines of the fence, in a light tone of grey, contrasts with the dark, wispish tones of the grass. The fence dissects the filigree detail of the white flowers and the tree in the distance. The leading lines of the fence give the picture depth.

The picture can be sharp throughout, or the subject can 'stand off' the soft, out-of-focus areas, giving the image depth, volume and a three-dimensional look. These elements combine to create a composition, and the information within the picture is direct and straightforward.

There are good reasons for choosing to shoot in black and white, even in this age of high-quality, reliable colour. It is a powerful choice for any image with a message, such as a news picture. In everyday photography, black and white is ideal for pictures where texture or shape is a vital element. Backlit or sidelit subjects, especially those with an inherent texture, are particularly suited to black and white.

The image opposite shows a very familiar object, seen in a different way. The matt texture of the outer leaves of the corn contrasts perfectly with the smooth, shiny kernels. By sidelighting the picture, the various contrasting details are registered in relief, emphasizing shape and volume.

The secret of shooting black and white is to know what the finished print is going to look like. You need to imagine the print before you take the picture, to decide what the point of the picture is.

Black and white photography means knowing your materials thoroughly: you know what sort of paper you are going to use because that will make a difference; you know the characteristics of the film you are using and how best to develop it. Gradually you find a style and quality of print that you like and shoot for that.

There is a maxim for shooting black and white: expose for the shadows and process for the highlights. Overexposing for the dark areas, or over-processing for the light areas guarantees that you have all the details in the neg. Whether you print them is up to you.

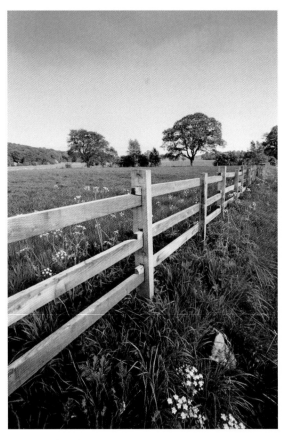

**Somerset levels**
*Nikon F4 28mm/Kodak Tri-X in Rodinal*

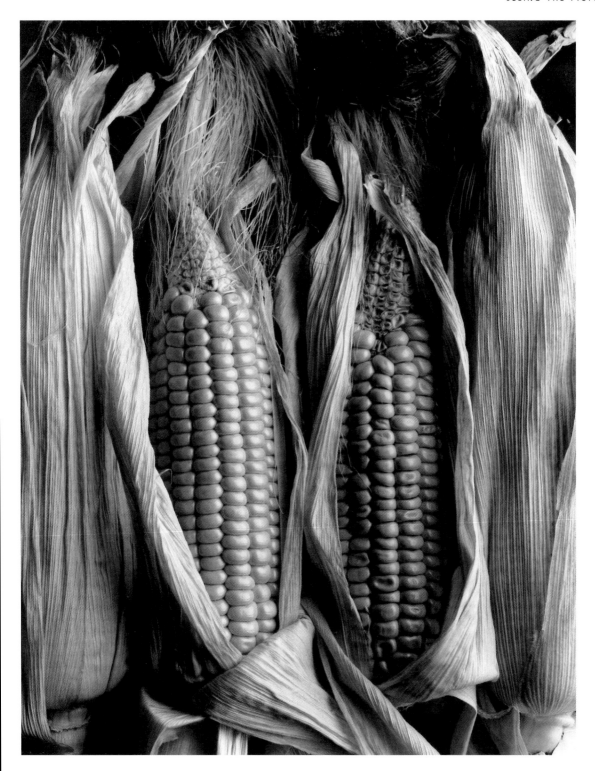

**Corn on the cob**
*Mamiya RB67 140mm macro/Agfa APX 25 film processed in Rodinal straight print*

# 2: THE CAMERA IN YOUR HANDS

Today's cameras – even the humblest point-and-shoots – are packed with technology that makes picture-taking in normal conditions almost foolproof. The medium and top-of-the-range bodies come with mind-bogglingly lengthy instruction manuals. It is important these are read and thoroughly digested.

The pictures in this book have been taken using almost every function incorporated in the modern camera body. But the majority were taken in manual mode; the camera's automatic decisions used as a reliable, but not infallible, guide. The various exposure and shooting modes contribute massively to taking a good picture every time. It is fair to say that most mistakes are the fault of the user rather than the equipment.

Manufacturers used to introduce a new camera body every 8–10 years. The digital revolution has changed all that. Updates are launched all the time. The top-of-the-range bodies are expensive. No one wants to keep buying new bodies, so in future only the firmware within the body will be changed at a fraction of the cost.

On the digital body, there are a number of additional functions that can make the photographer's life considerably easier. Perhaps the most obvious of these is the LCD screen, which – among other things – allows composition, exposure and focus to be checked instantaneously. Accurate exposure can be determined further by use of an on-screen histogram, giving an idea of the spread of tones throughout the picture, as well as by a highlight warning feature. This is particularly useful for digital, where it's so essential to expose highlights correctly, and uses a flashing white area to warn the photographer of any points of the image

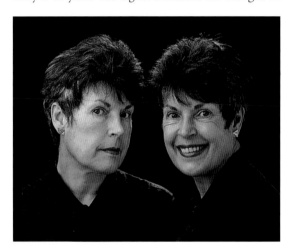

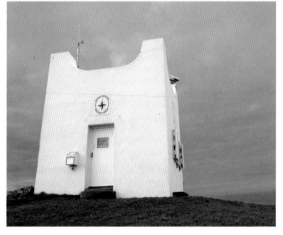

## Double exposure

This is where two or more images appear on the same piece of film. Set the SLR camera to multi-exposure mode or unlock the lever on a medium-format camera film back. It is also possible to rewind and re-expose the film, but make sure the sprocket holes line up exactly the same on the spools the second time around. A creative tool when used with the right subject, though comping two or more images together in Photoshop achieves the same effect with greater flexibility.

**Portrait of Ruth Rendell/Barbara Vine**

*Mamiya RB67 180mm on tripod/Fuji 100*

## Histogram

The problem here was how to expose for the building without losing the moody sky. If shot on film the building could have been held back in the printing stage. Here, the image was exposed for the sky and the curves on an adjustment layer in Photoshop selectively tweaked to lift the exposure of the building. The histogram helped to evaluate the contrast levels and ensure detail was kept in both the sky and the grass.

**Coastguard lookout in Cornwall**

*Nikon D100 18–35mm/RAW file*

© Duncan Soar

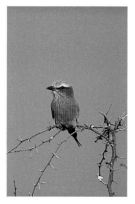 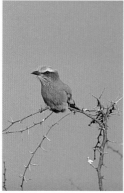 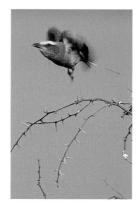

## Motor drive and auto winder

Motor drive and auto winder generally come as standard with most cameras. They are useful because you don't have to take your eye from the camera between pictures and this allows you to concentrate on what is happening in front of the camera. Used for an action shoot in short bursts, to capture the critical moment in one of the frames, or for a sequence of pictures that show the whole action. **Lilac-breasted roller, Botswana** *Nikon F5 80–200mm/Fuji Provia*

where highlight detail is being lost. A good example of where these features really come into their own is where a scene might require a mixture of ambient light and flash. Using these controls, the photographer can fine-tune the balance between the foreground, which is being lifted with flash, and the background, which needs a suitably long exposure to register in the shot so as to look natural. Other useful features include the ability to change the white balance of an image, much as you would with filters on a film camera. For example, just as tungsten light on daylight film could be balanced with a blue correction filter, you can simply dial in a tungsten white balance. Cold-looking images can be warmed up, and vice-versa. Furthermore, if RAW files are being shot, the photographer has the ability to fine-tune the white balance on the computer afterwards. Also, unlike on film, the effective film speed of the digital sensor can be changed from shot to shot. This information is then stored within the image file, together with details of lens length, white balance, aperture and shutter speed – all of which are helpful if a shot needs to be recreated. Digital cameras often allow the user to change the output size of the final image file. Sometimes it may not be necessary to shoot at full resolution, for example if rough snaps are being taken to be emailed. In this case you might want to change the setting to a low-res JPEG rather than a high-res RAW file. The digital body also allows you to adjust default image-sharpness, contrast and tone, giving the photographer a remarkable amount of control over an image even before it's shot.

Illustrated here are just four of the many functions that can help make a picture.

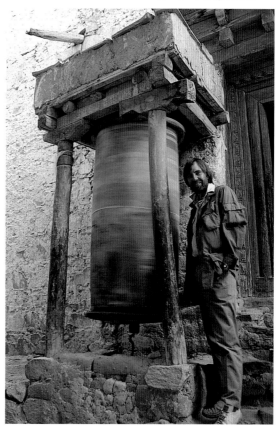

## Self-timer

Although not used very often, it is important because it makes it possible for the photographer to be in the picture – either as part of a group or for a self-portrait. Some cameras have a red light that flashes before the shutter fires, giving you time to look your best. The duration between setting the timer and the camera firing can be adjusted from several seconds up to about one minute. **Self-portrait with a spinning prayer wheel in Tikse Monastery, Ladak, India** *Nikon F3 35mm on tripod/Kodak Ektachrome*

# Exposure

The human eye is much more elastic than film or digital capture in its acceptance of a wide range of exposure values. When you walk between the garden and the house on a bright summer's day, the eye adjusts quickly to the extremes of light. Imagine a scene in Africa in the midday sun – a whitewashed building with somebody standing in its dark shadow. Your eye can effortlessly and almost instantly adjust from seeing the architectural detail of the sunlit building to the face of the man in shadow. The film in your camera, however, cannot register more than about five f-stops of contrast, digital about seven. The difference in contrast in this scene will be more like ten stops, and the camera cannot take a picture that has the detail in both highlight and shadow areas that your eye can see.

Most scenes don't have such strong contrasts. You often have to decide which elements are the most important in your scene, and which can be lost – either because the highlights are overexposed or the shadows underexposed. The preview button gives an indication of the contrast as the camera sees it. Since you are usually photographing recognizable tones, such as faces, grass and sky, these have to be correctly exposed, and this determines what happens to the rest of the picture. Your eye and brain are constantly editing the images you see. In order to understand what the camera sees, you need to slow the process down and really look at what is in front of you.

There is no such thing as the 'correct' exposure for a picture. There may be an exposure where most things are realistically exposed, but that might not be the point of the picture. You may want to lose unwanted detail by either underexposing or overexposing a little. Sometimes a lighter or darker picture helps to convey a particular mood. Overexposure works well with a subject that is backlit and haloed in light. If a small part of the picture is brightly lit and you expose for that detail, you add emphasis to that small area. Everything else will appear darker photographically than in reality.

Colour transparency film has to be exposed within one f-stop of a meter reading, but print film has more latitude – two stops either side of the correct exposure. If the film is scanned, regardless of whether it is a negative or a transparency, an astonishing amount of information is contained in it. If anything, it is probably best to err on the side of underexposure for transparencies and overexposure for prints.

If shooting digitally, expose for the highlights when set on autoexposure, or carry an 18 per cent grey card and take the exposure reading off that. Set the exposure reading manually again off the highlit area. Tweak the white balance. When transferred to Photoshop, detail from the darkest areas can be retrieved.

Most sophisticated cameras have three built-in metering systems: spot, centre-weighted and matrix metering. Spot meters are especially useful and enable you to expose precisely for a particular detail. With experience, you get to know what the variation in tone is likely to be in most situations, and whether the film can cope with it. For instance, a white face is about a stop lighter than 18 per cent grey, so the best bet is to use the spot meter to take a reading for a portrait, then overexpose from that reading by one stop to get correct skin tones. In bright sunlight there may be dark shadows on the face that will come out as black on film, even though they may not be very noticeable to the eye. For a flattering portrait in this situation, move your subject into slight shade to get rid of the contrast.

Centre-weighted metering reads the bottom two-thirds of the frame rather than the top third. It assumes that the interest of the picture is there and the top third is mostly sky. In most circumstances centre-weighted metering is more reliable.

Compare how centre-weighted metering operates when you look at a variety of subjects horizontally and vertically. There will invariably be differences. Familiarize yourself with them all so you can use the meters in the camera to supply you with exposure information to help you make up your own mind,

rather than allowing the camera to make up your mind for you.

Matrix metering – also known as evaluative, honeycomb or multi-pattern – produces good results in many situations. It is great as a fail-safe and for spontaneous, point-and-shoot or digital photography.

Although matrix metering gives you a picture, the exposure may not be correct for your visualization of the subject. When making pictures rather than taking them – especially if you are working in the margins, or your subject is small – you need to go beyond matrix metering. For example, if you are photographing a light figure in a green landscape, matrix metering is more likely to overexpose the picture than centre-weighted. Matrix takes too much information into account and looks at too many elements for a success-ful evaluation.

Matrix metering is used with fill flash. It reads the background so the surrounding area is well exposed while the flash throws a balanced light on the subject.

Whatever metering system you use, make sure it gives the right compensation when adding any form of filtration such as a Polaroid filter. Don't use matrix metering with graduated filters, or you will lose the desired effect of darkening the sky.

Serious photographers trust the

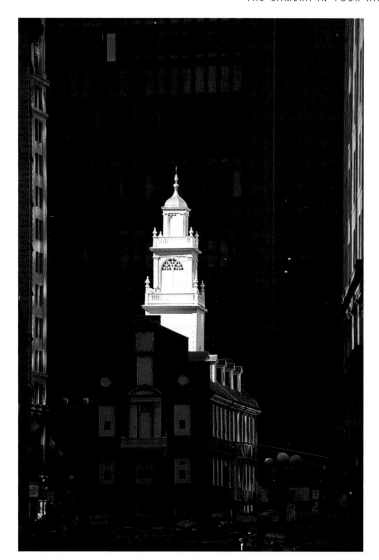

**Using the spot meter**
An example of exposing for extreme light levels. Hard sunlight illuminates the white church tower, surrounded by dark buildings in the shadows. The subject is the tower. Here reproduced from a transparency, it could have been scanned and adjusted in Photoshop, to retrieve the detail in the shadows – but the point of the picture would have been lost.
**Boston financial district**
*Nikon F3 80–200mm zoom/Fuji Velvia pushed 1 stop*

camera meters but also carry a hand-held meter for taking direct, incidence and spot readings to make their own calculations. Using a hand-held meter, you take a light reading directly off whatever you are photographing or, using the Invercone option, take a reading of the light falling on the subject. This is essential when shooting in a stadium where the over-all light is made up of hard spotlights. Using the spot meter, you can find out what the light is on a subject that you physically cannot reach. Separate meters are required for evaluating portable flash reading. A colour temperature meter is used in mixed light conditions and it will tell you what filtration to use to correct the adverse colour casts.

# Shutter

Modern cameras incorporate a new generation of super-fast shutters that are consistently accurate at speeds up to 1/8000 of a second. It is essential to understand the relationship between the shutter and the aperture. They are bound together, and choosing the right combination is one of the most important creative decisions a photographer makes (see page 37).

Most of the time, your camera works at shutter speeds from 1/30 second to 1/500 second. These speeds cover most conditions and capture what the eye sees naturally in daylight. However, if you work at below 1/30 second and above 1/500 second you are more likely to add drama to your work and get exciting results. For most pictures there will be a wide range of shutter speeds that are technically cor-rect – but only one may stand out creatively. There are images that it is only really possible to photo-graph successfully from 1/500 second up to 1/8000 second. At the top end of this range, you can freeze the wheels of a formula-one car travelling at more than 200 miles an hour, or a still a hummingbird's wings. At the other extreme, super-slow shutter speeds can be used with a tripod to record the pas-sage of time. An exposure can be made to last all night and track the orbits of stars. You can photo-graph a landscape by moonlight. It will look dark to your eye, but after an hour's exposure, every pebble and every leaf will be visible. One of the great capa-bilities of photography is to record a world usually missed by the human eye.

Slow shutter speeds can also interpret varying degrees of movement. Flowing water can be slightly blurred, for example, or turned into a milky smooth mist with an extra-slow speed. With fill flash and matrix metering, I often shoot at 1/4 to 1/8 of a second.

**Open shutter**
Set up in a studio, the juggler waved the flaming torches around in various patterns – the shutter was left open for about 3 seconds then the flash fired to light up the jug-gler. This sort of picture relies  a lot on judgement and trial and error.
**Juggler**
*Nikon F4 85mm on tripod/Kodachrome 64* © Chris Cormack

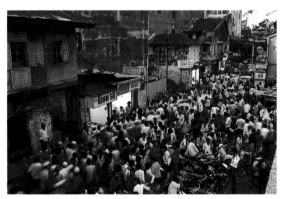

**8 seconds**
It is amazing how still some people can stand. I used the camera meter and also a hand meter which gave me a reading of about 8 seconds. Business and socializing is done in the cool of the evening. I wanted to show lots of hustle and bustle. I bracketed quite considerably from 5- through to 15-second exposures. Long exposure times can exceed those recommended by the film manufacturer which results in a colour shift, in this case to blue. This is not a problem when shooting digitally.
**Diamond district, Surat, India**
*Nikon F3 85mm at 8 seconds on tripod/Kodak EPP*

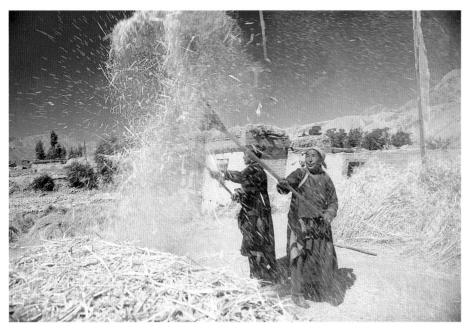

### 1/15 second

There are many picture situations where you don't want to freeze movement, but show an action. This should be the only movement in the picture: the rest should stay sharp. With practice you can hand-hold a camera at 1/30 second, but if in doubt use a unipod.

**Winnowing wheat, Kashmir valley, India**
*Nikon FM2 35mm at 1/15 second hand-held/Kodak EPP*

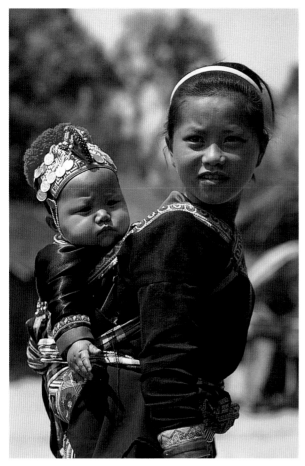

### 1/250 second

The normal shutter speed for hand-held photography is 1/100 second to 1/250 second. The most important thing is to capture the picture without camera shake. As a rule of thumb, if you are using a 105mm lens, use 1/125 second; a 200mm lens, 1/250 second; and a 500m lens, 1/500 second. There are times when 1/125 second is unsafe – for example if you have been running.

**Hill tribes, Thailand**
*Nikon F5 80–200mm at 1/250 second/Fuji Provia*

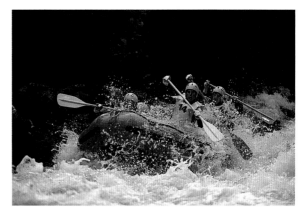

### 1/1000 second

1/1000 second will freeze most moving things – including sports action and flowing water.

**White-water rafting, Bala, North Wales**
*Nikon F4 400mm at 1/1000 second on unipod/Fuji 100D + 1 stop*

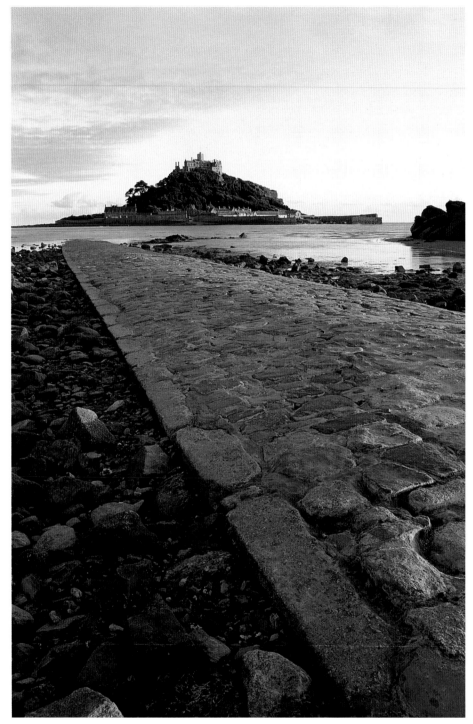

## Stopped down

The pin-sharp causeway leads the eye to St Michael's Mount across the sea. The lens is stopped down to f22. Focusing about 15 yards from the causeway will ensure overall sharpness. Foreground and background sharpness were checked in preview. I used a 0.6 grad filter over the sky to keep detail.

**St Michael's Mount** *Nikon F5 20mm on tripod/Fuji Velvia*

# What the aperture can do

The aperture, in conjunction with the shutter, controls the amount of light needed to expose an image correctly. The way these two are coupled will alter the look of the picture. A wide aperture coupled with a fast shutter speed results in a very narrow plane of focus – not much is sharp. Conversely, a small aperture with a slow shutter speed gives maximum sharpness to the whole picture.

The smaller the number on the lens barrel, the wider the aperture; the greater the number, the smaller the aperture. There is a direct correlation between standard f-stop steps and shutter speeds. An aperture of f8 allows in twice the amount of light than an aperture of f11, so requires the shutter to be open for half the time. A picture that can be exposed at f8 at 1/250 second will also work at f5.6 at 1/500 second or f11 at 1/125 second and so on. Your choice of aperture depends on how much of the image you want to remain sharp.

The choice of lens will also dictate how much is in focus. Use the stop down or preview button to check which areas are in focus at different apertures. Autofocus will help guarantee sharpness.

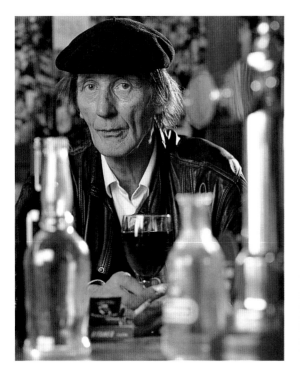

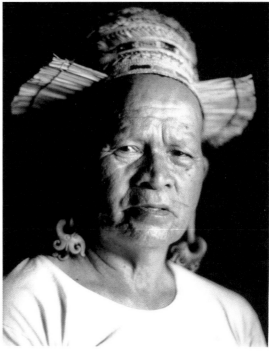

**Wide open**
The French House pub in Soho has a daily clientele of writers, artists and photographers and is the perfect location for a portrait of crime writer Robin Cook.
To capture the atmosphere of the place was important so I used a long lens, with the aperture wide open, and selective focus so only he would be sharp. The hard light has made the brass and glass sparkle. Shooting through strategically positioned bottles gives the picture depth.
**Robin Cook**
*Mamiya RB67 240mm on tripod/Kodak EPP*

**Wide open**
The majority of pictures can be taken on zoom lenses; the widest aperture of these is f2.8. If you want to continue shooting traditionally in black and white, invest in the widest aperture lens like a Nikkor 50mm f1.2. I couldn't have taken this picture on anything else. I was taken back to this man's Dyak long house as the sun was setting. I didn't have a tripod so I sat and rested the camera on my knee, photographing him at 1/15 second at f2.
**Dyakman, Sarawak**
*Nikon F3  50mm/Tri-X pushed 1 stop*

# Autofocus

However well you compose your photographs, they won't look good if they are not in focus. Something in the picture has to be sharp; there are not many successful pictures that are simply not focused.

Autofocus is an excellent tool, but it doesn't solve all your focusing problems. Early autofocus systems were often slow and frustrating and an experienced photographer could always focus quicker manually. Now all manufacturers produce fast autofocus systems but an experienced photographer can usually focus quicker than the autofocus on wide-angle fixed lenses. Autofocus comes into its own when the subject is in continual movement. Say, for example, you are using a 200mm lens to photograph children playing in a fairly small space and the arc of movement is small. The camera will lock onto them so you don't have to think about focusing, and you can concentrate fully on their expressions.

Most autofocus systems have features that enable you to take pictures almost impossible before their invention. Without focus tracking or trap focus, for example, the only way of capturing the expression on an an athlete's face as he or she wins a race is to use a motordrive, prefocus on the tape, press the shutter a metre before they break the tape, and keep it pressed. You will be taking five or six frames a second, but in that time an athlete travels ten metres, so there is still an element of luck. Autofocus has made a huge difference to sports photography generally. It allows photographers to lock-on instantly and fill the frame with action. It has also made a big difference in fashion and wildlife photography where, coupled with auto-exposure, you can achieve freer and more relaxed-looking pictures.

Autofocus is helpful in a portrait, to keep the eyes sharp when the lens is wide open, using a narrow plane of focus. It will also help you capture a butterfly alighting momentarily on a flower.

Only use autofocus where it can't let you down. If someone walks in front of you or something happens to fool the sensor, the autofocus locks onto the wrong area of the picture, and by the time it has readjusted, the picture may be lost. To avoid this, use the focus lock.

You have to use autofocus a lot to get the most out of it. You have to learn what situations it is ideal for, and when the risk of something going wrong is too great. Even when focusing manually, an indicator in the viewfinder tells you whether or not your picture is sharp. This is especially helpful if your eyesight is poor or if you are working in dim light. It is also ideal when working in low light levels where the camera can see more than you can. With most cameras, the in-focus indicator is compatible with older lenses, so there's no need for wholesale upgrades.

Since there are times when manual focusing makes more sense, it is important to choose autofocus lenses that are user-friendly in manual mode. Some manufacturers make the focusing ring too narrow for the nimblest fingers. Always try before you buy.

The new generation of medium format 6 x 4.5 cameras now offer autofocus. Even in the controlled environment of the studio, this has made a significant difference when the sharpness of the subject is of paramount importance. In the past, you often had to fine focus by using a x6 loop on the ground glass.

All in all, autofocus has made taking pictures a more relaxed experience.

**Holding focus**
With the lens set at its widest aperture, the plane of focus is only a few millimetres. Autofocus helps hold the stamen sharp – difficult manually, with the flower moving in the breeze.
**Wildflower** *Nikon F5 105mm macro/Fuji Provia*

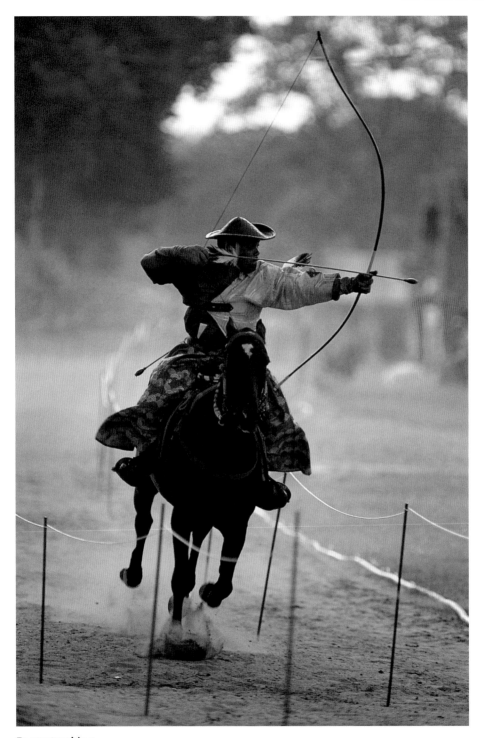

## Focus tracking

I used a wide aperture so the background was blurred, giving a plane of focus of just a few feet. Continuous autofocus tracking locked on to the archer as he came down the hill and held him sharp for a five-frame burst. This picture was of the fifth horse that came down the track. It's always good to have more than one chance of getting the picture. **Japanese archer** *Nikon F4 400mm on unipod/Fuji 100*

# Lenses – the range

Just as with camera bodies, modern computer-aided design and manufacture has produced a new generation of lightweight, good-value lenses. As a professional photographer, I have a responsibility to my clients, and to myself, to deliver images of the best possible quality. Most manufacturers produce super-quality professional lenses that are faster and sharper than the normal range. That sort of edge can sell a picture. If you buy all your lenses from the same manufacturer there is a bonus in ease of use. Lenses of the same make all turn the same way and have the same colour cast. Most will be the same filter size.

Before digital took hold, a professional photographer would usually carry three camera bodies, each with a different lens – maybe a 35–70mm, an 80–200mm and a 300mm, with a 20–35mm as a spare. An amateur won't want to deal with the bulk and weight of that amount of equipment, quite apart from the expense. Start with a single zoom – a 28–105mm is both manageable and adaptable.

Good lenses are expensive and it is not really worth buying poor-quality zooms, even though the price may be tempting. Their poor optics mean that you will be disappointed in the results: pictures will be soft, lacking

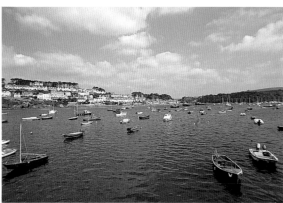

*20mm = 30mm*

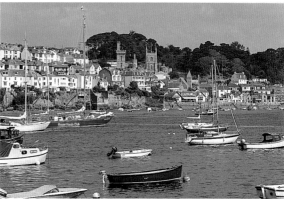

*28mm = 42mm*

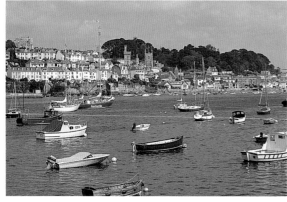

*50mm = 75mm*

*105mm = 160mm*

**Fixed focal length**
Fixed focal length lenses and what they translate to if used on a digital camera such as the Nikon D100
**Fowey Harbour, Cornwall**

in contrast, and may have substandard colour reproduction. (A variety of cheap, fixed focal-length lenses are a better bet than cheap zooms.) When buying a point-and-shoot camera, take note of the optical zoom, but don't be impressed by a digital zoom, where the quality of the picture deteriorates as you zoom closer.

Each focal length has a characteristic and a personality that can enhance a picture. Most photographers have their favourite lenses that they feel happiest with. I feel that 35mm lenses do a lot of work and add a great deal to the picture. With medium-format lenses the photographer has to do much more.

In the pictures below I have used the familiar fixed-focal-length lenses to characterize the optical effects of different lengths. These pictures were all taken from the same spot at the same time of day on lenses ranging from 20mm to 600mm. They show what you can get from the same position with a variety of lenses. Each one makes a picture, but the angles of view vary dramatically. The nearest boats in the first picture are only 15 feet or so from the camera. The church in the last picture is half a mile away. These shots demonstrate that you can photograph almost everything on a range of lenses and get very different-looking pictures. If these lenses are used on a digital camera like the Nikon D100 the focal length is multiplied by 1.5 – so a 28mm operates as a 42mm lens. A new range of wide-angle lenses has been introduced specifically for digital cameras where the chip size only covers 60 per cent of the 35mm format, to bring them in line with traditional framing.

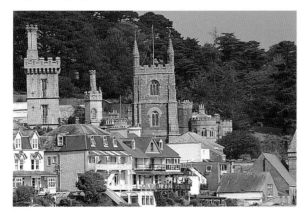

*180mm = 270mm*

*300mm = 450mm*

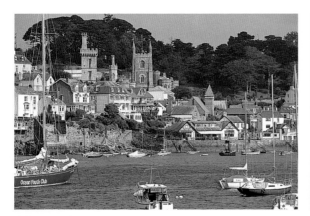

*400mm = 600mm*

*600mm = 900mm*
*with x 2 double – 1200mm*

# What a lens can do

The most important function of a lens is to produce sharp pictures, both at its widest aperture and when stopped right down. The way lenses are designed today means that they should produce sharp images whatever the f-stop. There are a lot of ways of producing unsharp – or degraded – images, but you should be able to control this.

A way to test lens sharpness is to pin a big newspaper on a wall and fill the viewfinder with it. Photograph it with the lens at its widest aperture and then check there is no fall off in sharpness at the edges and corners. Then do the same with the lens stopped right down. A lens hood will reduce flare and with longer lenses (especially zooms) it will increase the contrast, giving an added impression of overall sharpness. Shooting digitally, it is safer to use the sharpening tool in the computer software rather than in the camera.

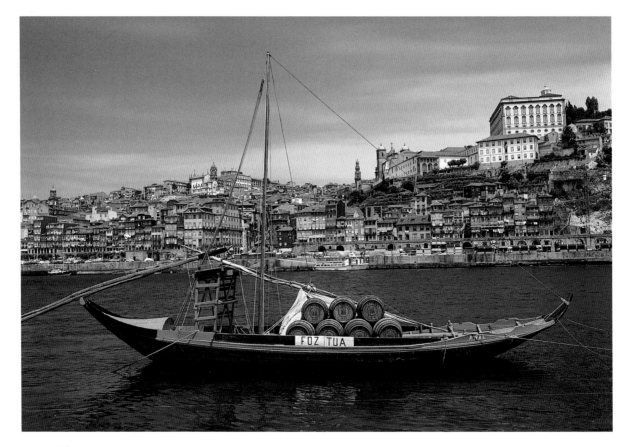

### Sharpness
Critically focused on the boat, the texture of the hull, the barrels and the edge sharpness of the rigging are apparent. Sharpness will be guaranteed by using a tripod and an f-stop of around f11. It used to be said that the sharpness of German lenses came from resolution and the sharpness of Japanese lenses was due to their being more contrasty. Some photographers, shooting black and white, liked to have Japanese lenses on their cameras and German lenses on the enlarger – or vice versa – in order to get the best of both worlds.
**Oporto, Portugal**
*Nikon F5  28–70mm/Fuji Velvia*

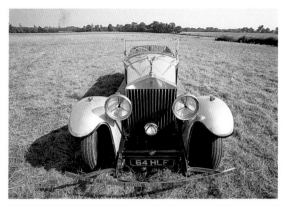

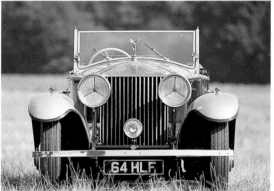

## Perspective

In these two very different pictures shot with the same camera the car hasn't moved but the photographer has. For the picture shot on the wide-angle (18mm) lens I was about three feet from the car. The background appears further behind the car than it is in reality. The lines of the car have been elongated by the lens, which gives it a dramatic, sweeping shape. The second picture was taken on a 300mm lens from about thirty or forty yards. The background is brought right up behind the car, which looks much squatter than in the wide-angle picture. Its shape seems flattened and more one-dimensional. It is the understanding of these differences, what happens when the photographer changes his relationship with the subject, that can help you make pictures.

## Pulling zoom

This is a technique that should be used sparingly. For maximum effect you need distinct points of light – a city night-time street works well. The camera is on a tripod. The 300mm lens is set at its widest focal length and stopped down – you need a long exposure time to work with. During the exposure, pull the zoom to its other extreme. The lights will streak, while the centre of the image is unaltered. Different effects are achieved by going from tele to wide angle and by varying the distance between focal lengths and length of exposure.

**Nathan Road, Hong Kong**
*Nikon F4 80–200mm on tripod/Kodak EPP*

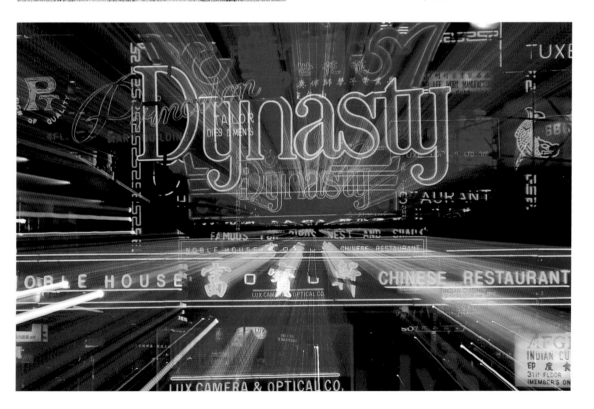

# Special lenses

Many great pictures are taken with what a photographer would consider everyday lenses. However, there are a number of special lenses that broaden picture-taking possibilities. Recently, stabilized tele-lenses have come onto the market, and these allow you to shoot at really slow shutter speeds without camera shake. There are several de-focus lenses, which are used for portraiture and still-life, where you focus on the subject but can then control how much out-of-focus you require in the rest of the picture.

On a trip to India a few years ago, I narrowly missed getting through customs with all my equipment. After lots of haggling, I came to a deal with the officer that he would hang on to 60 per cent of my equipment and let me keep 40 per cent. So I chose to keep my 80–200mm zoom, 55mm macro and 35mm; he kept my 300mm, 180mm, 28mm PC and 20mm lenses. What I really missed was the 20mm because, when there isn't a picture to be had, a wide-angle lens often gives an interesting new perspective. It has the ability to enlarge the foreground, diminish the background and exaggerate sweeping lines. It allows you to play with the scale of foreground to background and to be in focus from close-up to infinity. Thankfully, all the lenses were returned when I left.

**Wide angle**
John Wood's Circus in Bath has been a good subject for the 20mm lens. Keeping the shadow in the foreground completes the circle.
*Nikon F4 20mm/Kodachrome*

**Mirror**
A mirror lens is a much cheaper and lighter alternative to a fixed, focal-length tele-lens. The fixed aperture, usually f8, was once a problem for action photography, but with new, higher quality fast films and the fast ASA of digital capture, they can now be used for most types of photography. Mirror lenses have an incredible close-focusing ability down to 6 feet. You can spot their use by the doughnut shapes of out-of-focus points of light.
**Ski jump at the Nagani Winter Olympics**
*Nikon F5 Tamron 350mm/Fuji Provia*
© Bob Martin

## Macro

If you want to get in close and record the world in detail, you'll need a macro lens. Most general location photographers will carry one of these in their everyday kit. My preference is for the 105mm because not only is it a close-up lens, it is also a still-life lens and great for a warts and all portrait. This family of lenses is so sharp that you can almost feel the texture in the pictures. They have a narrow plane of focus so the background is soft, accentuating the focused detail. The 200mm macro is very good for small wildlife.

**Owl** *Nikon F3 200mm/ Kodachrome*

## Perspective control

It is surprising how many pictures you see of buildings appearing to fall over backwards. This can be corrected simply by using a perspective control (PC) or shift lens. Instead of tilting the camera, the lens itself shifts position, while keeping the film parallel with the plane of the building. PC lenses are slow to use and the camera exposure meter has a problem giving the correct exposure, but this is easily solved by bracketing or checking the preview screen. PC lenses can also be shifted horizontally, which is useful for avoiding your reflection appearing in reflective surfaces. If you are shooting digitally, this lens could be redundant as the toppling building can be re-aligned in Photoshop.

**Chateau at Ussé** *Nikon F4 28mm/Kodachrome*

# Perfect lenses

All photographers have their perfect lenses – those that result in pictures they can look at again and again and never find much fault with. Here are my four principal 35mm/SLR lenses. I also use a similar range when shooting medium format – 50mm, 80mm and 250mm. I have used people as a subject to demonstrate why these lenses work for me.

### 80–200mm
This and its cousin, the 24–70mm, are the most versatile lenses. They are the essential two for the general photographer. With them you can cover every photographic subject. The zoom allows critical composition, eliminating unwanted rubbish from the frame. I have often found that a zoom at its widest will give you the vertical shot, and at its greatest focal length a horizontal one, but this does vary depending on the subject. The zoom will give you lots of picture options if you are forced to be in one place, but you should always be willing to use your legs to find another viewpoint, not just rely on the zoom.
**St Patrick's Day parade, New York**
*Nikon F4 80–200mm/Kodachrome 200*

### 28mm
This is the ideal lens for an environmental portrait when the person is showing something they have made, is selling something, has just found something, is proud of something and so on. The neutral distortion of the lens means you can use scale effectively. Here, the girl's face and the watch are the story. This is also the perfect lens to use in among working people, crowded rooms or even for nudes.
**It'aewon Market, Seoul**
*Nikon F3  28mm/Kodachrome 200*

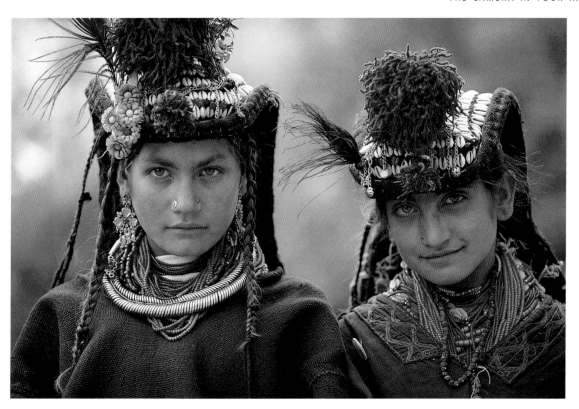

### 105mm

This focal length has always been the lens for a single or double portrait. You are close to your subject(s) but you don't invade their space. It is effective whether you use it hand-held or on a tripod. The background detail can be controlled because these lenses have a wide aperture. It is interesting to see how often, when you use a zoom lens for a portrait, the focal length settles at around 105mm.

**Kafir Kalash girls, Bombruat Valley, Hindu Kush, Pakistan**
*Nikon F2 105mm/Kodachrome 200*

### 300mm f2.8

An expensive piece of glass that gives a picture a distinctive look. It is mainly used as a sports lens, but is a favourite with fashion photographers on location because its wide aperture 'blows out' the background as long as it is reasonably far away. If you move the angle of view only slightly, the background will change a great deal. It is this that makes it a good portrait lens, especially if the subject is top- and side-lit, and you have an assistant to fill in the shadow side with a reflector. The one drawback is you have to shout.

**Swaledale farmer**
*Nikon F4  300mm f2.8 on unipod/Fuji 100D*

# The art of lensing

Knowledge of the qualities of individual fixed, focal-length lenses doesn't seem so important now we all use zoom lenses, but it is still useful to know what happens to a picture when different lenses are used. A better picture may result by walking away from the subject and then 'coming in on it' with a long, focal-length lens, or the reverse may be effective – switching to an extreme wide-angle lens to capture a broader view. It becomes an automatic skill to be able to see the picture using the visual properties of a particular lens.

Not every photographer is interested in the latest lens a manufacturer produces. For the technically minded, it is satisfying to understand the potential of a lens and what it can do over and above what it was designed to do. This is where technology and craft combine to make a picture.

### 600mm and tele-converter
A 600mm lens with 1.4 converter gives a focal length of 840mm. This foreshortens the perspective, and is an excellent way of creating mass.
**Trooping the Colour**
*Nikon F5 600mm plus 1.4 tele-converter on tripod/KodakE200*

### 18mm wide-angle
Extreme wide-angle lenses are not regarded as portrait lenses – especially used close-up to a face, which results in a huge strawberry-like nose and an oddly shaped head. Here it has been used for effect – to emphasize the gun and exaggerate the graphics in the composition. Choose your shooting position carefully and keep an eye on how the various elements in the picture react to each other.
**Purdy shotgun** *Nikon F5 18mm/Fuji 100*

### 80–200mm zoom and 200mm f2 lens

This portrait combines the properties of two lenses. The lit portrait was taken on an 80–200mm zoom at a focal length of 135mm at f5.6, against an unlit white background. The top and rim light hold the subject off the background. The background is an office detail taken on a 200mm f2 lens at f2, but deliberately unfocused to create the coloured shapes. The two images were then comped together. I am always shown a shoebox-sized room in which to do this type of portrait. Applying this technique you overcome the space limitations and regain control of the lighting and the background. This is how the picture would look if it had been taken on the fixed lens in a spacious office.

**Sir Roy Gardner, CEO of Centrica plc**

*Nikon F5 80–200mm and 200mm f2 on tripod/Kodak EPR/ Photoshop*

### Macro

A standard portrait lens won't focus close enough to give a tight head-shot. You could use a wide angle for a similar image, but you would crowd in on the sitter too much. The macro is ideal for this sort of portrait. I wanted to see the tycoon in Richard Branson's head: what was behind that smiling face? I bought the lens when I was asked to photograph him. The colour version of this picture has sold many times so the investment was worth it.

*Mamiya RB67 140mm macro on tripod/Agfa APX100/ lith print*

### 50mm

This picture was taken at an agricultural show for a story on a Yorkshire hill farmer I photographed in black and white over a period of six months. In order to give the story a documentary feel, I used two Leicas with a 28mm and a 50mm lens. Using such limited equipment made me look for pictures, walking and moving to frame each shot, rather than relying on zooms.

**Swaledale, North Yorkshire**

*Leica M6 50mm/Kodak Tri-X processed in Agfa Rodinal*

# Different cameras for different pictures

A dizzying array of cameras is available to photographers. Within each format, many models compete head to head. There are small cameras that fit in your top pocket and unwieldy systems that require an experienced assistant to get the best out of them. Different makes and models have a distinct personality and influence how the picture will be taken and how it will look. Photographers tend to have favourites for particular jobs or locations. The models illustrated here are those I and my friends have found consistently reliable over the years, photographing every type of subject in all kinds of locations.

### Canon Ixus

This classic APS film camera offers three print sizes, and a thumbnail contact sheet which stores fifty pictures. The slimline format fits easily into a top pocket. The Ixus crams all the sophisticated microchip technologies into this tiny package, and is auto everything – perfect for skiing/family group shots. The characteristic Ixus styling and performance is now available in a range of digital point-and-shoot cameras.

**Sailing through the Corryvreckan, Western Isles, Scotland**
*Canon Ixus/Kodak Advantix*

### Canon Sureshot A1

A little jewel designed for the outdoors as well as for underwater. This camera is good for snorkelling down to 16 feet and for use on the beach when you don't want to risk your SLR equipment. The quality of the pictures is very good – I have done a paid job with one. The lens is a little wide, so the subject should be closer to you than you might think. The flash is weak for general underwater pictures but fine for close-ups. Keep the 'O' ring seal clean and greased (you can use Vaseline for this). Canon will check that it is waterproof. The camera feels oversized compared with today's point-and-shoot digital cameras.

**Majorca, Spain**
*Canon Sureshot/Kodak Portra 160*

## Canon EOS 1000F

The EOS (Electro-Optical System) was developed and refined over the last decade and has enabled Canon to become the largest camera manufacturer in the world. Because of its superior autofocusing abilities, it is also the leading camera system for professional sports photographers, photojournalists and wildlife photographers. The EOS is also the cornerstone of Canon's digital SLR range. The camera illustrated here with 35–80mm zoom was the family camera for twelve years. Ideal at home and on holiday.

**Inishmore, Aran Islands, Ireland**
*Canon EOS 1000F 35–80mm/Kodak EPP*

## Nikon F with sports finder

The second-hand market is flooded with old cameras, many in perfect condition. I bought this camera for a trip to the Arctic. Solid and robust, it worked well at -40 degrees. The cushioned sports finder meant the camera didn't take the skin off the bridge of my nose, and the soft release button enabled me to photograph with gloves on. I couldn't have got certain pictures without it.

**Gris Fiord, Ellesmere Island, Canada**
*Nikon F 85mm/Kodachrome*

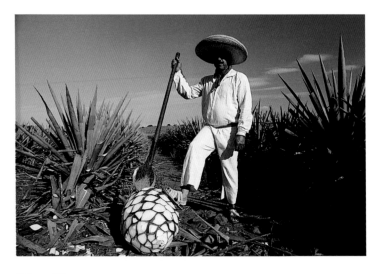

### Nikon F5

This camera body has a long lineage but it will probably be the last and best film camera body to be made. It is wonderful to hold, robust and reliable – the ultimate body for all Nikon lenses and accessories. You feel there is nothing this camera can't do. You should become fully acquainted with everything a system manufacturer produces, as there is usually a lens or an accessory that will help make a specific picture, or solve any photographic problem. Nikon F system lenses are compatible with Nikon's digital SLRs.

**Tequila harvest, Guadalajara, Mexico**
*Nikon F5 20–35mm/Fuji Provia*

### Hasselblad Xpan

I owned a Widelux camera for many years, but only ever had two pictures published. The lens was too wide and it only had three shutter speeds. However, it was still a lovely format to use both horizontally and vertically.

The popularity of panoramic prints from APS film has changed people's attitude towards wide-format photography. The Hasselblad Xpan filled a niche, and was an instant success when it launched in 1999. It has the same solid construction as a Leica, but with automatic film wind and rewind, film loading and metering. It can be used in the conventional 35mm format but it is as a panoramic that it excels. Make sure the horizontals are level and try shooting the camera vertically.

This unusual format takes a bit of getting used to, but it's very exciting when you see the right subject that fits the format. It is ideal for travel, landscape and documentary photography and for personal work.

The camera is manufactured by Fuji and the lenses are so sharp that big prints are impressive.

**School sports day, Putney, London**  *Hasselblad Xpan 90mm/Kodak E100S*

## Nikon FM2

Nikon is constantly developing camera bodies, but the FM2 has remained unchanged for twenty years. This camera appeals to traditionalists who want to use a basic camera. It is fully manual and has no modes or programmes. Only the light meter needs a battery. It was the first camera to have a 1/4000 second shutter speed and 1/250 second flash sync. Experienced photographers still carry this camera as back-up when travelling, or when they don't want to draw attention to themselves as a photographer. Adding the motordrive balances the body when using wide aperture lenses like the 85mm f1.4. The recent FM3A incorporates an electronic shutter, which allows shutter speeds between the manual settings, but the basic camera remains the same.

**Grand Trunk Road, Peshawar, Pakistan**
*Nikon FM2 35mm/Kodachrome 64*

## Nikonos V

I am not an underwater photographer, but I use a Nikonos V in conditions where it would be risky to use a conventional camera – at sea, in heavy rain or whenever I'm worried about damage. The quality of the pictures is good, but it is a camera to use when getting a picture, regardless of the quality, is important. Taking pictures is ponderous compared with fully automatic SLRs but, as long as you are methodical, you can take pictures with confidence in the roughest of weather.

**Butt of Lewis**
*Nikonos V 85mm/Kodak 400*

# The Leica

Even in these days of auto-everything cameras, the Leica retains a legendary place among serious photographers.

Taking pictures with these cameras is very different from the top SLRs, where in-body microprocessers are taking foolproof picture decisions on your behalf. You don't see through the lens, you see through the viewer and compose within framelines that correspond to the lens on the camera. As you can see more than you are photographing, you can anticipate the decisive moment when something on the fringes will appear in the frame.

There is no mirror, so less noise, which makes these cameras inconspicuous and ideal for reportage. The choice of lenses is limited compared with the leading SLR systems. This, in fact, is their real benefit: the wide lenses make you involved, physically, with the subject. You cannot avoid being close.

Because you have to engage with your subject you have to concentrate on what is happening right through the picture-taking process. Loading film is slow, so you tend to shoot methodically. The meter is very sensitive, perfect for black and white, but for colour make sure the reading is taken exactly off the point of interest of the picture.

Shooting reportage, pre-focus the lens at 10 feet, use a film rated at 800 ASA, which should give an f-stop of f11. Everything in the picture should be sharp, no need to focus. When shooting with the lens at its widest aperture, the out of focus areas of the picture have a distinctive blur, bringing the subject to the fore. This is especially apparent on a big 20 x 16 print.

The film winder for the M6 and M7 allows you to wind on without taking the camera from your eye, which some photographers say saves a vital fraction of a second. It is very quiet too.

When I go on holiday, I always go back to basics and take a Leica for black and white.

The Contax G2, although a relative newcomer, also has many fans. The lenses are superb and the autofocus facility is a great help for older eyes.

**Imber graveyard, Wiltshire**
An old lady with failing eyesight visits the grave of her
parents on St Giles' Day, one of the few days of the year
that the village of Imber is open to the public because it is
in the middle of an army training area. Her father was the
vicar and she grew up playing in the churchyard.
*Leica M4 90mm/Kodak Tri-X in Rodinal*

## Rolleiflex twin lens reflex

These cameras have been around since 1932 but you don't see many people using them today. There have been many modifications and models – the current one in production is the Rollei 2.8GX. Many famous photographers have used this camera: Cecil Beaton and Irving Penn to name but two. It is very good for black and white portraits in a daylight studio. You don't have an aggressive stance when you use a camera like this. Looking down into the viewfinder makes the photographer appear reverential and, in certain situations, this may be all it takes to achieve the picture.

**My studio in daylight**
*Rolleiflex/Ilford HP5*

## Mamiya RB67 Pro S and R2

This camera system is the workhorse of magazine and corporate photographers, where basic to complicated lighting is being employed either in the studio or on location. Ideal for the planned, art-directed picture. This is a heavy camera system, requiring a good tripod or unipod. The shutter is in the lens: in the RB it is mechanical; in the RZ battery-powered. 6 x 7 film and superb Sekor APO lenses ensure maximum image quality. They are not the quickest of cameras to use, requiring an assistant to load and log film. To fine focus, I use a Schneider x6 loupe on the ground glass rather than relying on the prism. A camera system that does the job it was designed to do – perfectly.

**Artist Andrew Logan in his studio**
*Mamiya RB67 90mm on tripod/Kodak EPP lighting balanced with daylight*

## Hasselblad

For many years, this system has set the benchmark for medium-format cameras and is favoured by serious and professional photographers. The camera is at home in the studio or on location, and at its best produces the classic square image (all too often cropped by art directors and designers). The Hasselblad is well made, robust and a joy to hold – as befits a camera that went to the moon. As with all systems, there are distinctive picture-taking procedures, but once these are mastered it rarely presents problems. The range of bodies, lenses and accessories is impressive, and now all digital backs fit the Hasselblad.

**Path at Lansallos, Cornwall**
*Hasselblad 80mm/Kodak T-max 100 Selenium print*
© Kim Sayer

## Hasselblad H1

The 6 x 4.5 format has all the manageability of a 35mm system, but because of the large film size also has the benefits of a medium-format camera. The lenses are very sharp, and the latest models offer Polaroid, film and digital backs. The 220 film gives you 30 frames – perfect for portraits, since you don't run out of film just when you are working up to the perfect look. A good travelling camera, the H1 packs into a manageable case, while the Polaroid is a good size to see the shot is OK. This will become the popular format for professionals because the high-end digital back is directly compatible – no compensatory conversions when switching between Polaroid (or film) and digital. There are competing systems from Mamiya, Pentax and Contax, all of which have autofocus. The Hasselblad has flash sync at 1/800 second, the Mamiya has a shutter speed of 1/4000 second and the Contax has Carl Zeiss lenses.

**Model test shoot**
*Hasselblad H1 150mm/Ilford FP4*

### Mamiya 7

This camera followed the Mamiya 6, a square format I always found limiting for the type of work I thought this camera was ideally suited for: medium-format corporate photography.

This system is perfect if you are travelling and working alone, but with lighting, and you need to check the picture with a Polaroid. The six lenses cover all picture requirements. It is so compact that you can carry it as hand baggage. Art directors prefer it because they can use the whole frame rather than cropping into the square format of its predecessor. One drawback is that the Polaroid back is cumbersome to fit, so you should use a separate body just for the Polaroid. The meter is centre-weighted, good for most pictures, but it is advisable to carry a hand meter just to check. As with all rangefinder cameras, using a polarizing filter is difficult, as you cannot see its effect.

**Ciba Chemical Works, Basel**
*Mamiya 7 80mm on tripod/Fuji 100D*

### Fuji GSW 690 II

Fuji also make the GW 90, the same camera with a fixed 90mm lens. Both are big rangefinders, but not heavy. I carry the 65mm version alongside 35mm kit when detail is required, or out on a walk for black and white landscapes. It is very versatile. You don't need to go hunting for pictures. Once you are familiar with its characteristics, pictures appear for you. Shooting hand-held presents no problem and it is very quiet.

**Lantivet, Cornwall**
*Fuji GSW 690 II on tripod/Agfa APX 100*

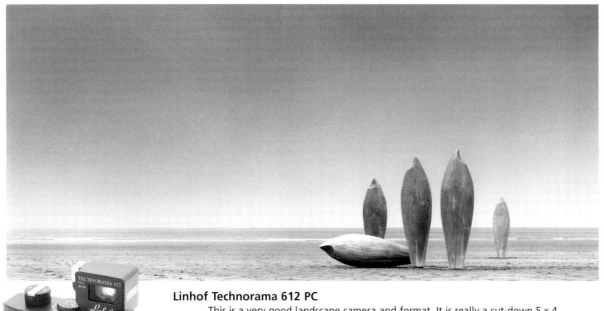

### Linhof Technorama 612 PC

This is a very good landscape camera and format. It is really a cut-down 5 x 4 camera using 120mm roll film. The bellows of a conventional 5 x 4 camera cause a problem in the wind so the compactness of this camera makes it ideal. With this camera, you are composing in two joined-up squares (a ratio of 1:2). You have to get the balance of the positive and negative space right. I chose the Linhof specifically to photograph this sculpture which was set up in different locations. This is an interesting camera to use in crowded areas as it photographs the peripheral view as well.

**Saunton Sands, Devon**
*Linhof 612 PC 135mm on tripod/Agfa APX 100 Iris Print*

### Fuji GX 617

I hire this camera system when a picture requires its distinctive look. It is not a diffi-cult format to compose on, but is slow to use. Focusing is done by attaching a ground glass to the back of the camera, then film is loaded in the conventional way. The sharpness of the image is awesome if you are primarily accustomed to 35mm.

**Houses of Parliament, London**
*Fuji GX 617 180mm on tripod/Fuji Velvia*

### Canon Powershot G5

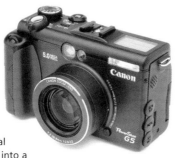

The quality of many consumer digital cameras is now so good that they can provide a great addition to a photographer's kit. While a digital SLR may be too bulky to carry around at all times, a compact digital camera can be slipped into a pocket and forgotten about until a chance photo opportunity arises. At 5.5 megapixels, the Canon Powershot G5 is a great example. The quality of the image is arguably better than that from an average SLR camera – with a bit of up-sizing and sharpening on the computer, you can get a pretty respectable A3 print from it. Some of the most extraordinary photos taken are the result of luck and chance. Everyone knows how often they see something and think 'that would make a great photo'. With a quality digital compact on you at all times, these opportunities need never be missed again. This camera is used by photographers when they don't want to be recognized as professional shooters. It was recently issued to Reuters photographers in Iraq.

### Nikon D100

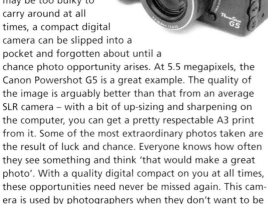

This is a superb camera for first-time digital users. Although a 'budget' version of its bigger brother, the D1X, the picture quality and functionality are excellent. At 6 megapixels, even A3 prints from a profiled Epson printer look fantastic. Once you get to grips with the usual idiosyncrasies of digital shooting, you'll be amazed at the creative control that can be had relatively cheaply. Compatible with all recently manufactured lenses and accessories. The batteries last a long time and the added battery pack makes the camera better balanced.

### Hasselblad Hi with Phase One back

Many people consider the quality of a digital image from a Canon 1DS to be better than that of a medium format transparency – so why bother with a medium format digital back? For the very same reasons photographers opted for medium format film rather than 35mm. The image quality from a medium format digital back is going to be better than the 11 meg capture of a 1DS – or any other full-frame DSLR. This area of photography is developing all the time and for that reason the backs will remain expensive and of interest only to professional photographers.

Hasselblad, Mamiya, Contax and Rollei kept pace with digital developments and are compatible with digital backs. As well as working in the studio, they have to be location-friendly, necessitating a lot of battery power. The latest models are linked to a laptop via a radio connection, rather than being tethered on a firewire.

### Using the white balance

A grab shot like this is much easier to shoot digitally than on film because of the difficult lighting conditions and public location. It was shot hand-held at 1/60 second when there wasn't a person in view. The ASA was set at 200, the auto white balance made the right decisions to correct the colour of the lighting and the meter picked the correct exposure. A quick check in the preview window was all that was needed – it was tidied up in Photoshop when Martin got home to England. A similar shot on film would have required a tripod and filtration for fluorescent and sodium lights, and there would still be no certainty the picture would turn out as you wanted. If it didn't end up underexposed, there'd be a high chance of someone walking into the frame during the longer exposure.
**Escalator at Pitt Street subway, Sydney**
*Canon 1DS 17–35mm/RAW file* © Martin Brent

## Stitching

One of the great things about digital photography is the ease with which you can manipulate an image. This picture is an example of a basic 'stitching' effect created by merging five individual photos together. Many consumer digital cameras now offer such a stitching function, where the last third of the previous frame shot is shown superimposed on the LCD screen as a semi-opaque image. This easily allows the photographer to overlap subsequent frames, which are then comped together with specialist software to create one complete image. In this case, the camera was placed on a tripod with a spirit level to ensure consistency through the horizontal plane. As the camera was moved through each frame to allow roughly one-third overlap, the model moved to various new positions around the bandstand. Once downloaded onto the computer, it was remarkably easy to merge them together – something that would have been both time-consuming and costly if shot on film. Digital cameras allow endless scope for experimentation like this, and can be fantastic creative tools. The great thing is, if something doesn't work the first time, you can always delete it and start again – and you haven't wasted any film.

**Five Sams in the bandstand on Clapham Common**
*Nikon D100 20–35/RAW file*
© Duncan Soar

## Canon 1DS

Experienced and long-time users of film cameras who have switched to digital believe the 1DS to be the best camera body ever made; the one against which all future digital cameras will be compared. Canon stole a march on its competitors by making the 1DS fully compatible with the trusted EOS system lenses, making the switch to DSLR more practical and affordable. It is a fine and impressive piece of machinery. Based on the indestructible EOS 1 chassis, it is suitably tough and handles extremely well – although it is very heavy and the supplied hand strap is invaluable. Quality is comparable to scanned 6 x 4.5 transparency. On the L setting (50 ISO equivalent) it handles mixed lighting very well indeed. Shooting RAW files then converting in either Photoshop CS or Capture 1 DSLR will retain all the information. The metering isn't 100 per cent reliable in all conditions, but then it's always a good idea to take a separate reading. The only real quibble is that battery usage could perhaps be improved. A fully charged pack will generally last less than half a day, although this can be extended by not using the LCD to play back images. Carrying several batteries isn't half the trouble of the camera dying mid-shot. Digital camera bodies are expensive, so photographers have become accustomed to carrying and using two bodies rather than the three or four when shooting film.

# 3: DIGITAL PHOTOGRAPHY

With the onset of digital photography, we are said to be in the throes of abandoning film, wooed by the instant gratification of seeing our pictures more quickly. This trick was first attempted, very successfully, by Polaroid. But the digital revolution has proved still more seductive, being even more immediate. In addition, gaining ultimate control over our images on our home computers has probably tipped the balance. No need for a home darkroom under the stairs or expensive wet processing by labs and chemists. We can now make complex changes to an image that would once have taxed a team of skilled professionals, with the greatest ease, and if we don't approve of the result, we simply 'undo it'.

This new 'instant' technology resonates with our frenetic lifestyle and has put the sparkle back into the whole hobby – and not just for the hobbyist. Most professionals now carry a digital camera.

But surprisingly, although sales of digital cameras are rocketing, amateur film sales are also buoyant: film sales have actually risen since the onset of digital. So, clearly, we are becoming ever more passionate takers of photographs and ever more picture-conscious.

For many amateur photographers, this new enthusiasm is encouraged by the internet and the possibility of sharing images across continents and extended families or groups. Digital photography has certainly raised our whole hobby to a new level when it comes to distributing and sharing pictures or creating a visually rich website for friends to visit and enjoy. And it increasingly does this with a point and shoot simplicity.

## Why choose digital?

There remain big question marks over digital quality in the minds of many purists, who still resist the notion that it will ever compete with the traditional one-hour colour neg/print route, the hand-crafted black and white darkroom masterpiece, or the perfect professional transparency.

Despite the great advances made in digital cameras, film remains a bargain for the occasional photographer. The total investment for a 'single use' film camera to take 39 pictures can be under £15 including processing – and someone else does all the work.

Digital quality is catching up very fast and prices continue to tumble. It is true that to get a really superb result from a digital camera at the moment requires both a large outlay of cash and a very steep learning curve in terms of file handling, post-production, colour management and general computer skills. But what it does not require is any new skill in shooting and visualization.

For the professional and semi-professional it is fast becoming a necessity to work with the new digital methods. In the same way that the fax replaced the mail and email has almost replaced the fax, it is imperative for professionals to use the fastest and most efficient methods available if they are to compete in a commercial marketplace. This is a heavy burden for the professional studio photographer and one that many still resist, citing much the same arguments about film and quality that the passionate amateur purists employ.

High-end digital camera backs already produce image quality easily exceeding that of film. This is the clear opinion of the users, but much more importantly, it is the considered opinion of buyers and commissioners of images for advertising and print. These buyers are the ones who really count, and they now see pictures produced much quicker with extremely accurate colour, without scanning costs, but with a far greater certainty of what the end result will look like on a magazine page or poster hoarding. It is sadly true that these same buyers hope to get all these new advantages at all the old prices – a continuing battleground for the professional trying to survive in this field.

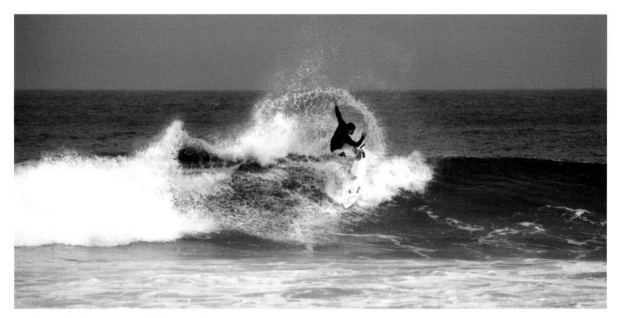

**Surfing at Wollongong Bay, NSW, Australia**
This shot was a test for a possible advertising job and it needed to be moody, so the stormy weather was a bonus despite reducing the available light. A shutter speed of 1/250 second was needed to freeze the water spray, so the ISO setting was increased to 400. There is no visible noise on 1DS at this speed in spite of the dark conditions.

Using Capture 1, connected through the firewire port, gave an instant preview of the captured image – a massive advantage over shooting roll after roll of film for insurance. A range of five cool, crisp surfing shots were on their way to the client in London in next to no time.
*Canon 1DS 300mm/RAW file to Apple Powerbook running Capture 1 DSLR*
© Martin Brent

## The digital advantage

So in the great debate about switching to digital there are many clear advantages. Speed of access is unrivalled – whether on the camera back itself or for later distribution. To this must be added adaptability. Whether at an amateur or professional level, the manipulation of images is easier than ever. Equally, the monotony of darkroom work is a thing of the past, with its waste bins full of spoiled silver paper (though, for some, the magic of seeing the image come alive in the developer will always remain). Non-destructive retouching, colour correction and manipulation open up a whole new field to be enjoyed (or abused) by anyone with even a simple computer and a program such as Photoshop Elements.

For instance, it is now easy to include yourself in a family group, taking the main shot yourself and then getting a family member to do a couple of frames with you positioned in a gap left for the pur-

pose. Cheating? Yes of course, but who cares?

Cost is another advantage, but it is easy to overestimate it. A memory card can be endlessly re-used, altogether doing away with film and processing bills. But there are still capital costs to consider, especially since a film camera was often bought once and gave a lifetime's service, whereas digital cameras change almost by the month and the new ones will always be better and invariably cheaper. Storage costs money too and even at present prices, CDs and DVDs to back up your picture archive will add up in the end.

Beyond such simple arithmetic looms an enduring market for conventional prints for commemorative albums, or to carry around in a handbag or wallet. The firm prediction that every household with a digital camera would also buy an inkjet printer with which to make their own prints has proved false. While many digital households do have an inkjet printer, photographic paper remains expensive, and

many users are returning to the notion that it's nice to have someone else pay for any mistakes.

From this insatiable desire for prints has sprung a whole range of services sold by one-hour photo labs. These new services, known as 'hybrid print technologies', involve using lasers or LEDs to expose the digital file onto traditional photographic paper.

The machines that do this are even cleverer than the fully automated negative colour printers that stand alongside them and with which they share chemistry. Able to take a digital file and resize it, change the resolution and auto-colour balance it in thousandths of a second, they can also collate and print multiple orders at an astonishing rate.

The new printers will save the photofinishing industry from extinction when, sometime in the future, film really does disappear. In the meantime, these services expand in incredibly inventive ways and it is possible now to upload your digital images to a website for a lab to collect and print out. The lab of course can be in Australia and the photographer in Lapland or any other unlikely geographical mix.

Nothing changes as fast as new technology and no doubt one day we shall see high-end video and superb stills captured on our mobile phones. But we certainly aren't there yet.

A good picture can be recorded with either film or digital, and in the end the beauty or force of an image lies in the vision of the photographer and not in the means of capture. Capture is only capture, and all methods have some drawbacks and some great strengths.

## Resolution

Digital terminology seems designed to confuse, and everyone starts off confused by resolution. Dots per inch (dpi), pixels, screen rulings, etc. are all ways of describing how many individual bits of information are used to make an image.

A good analogy is a Roman mosaic. If each stone in a 5 foot x 5 foot Roman pavement is 6 inches square it will use just 100 stones for the whole design. It will be a very low resolution design with almost no subtlety of colour or detail. But if each stone was only 1 inch square it would now have

3,600 individual stones (60 stones x 60 stones), which would enable much finer detail to show up in the design and permit a smoother gradation between colours as well.

There are some very complex tricks played by some manufacturers to apparently increase the resolution available from a given number of pixels. But a normal 6-megapixel camera sensor has 6 million pixels available to record the image. When this is split into the three primary colours (red, green and blue) it yields 18 million individual points of information across the image area. As a general rule, the more pixels on a camera sensor, the better the image resolution. The very highest medium-format camera backs currently have 22 million pixels, which give an enormous 65-megabyte finished file in RGB.

So in digital terms the more individual points you can employ to show your picture, the better the resolution. This is equally true of printers (output devices) as it is of cameras and scanners (input devices) The more individual dots of ink (and the smaller they are) the better quality the print will seem.

Of course, when you have enough dots in a print or a digital camera file you can no longer see them individually and they merge, appearing as continuous tone.

Choose a camera with enough resolution for your needs. Broadly speaking, an 18-megabyte file (from a 6-megapixel sensor) will be just enough for quality repro in CMYK at A4, or exhibition quality prints at A3.

Fewer pixels than that will definitely compromise quality. But if you only ever work for websites or presentations on a projector or any other online digital medium, 6 megapixels are probably more than you need.

## Workflow

To achieve maximum efficiency when shooting digitally it is essential to establish a sound workflow (method of working) and to be very disciplined and meticulous about following it. Shooting digitally is quite different in one major respect from shooting film. With film, processing and accessing the images are relatively straightforward and highly automated,

just like a good laundry service. But digital involves far more work after the event and simplifying that workload is crucial.

Most studio photographers will work with the camera connected to the computer and their images will appear on screen on the camera software contact sheet as the shoot progresses. The best RAW camera files will then be selected and processed at once to produce the final reproduction quality files, which are backed up immediately. However, sensible professionals will back up every RAW frame shot, because art directors and clients have been known to change their minds – and computers do sometimes crash.

## Mobile storage

Consider the storage implications when working out in the field. Most fully portable single-lens reflexes like Canons and Nikons use Compact Flash (CF) memory cards for storage. Simple to use, CF cards range from 8 to 8000 megabytes in capacity and are robust and cheap (though those with bigger capacities are relatively more expensive). Very large capacity cards hold lots of valuable data and you may prefer several smaller cards rather than one huge one which risks so much if it is damaged or corrupted.

Medium-format digital camera backs mostly use proprietary storage devices in the form of dedicated FireWire hard drives. Exceptions are the Kodak Pro backs, which use CF cards.

In either case, the pictures must be downloaded from the storage medium to the computer as soon as possible: indeed, the sooner the better. Press, sports and other itinerant photographers download their cards onto portable CD writers – these are more portable than laptops. This frees up space on the CF

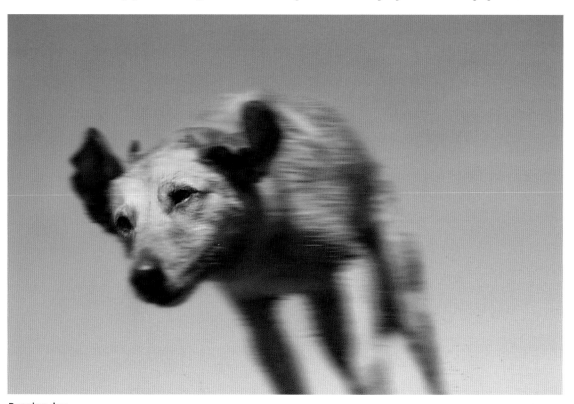

**Running dog**
Localized motion blur and sharpening were added in Photoshop. Though the point of focus was on the dog's back, the impression of movement was created by blurring the body and sharpening the eyes.
*Nikon D100 35–70mm*
© Duncan Soar

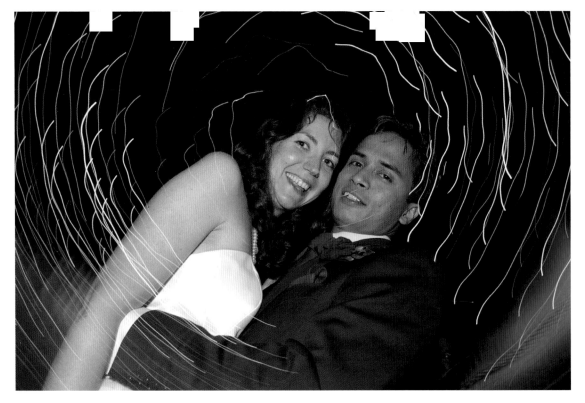

**Jess and Trilokesh**
Even if the photographer has had one glass too many and starts getting creative with the camera, the wonders of digital photography and matrix metering mean the technical issues are taken care of. A shutter speed of 1/2 second captured the movement of the lights.
*Nikon D100 18–35mm*
© Duncan Soar

cards. A back-up CD, edited or not, can be burned on the laptop later. Some people burn two CDs, just in case – and then later still, burn a DVD containing several CDs-worth of images.

## Camera care

Dust is a major problem with digital cameras. A tiny piece of dust adhering to the surface of the sensor will become a large black blob on every single frame until it is removed. The surface of the camera sensor is extremely easy to damage and normal aircans (containing compressed air, propellant and drying agents) can ruin a sensor with a single squirt.

Prevention is better than cure. Keep all digital lenses, bodies and body caps as clean as possible. Clean the exterior of the camera regularly, and never leave a body without a lens on it. Never change lenses in a dusty atmosphere if it can be avoided, and keep the inside of your camera bag clean.

If the sensor does need cleaning, it is essential to follow the manufacturer's advice very carefully and only ever use the rubber-bulb type of blower to remove dust. Most professional repair shops will do this for you, but it is inconvenient and costly. If you clean the sensor yourself, shoot an evenly lit sky afterwards to make sure you did a good job.

## Battery life

Pay close attention to batteries. They keep your camera alive. If the camera uses rechargeable batteries, follow the instructions closely and discharge them properly from time to time before recharging them fully. Good maintenance will prevent the disaster of a dead camera.

There are excellent third-party external battery packs that provide extra capacity for extended shooting. Quantum and Digital Battery are two names to note.

Limiting your use of the preview screen, if the camera has one, and powering down when you don't need the camera for a while, are both battery savers. And remember that using autofocus gobbles up the power too.

## Colour management

Good colour management is a thorny and complex subject that relies on two seemingly simple procedures. The first is that you must calibrate your monitor so that it shows you exactly what colours and densities are present in your picture files. Since all colours can be described numerically (by the percentage of red, green and blue light that is present) this is fairly simple and verifiable. No opinions here, just maths.

The ambient light around the monitor and in the workspace may also have a big effect on your ability to judge colour accurately, even when the monitor is correctly calibrated.

The second stage is that you must calibrate your printer to output prints that exactly match what your monitor shows you (and hence what the file actually contains).

To calibrate a monitor you will need a hardware device (a puck) that can read from the screen the precise colour values it shows when known colours are displayed on it. By adjusting the individual red, green and blue colour guns using the software supplied, it is possible to set the monitor to show correctly all the colours in a known target image. This may not be true of old monitors whose ability to generate a full colour gamut may have fallen with age.

The final step is to print a known target on your own printer and then read the colour values. The adjustment of each of these values back to its true colour is known as profiling a printer, and each printer will require a different profile for each combination of ink and paper type that you plan to use.

## Printing

You can have all the pleasures of printing from digital that a traditional chemical darkroom offers. Experiment with producing your own duo-toned prints by converting a colour image to grayscale in Photoshop, and then re-converting it back into RGB. Your image will now appear as a black and white image, but is actually composed of red, green and blue channels which you can play with to produce exactly the toning effect you want using the channels or curves controls.

If you hit on a really happy toning effect, save it in the curves or levels palette for re-use with other images. If it is very complex, make it into an action in Photoshop. Recreating old print techniques has never been easier or more fun and certainly never so repeatable.

## Archiving

While there is no single approved method for digital archiving, there are definitely certain points to bear in mind. No digital storage medium is 100 per cent reliable, so keeping multiple copies of files is certainly advisable. When archiving to CD or DVD, it's best to avoid cheap bulk packs. CDs are generally agreed to be more fail-safe than DVDs, and those that have a gold reflective layer are considered to be the safest. You can reduce the risk of error on the disk by burning at a slower speed. When it comes to storing disks, any sort of casing that comes into direct contact with the disk surface should generally be avoided. Full-size jewel cases are one of the best storage devices, while paper sleeves are one of the worst. The reflective layer contains the information, and if this becomes damaged, files can be lost. Many people recommend that you don't mark the disks in any way, but instead reference the casing. There are plenty of software systems around to aid cataloguing, one of the most comprehensive being iView Media Pro. Used in conjunction with a clearly labelled disk case, retrieving files can be simple and fast. Another storage option is hard disk space – recent work can be backed up onto an external or extra internal hard drive before being archived to disk. You never can be too careful – once a digitally captured image is lost, it's lost forever.

# 4: FILM AND PRINTS
## Negative/Transparency

Film will be with us for a few more years yet. Camera manufacturers are still producing fantastic film-based cameras – the Leica M7, for example. Digital photography has many advantages over film, but the entry cost at the professional level is very high and it is really only at this level that digital surpasses film. Film is convenient: you press the shutter, someone else processes the film and you collect the pictures. With digital, you press the shutter and that's just the

beginning. It's necessary to master all the photography software programs if you are going to maximize the potential of the digital picture file.

Transparency film must be correctly exposed. This is not a problem with today's sophisticated built-in meters, and learning to master the hand-held meter for back-up doesn't take long. Most of the pictures in this book were taken on transparency. Rather than illustrate every type of film available,

**Slow transparency**
Photographed with electronic flash, which has picked out the texture and detail. Fuji film has always had a reputation of having 'commercial' colour – the primary colours are stronger than other makes. This is fine for most subjects, but it's not a good film to use for skin tones. Any redness in the face will be exaggerated, especially if underexposed.
**Curlew walking stick**
*Nikon F5 105 macro on tripod/ Kodak EPR*

### High-speed neg.
The lighting in pubs helps to create a warm and welcoming atmosphere, but the light level is very low. In order to take hand-held pictures without camera shake or the people being blurred because of a slow shutter speed, I had to use an ultra-fast film. The increased grain adds to the picture – a glimpse of a fleeting moment. This picture was hand-printed in order to control the flesh tones.
**Denmark Hill**  *Nikon F4  135mm/Kodak Ektapress 1600*

I picked out two extremes – an ultra-fast negative film and a slow transparency.

Colour negative is the easier of the two types of colour film to shoot, because it is more forgiving. If you should get the exposure wrong, it can be corrected at the printing stage. Colour prints are usually truer to the original scene than prints from transparency film.

Negative film comes in a range of speeds from 100 ASA to 3200 ASA. The slower speeds are designed for general photography either in found or controlled conditions. The 400 ASA range and faster are for conditions where the lighting is poor or a fast shutter speed is required.

The one problem with colour negatives is the printer. The machine has no way of telling what the original scene looked like. If you are unhappy with the colours of the machine print you can get the colour and feel of the original by hand printing. All negative film is processed in C41 chemistry and it should be the film of choice when a run of prints is required.

If pictures are to be published, the colour print is used as a colour guide. It is also possible to scan direct from the negative and colour-correct using digital proofs.

Transparency film is the choice of most professional photographers, where pictures are for reproduction or for picture libraries. Transparency film also comes in a range of ASA speeds from all the major manufacturers and all, except Kodachrome, are processed in E6 chemistry. Kodachrome is the benchmark transparency film. It is a mystery to me why Kodak never markets this product to consumers, but then they still seem to believe that wedding photography is the only subject worth promoting.

# Black and white

Even though colour dominates photography, there is still demand – and it is growing – for black and white. If you are going to have a photograph on your wall, black and white is easier to live with, and a portrait in black and white has gravitas and looks particularly good when framed.

There are three categories of film divided into three ASA groupings: 100 ASA, 400 ASA and 1000–3200 ASA. All the major manufacturers produce films in these groups. As always, there are exceptions: Ilford and Kodak both make ultra-slow 25 ASA negative film, while Agfa makes a 200 ASA black and white transparency film (see page 73). The grain structure differs as well – traditional grain which has

been around for years is used in Kodak Tri-X and Ilford FP4, and tabular grain in Kodak T-max and Ilford's Delta.

Get to know a film in each category. Use slow films for landscapes, portraits and subjects that have lots of detail and texture, and also when you are planning a large print. The 400 ASA range is for general photography and photojournalism, where the gritty grain adds to the documentary feel. Down-rate the film to 320 ASA if you are using it in the studio; it can also be up-rated to 800 ASA without any loss of quality. Faster films are used when the lighting conditions are not good, and the content of the picture is more important than the photographic quality.

**Slow film**
When the tide is out is not the time to use colour film. The texture of the mud and the ropes, and shapes of the boats and buildings are enhanced when taken on a fine-grained black and white film. Pan F is compatible with all major developers. A yellow filter was used to lessen the contrast.
**Polperro Harbour, Cornwall**
*Nikon F 28–70mm on tripod/Ilford Pan F 50 ASA*

### Medium speed

The most popular ASA film for studio use or controlled lighting. The traditional-grained films Ilford FP4 and Agfa APX 100 all have a good tonal range. Agfa films characteristically produce blacker blacks than the others when printed on Agfa paper. The tabular grain films have a finer grain but they don't like to be over-exposed or over-developed. Both Ilford FP4 and Kodak T-max are good films for portraits when you require flattering skin tones. A high-key lighting set-up helps. This is where a lot of light is used – one on the background, one on the front bouncing off white polyboards on each side.

**Harry's going swimming**
*Hasselblad 150mm on tripod/Kodak T-max 100 ASA*
© Alan Newnham

### Fast

Kodak Tri-X, a legendary film, has undergone a few changes but is essentially the same film that came on the market in 1954. This film is the benchmark by which other films are compared. It performs well in almost any situation, even when pushed to 800 ASA when developed in Agfa Rodinal. It has a lovely tight, gritty grain that contains all the tones.

Medium-format Tri-X has a different emulsion, more suited to the studio than the street. The tabular-grained films, Ilford Delta and Kodak T-max, have finer grain than Tri-X especially when processed in T-max developers. I have seen very good, moody landscapes shot on Fuji Neopan with an orange graduated filter. Prints from this film have a tonal richness similar to the saturated colour of Fuji Provia.

**Gossiping in San Gimignano, Italy**
*Nikon F5 35–70mm/Kodak Tri-X*

### Ultra-fast

These films are used when it is important to get the picture even though the conditions are not photo-friendly. The fast ASA results in an enlarged grain. Fuji Neopan 400 pushed two stops looks very similar to Neopan 1600. Ilford Delta 3200 is a liberating film because it is possible to take night-time pictures, hand-held with a wide-aperture lens. Ilford maintains it can be rated at 25000 ASA.

**Sir Dirk Bogarde at the National Theatre, London**
*Leica M6 90mm on unipod/Fuji Neopan 400 pushed 1 1/2 stops*

# Special films

Although you may know the characteristics and vagaries of two or three films, there will be subjects that your favourite film cannot deal with. You may want to use a film specially designed for the conditions or to get a particular effect of a film, or you may be using the film as the basis for further effects in the printing or scanning stages. It is a good exercise to test similar films from different manufacturers as all have something going for them, especially the C41 black and white films. These are so convenient and should be in every camera bag just in case a black and white picture presents itself.

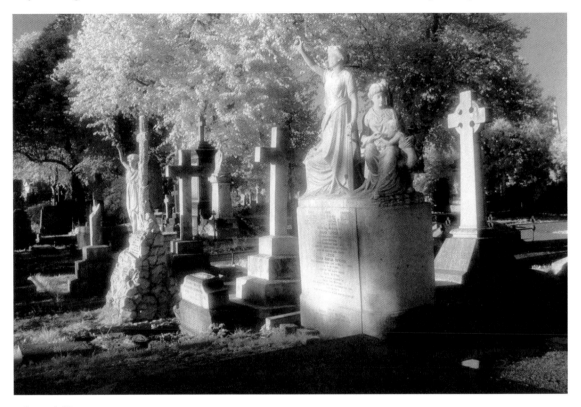

### Infrared film
Pictures taken on this film are instantly recognizable: the dream-like quality of black skies, white trees and foliage and a distinct glow off warm stone, sand, clouds and even people. Kodak HIE infrared film needs to be handled with care. Even loading the camera has to be done in total darkness. If you are changing film on location, do it in a rubberized changing bag. This film is also sensitive to heat, so keep it cool. To accentuate the infrared look, this film should be used with a Wratton 25 red filter; a yellow or orange filter of equivalent density will give a lesser effect. For dramatic skies and snow-white foliage, use a Wratton 87c filter. This is opaque, so you cannot see through the lens. Focus first, then add the filter. The film is recording visible light and also the infrared radiation that you cannot see, so conventional meter readings are only a rough guide. Bracketing is essential, as is experience of how the film reacts in various different light conditions. The best time of day to use this film is when there has been a lot of sunshine, so there is plenty of radiation. It is possible to use it at the end of the day, but you will need more exposure. Ilford SFX and Konica 750 are two films with extended red sensitivity. Although they are not true infrared films, by using the same filters they will have that infrared look. Their main advantage is that they can be handled as normal films and they are safe to travel with. Kodak also make an infrared colour film but it is designed for scientists and agriculturalists and I cannot recall ever having seen a good photograph taken using this film. Landscapes, ivy-clad ruined buildings and nudes are subjects that look good when photographed with infrared films.
**Brompton Cemetery, West London** *Nikon F5 28–70mm on tripod plus Wratton 25 red filter/Kodak HIE*

### Ilford XP2

A fantastically sharp, fine-grained film that is particularly suitable for high-contrast conditions. It can be rated from 50 ASA to 800 ASA, without any loss of image quality. This is not a replacement for traditional black and white film, but rather a film with its own characteristics. It is processed in standard C41 chemistry, which is very convenient, but don't rely on mini-labs to do your prints – you might be surprised by the colours. Properly printed on colour paper, the prints will look slightly sepia-toned and impressive results are obtained on black and white papers. Kodak, Fuji and Konica all produce similar films.

**Candlelit dinner**

*Nikon F5 80–200mm on tripod/Ilford XP2 at 800 ASA*

### Tungsten-corrected film (Type B)

The main light source in a make-up room is from the raw tungsten light bulbs around the mirror. Exposure here was taken from the mid-tones, not from the bulbs – I was happy to let them burn out. Introducing another light like an electronic flash head, or even colour-correcting an on-camera flash, would have destroyed the atmosphere. In circumstances like these Type B film helps keep the sense of place. Treat like any other transparency film.

**Royal Shakespeare Company make-up room, Stratford-upon-Avon**

*Nikon F4 35mm on unipod/Kodak 160T*

### Agfa Scala 200X

A black and white transparency film that has very sharp, fine, gritty grain structure and a good tonal range. It can be pushed or pulled in the processing without a loss of image quality, giving the film fine contrast control. Treat this film as a transparency film that just happens to be black and white – as opposed to a black and white film. Don't overexpose it, there is plenty of detail in the shadow areas and it has an eight-stop range. The film can be toned, either with sepia, selenium or blue tone. It drum-scans very well too and will result in good straight digital prints or withstand further manipulation in Photoshop. The film has to be specially processed by a lab that has Agfa chemicals.

**Tarr Steps, Devon**

*Fuji GSW690 on tripod/Agfa Scala*

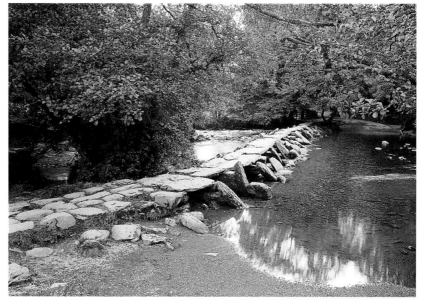

# Cross-processing

Photographic equipment and materials are very expensive, especially when you are starting out in photography. Some people feel it is important to establish an individual look to their pictures and one of the cheapest ways of doing this is to manipulate the processing rather than rely on expensive technology. Cross-processing – where slide film is processed in neg. chemistry and vice-versa – can give a dramatic effect.

Processing transparency film in C41 results in strong, rich, solid colours and the contrast is increased. Lighting should be flat as the highlights will blow out and the shadows fill in. Simple, colourful compositions work well. To retain shadow detail, overexpose the film by 1 stop. Fuji Provia 400 pushed 2 stops gives neutral colours. Agfa 100, like Kodak EPP, will give good grain and very saturated colours. The extra exposure adds to the colour saturation; whereas extra processing will only increase the grain. Getting the exposure correct is important – expose as accurately as you would if shooting the film for normal development. But be aware that there will always be an element of uncertainty as to exactly how the colours will turn out.

Not so common is processing neg. film as transparency. This results in cool colours and yellowish skin tones with blue and green shadows and details in the shadow area. Films' emulsions keep changing so it's best to ask your local lab or look up on the internet for the current best film make. As a guide rate 400 ASA film at 100 ASA or 160 ASA film at 80 ASA, overexpose by 1 stop and process pushing 2 or 3 stops. Minilabs may be reluctant to cross-process your film and it is better to use professional labs. These kinds of pictures are used as illustrations – you will have seen them on book and CD covers. All these effects can be mimicked in Photoshop – which gives far greater control rather than endless experimentation and fine-tuning.

**Joshua Tree National Park, California**
Cross-processing 35mm film works as well, but the grain will be more apparent when enlarged. Pushing it 1 1/2 stops has caused the bleeding effect at the edges.
*Canon EOS 3 28–70mm/Kodak EPP*
© Martin Brent

**Portrait after Andy Warhol**
The four images were photographed in the studio in the same lighting conditions. I had to re-shoot the green background to achieve an even tone, because greens appear much darker when cross-processed.
*Mamiya RB67*
*180mm/Kodak EPP*

**Toni & Guy advert**
Pre-judging the results when using cross-processing is always a bit of a lottery, so it is best to test first, especially if you are using it for a job. Using Fuji Provia, rated normally and pushed 1 1/2 stops in the processing, caused a magenta cast. The clothes were chosen to reflect this and the highlights blown out, giving nice, porcelain skin. The picture was lit with a Balcar Diamond Box, a beauty light that is great for hair as it gives extra shine.
*Mamiya RB67 180mm on tripod/Fuji Provia* © Martin Brent

**Norbert in the garden**
There are very few choices of negative film to use. The best films have been discontinued. Here, Fuji 160 rated at 80 ASA and exposed for the shadow areas, then pushed 2 stops, has been used. In studio lighting, it can be pushed 3 stops.
*Mamiya RB67 350mm on tripod/Fuji NPC160 rated at 80 ASA pushed 2 stops*

# Film effects

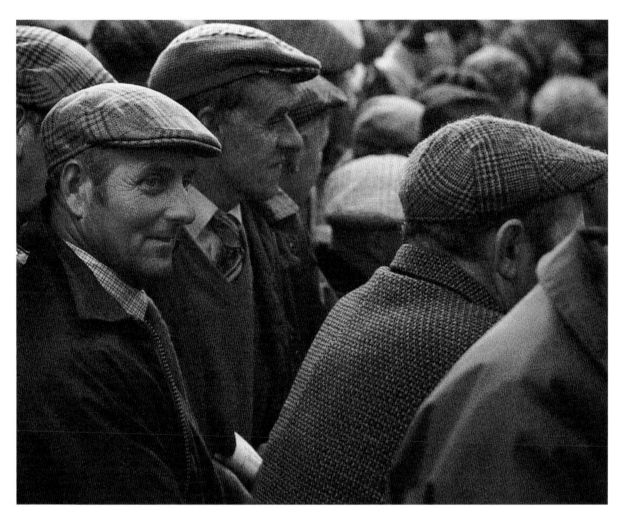

### Grain and noise
In most instances, grain (and its digital equivalent, noise) is to be avoided, but it can be used positively for good effects. Fast film (1600 or 3200 ASA) is naturally grainy and pushing a 100 ASA film 4 or 5 stops will also give you 'bigger' grain. Kodachrome 200 has a very good, tight grain similar to Tri-X processed in Agfa Rodinal which is excellent for urban pictures as it adds to a grimy, industrial feel. Grain can be used effectively to reinforce the natural texture of a subject. For high-key lit subjects, the grain adds a painterly, pastel look. Adobe Photoshop has a 'grain surgery' filter that can simulate the grain structure of film.
**Hawes Farmers' Market**
*Nikon F4  85mm/Scotch 1000*

## Pushing and cutting

There are situations that require film to be pushed, or there simply wouldn't be a picture. This doesn't present any major problems other than there is an increase in contrast, the background will darken and there is a colour shift – usually the reds become more apparent, so this would not be good for a portrait. To overcome the increase in contrast, use fill flash to clean up the foreground. If the subject is already very contrasty and you cannot even out the tonal range with lighting, it is possible to minimize the contrast by using the film at its recommended ASA and cutting it by 1 stop in the processing. This will flatten out the tonal range and return details in the black without overexposing the whites. Shooting digitally, the preview screen shows instantly whether a shot is working, and even in poor light conditions details will be retained that can be adjusted and enhanced in Photoshop.

**Madrid nightlife** *Nikon F5 35–70mm Nikon SB-28/Kodak E200 pushed 3 1/2 stops*

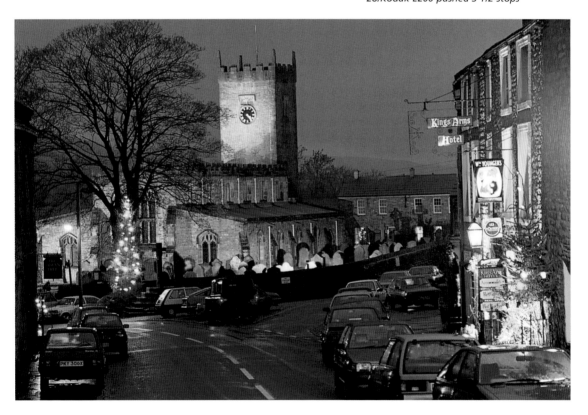

## Using the wrong film for the right picture

Using a film in lighting conditions it was not made for results in shifts in colour. Tungsten film used in daylight will result in blue pictures with stronger reds. Daylight film in tungsten light results in yellow and orange colours.
In this picture, using tungsten film so the illuminations are the correct colour has resulted in a blue cast to the unlit areas, including the early evening sky. If I had waited until dark, the shadow side of the tower would have been lost against the sky.

**Askrigg on Christmas Eve** *Nikon F4  80–200mm on tripod/Fuji 64T*

# Polaroid proofing

The development of Polaroid as a proofing medium transformed creative photography. When employing one or more lights you can see how they look, you have control of the picture environment and you can fine-tune and adjust the lighting until it is perfect. You can consider whether the picture is any good; it is also useful to be able to show the art director what the final picture will look like, especially if they are not experienced at looking through the viewfinder.

For all its advantages, using Polaroid is time consuming and tedious. It is frightening to add up all the minutes I have waited for a Polaroid to develop over the last twenty years! Shooting digitally, you obviously don't need Polaroid. All the lighting and picture adjustments can be done through the preview window or on the computer screen, where you can zoom into areas of the picture.

**Master baker, Symbol Biscuits, Blackpool**
This finished picture does not look anything like the conditions it was set up in. It was photographed in bright fluorescent and sodium light that could not be adjusted or turned off. I wanted to create a picture that was warm and romantically lit, showing the master baker giving his care and attention to the biscuits even though it is an industrial process. The flash has overpowered the factory light: by shooting at 1/125 second, there was not a chance of it influencing the picture. Using several sheets of Polaroid 669 allowed me to control and mould the light and its effects, from three pack-powered flash heads.
*Mamiya RB67 180mm 81A filter on tripod/Kodak EPP*

# Polaroid film and effects

Many effects can be achieved with Polaroid film. The uniqueness of the image attracts fine-art photographers and commercial photographers pursuing their own projects. Most importantly, they are fun to do. As always, it takes experimentation and practice to gain a sound knowledge of how the various materials will work, and to be able to produce successful images consistently. You can now take the creative process further by scanning and manipulating in various software programs, and using a full range of digital papers.

## Image lift

If a Polaroid Type 59 print is soaked in warm water, after a time, the emulsion layer will separate from the paper base. This emulsion, now an extremely delicate goo, can be carefully lifted out and re-fixed onto another receptor: paper, wood, tiles — basically anything. The best receptor is a high-quality rag, acid-free, fine-art paper. Different surface textures will alter the appearance and feel of the final emulsion lift. Although it may take several attempts to successfully extract a whole emulsion, once achieved you are then able to manipulate the wet image, adding a wavy edge, or twisting and creasing the emulsion to make delicate folds. The white border of the Polaroid, if captured, dries to a wonderful magenta. Keeping the new image wet over the course of a few days will allow you to revisit it and add to or reduce the distress. It is a slow and organic process – not something to be attempted if you're in a hurry! Because image lifts retain their wet and organic feel after being dried, it suits subjects like flowers or fruit particularly well – although there's no reason why any subject can't be experimented with.

**Jeans**
*Sinar F1 150mm on tripod*
© Martin Brent

## 55 pos./neg.

Polaroid Type 55 provides both a positive and a high-quality negative. Although most professional photographers use a 55 neg. as an accurate way to check focus, it can also be used creatively to produce interesting prints.

Shooting as normal, maybe overexposing half a stop, allow the print to develop fully. Upon separation, being extremely careful not to damage the delicate emulsion, discard the positive and immerse the neg. in a cleaning solution. Although the image will be permanent, fixing the neg. and thorough washing will ensure archival quality. The neg. will have a distressed edge, always unique, that adds to the beauty of the final print. The neg. exhibits a very fine grain although, depending on how smoothly the positive was separated, it will have an almost organic feel that adds to the unmistakable look of this kind of print. Shooting people with Polaroid can be very gratifying. The relationship between the photographer and the subject becomes more of a collaboration as the instant print is viewed and discussed. The tonal range of a 55 neg. is superb and out-of-focus areas appear to bleed into the sharp, making it particularly suitable for selective focusing. 665 is the medium-format equivalent of Type 55, again with superb tonal quality which also produces a fine positive.

**Boxer**

© Martin Brent

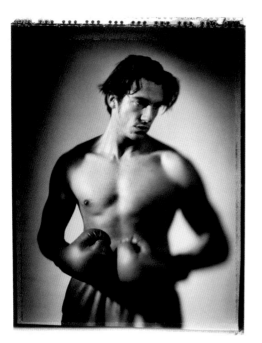

Another popular effect is solarization (or sabatier effect). A Type 55 or 665 Polaroid is exposed normally, then allowed to process for 10–15 seconds. The positive and negative are separated in a very dim light. The negative is then exposed to a flash of light and placed in a lightproof box for two more minutes before being washed and fixed. The neg. can now be printed or scanned, but be careful, as it is very fragile. Even using conventional black and white chemistry, better results are obtained by flashing the neg. – usually an interneg. – rather than flashing the print, which results in a fogged image.

The photogram, made famous by David Hockney, is where a whole series of Polaroids are used to make up a scene. The finished image looks like a mosaic. On a smaller scale, if you can't get it all in one picture, take three Polaroids and butt them together.

Finally, using a Vivitar slide copier or a Daylab, it is possible to transfer a traditionally shot image to a Polaroid film for subsequent manipulation. If you print onto Time Zero film you can manipulate and move the emulsion just the same as if it had been photographed on an SX-70 camera.

If you want to explore these and other techniques, Polaroid produces an excellent magazine, and there are many websites offering tips. Fiddling around with Polaroid is a hobby in itself. It's a bit like cooking – you experiment, see how it looks, improve on it and then remember the recipes.

### Image transfer

Polaroid Type 59 and 59T can also be used to make image transfers. In this instance, rather than exposing and processing the Polaroid normally the process is interrupted and the Polaroid packet separated after only 10–20 seconds (it is helpful to cut the hinged end of the packet off with sharp scissors). The positive is discarded (although the faint, sepia image can occasionally work well), the neg. is positioned over a new receptor, rolled onto it – a glass rolling pin is useful at this point – and weighed down. After several minutes the neg. is carefully removed to reveal the transferred image. The developing time differs depending on many factors including the subject, the receptor used and the effect required. The image will have a painterly quality, its sharpness varying according to the chosen receptor. The drier the receptor, the sharper the final image – although you have to watch for the neg. sticking to the surface, creating unsightly blobs and blemishes. Allowing the neg. to over-process on a very wet receptor will create an almost watercolour effect. The exposure needs to be adjusted to compensate for over- or under-processing.

**Dead flower**
*Sinar F1 240mm on tripod*
© Martin Brent

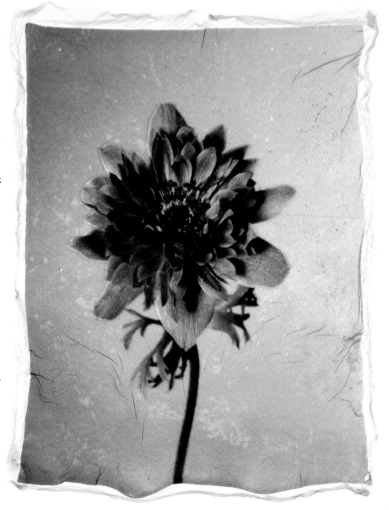

# Polaroid cameras

Serious photographers favour two types of Polaroid camera. The SX-70 has a cult following. Although the camera has been discontinued, it can still be found on ebay and in second-hand shops. It uses Time Zero film. The developer takes a long time to dry so, after the picture has appeared, it is possible to move the image physically with a selection of pointed or blunt-nosed tools. The end results vary hugely, depending on the look you are after but the most common looks a bit like a Van Gogh painting. Non-purists can of course achieve a similar effect on any image on the computer.

The Spectra 1200 SI camera uses standard Polaroid film. This is a good camera for shooting projects and fine-art pictures. It is a very relaxing form of photography as there are few technical decisions to make. Your vision is bound by the properties and limitations of the camera in your hands, and the picture is ready almost instantly.

There are two monster Polaroid cameras. The unique 40 x 80 camera has its own studio in New York. It produces prints 44 inches wide by 100 inches long and is capable of producing a life-size portrait. American photographer Joe McNally used it to produce a collection of pictures of the people who helped in the aftermath of the 9/11 disaster.

The more common camera is the 20 x 24. A few are available in Japan, USA and Europe. They are on constant daily hire for all kinds of subjects. If you are interested, it is possible to have one built to order. The quality of the pictures is stunning.

**Some glimpses of my mother's garden** *Spectra 1200 SI/Spectra 640* © Justin Pumfrey

# Black and white papers and printing

There are two basic types of black and white papers: resin-coated (RC) and fibre-based. Most prints are done on RC, as the process is simpler: the thin plastic layer prevents the chemicals soaking into the paper base, reducing the time the paper has to fix and wash, and the prints can be air-dried flat. Fibre-based papers take longer to fix and wash and have to be dried on a print dryer, but they have a pleasing tactile quality.

The construction of the emulsion in the papers also differs. Warm-toned papers are 40:60 silver bromide to silver chloride, while neutral-toned papers are 60:40. The surface of the paper ranges from high gloss, through semi-matt and matt, to the coarse texture of a watercolour paper. Just choosing a paper with the right surface can make a picture. Papers come in two weights, single and double (also known as Museum and Portfolio).

Papers can be bought in grades, from 1 to 5. A low number will produce a soft, high-key image whereas a high number will produce a hard, contrasty print. However, most printing is done using multigrade or variable contrast (VC) papers. The paper has two built-in emulsions – one sensitive to yellow light and the other sensitive to magenta, which does away with the need for graded paper. To control the tones, you use an enlarger with a filter drawer to take the mix of yellow and magenta filters.

Like everything in photography, printing takes time and patience to learn, but it is very satisfying to be able to produce a print just as you want it. There

has been a renewed interest in black and white printing as a direct response to the rise in colour digital photography. The technologies can be combined: black and white negs can be scanned and digital prints made, or large acetate negs can be produced on an inkjet from digital files, and used with traditional printing processes. It is now possible to print from a digital file onto traditional photographic paper. Photoshop software coupled with a De Vere digital enlarger produces a 'virtual negative'. The image is created on a high-resolution LCD panel that replaces the traditional negative carrier. This process has been especially useful for old, valuable and damaged negs such as Bill Brandt's nudes and Herbert Ponting's pictures of Shackleton's *Discovery* expedition, which are now printed on archival bromide paper from retouched digital negs.

Shadow detail is controlled by exposure and contrast predominantly by developing time. Know your film well and use an exacting developer, not one that is too 'elastic'. If you are shooting roll film, you may have to use several rolls of the same subject and process them for different times in different developers. Bracketing will ensure you achieve the ideal negative. Printing on VC papers allows you to have fine control of all the subtle tones. Purists may be horrified, but it's now possible to drum-scan straight from the negative. There is also an impressive range of fine papers for use with inkjet printers, leading some photographers to abandon the darkroom altogether.

**Zone scale**
The zone system, devised in order to achieve the perfect neg. for the perfect print, translates the scene in front of you into tones of black through to white. Zone V represents 18 per cent grey. An exposure reading taken off this area of a grey card will give you the average exposure. The system was perfected by landscape photographer Ansel Adams, who wrote *The Negative,* the definitive work on the subject, at a time when photographers were shooting 5 x 4 sheet film, processed in a range of developers, and before the advent of VC printing papers. Many photographers still shoot sheet film, but the majority of commercial work is done on roll film or digital.

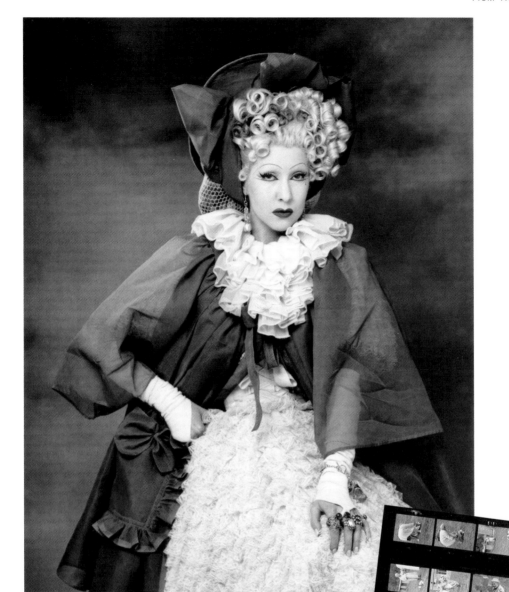

**Miss Pinki Tessa**
*Mamiya RB67 140mm macro/Agfa 100 printed on Ilford Gallery*

## Contact sheet

Don't look for the picture on the sheet, the best pictures jump out from the rest. Keep returning to the contacts over the years, it is interesting how a picture you overlooked at first will look interesting a few months or years later. This is a worry for digital photographers who edit there and then; best to store everything for a while longer.

# Print effects

Once you have tried the different types of photographic papers and have mastered different types of developers, it is time to try the many toning and tinting processes that have been used since the 1840s. Successfully employed, the resulting prints have a fine-art quality and will convey a particular mood. The simplest effect can be done at the printing stage. For instance, lay a sheet of tissue paper over the photographic papers. Expose for one-third of the exposure, remove the tissue paper and expose the remaining two-thirds without it. The resulting image will look slightly distressed like an old picture.

Not all tones work with all types of paper – as a general rule, stick to fibre-based papers, though this is not to say you can't successfully tone RC papers. Three things affect the colour of the final print: the type of paper, the strength of the toner, and how long it is in the solution. The toning process continues in the wash, so snatch the print from the toning solution fractionally before you think it is ready. The original print that is to be toned should be thoroughly fixed and washed in a hypo-cleaning agent to get rid of all the fixer, otherwise the residue will react with the toner either by staining it or by spots appearing. Don't use your hands: use gloves to minimize any chances of cross-contamination with other chemicals. Toning can be done with the room lights on, but make sure you are in a well-ventilated room.

Most processes are explained on the internet or in the best reference book on the subject, *The Master Photographer's Toning Book* by Tim Rudman, in which every possible effect is explained lucidly and thoroughly – a real insight into the craft of photography.

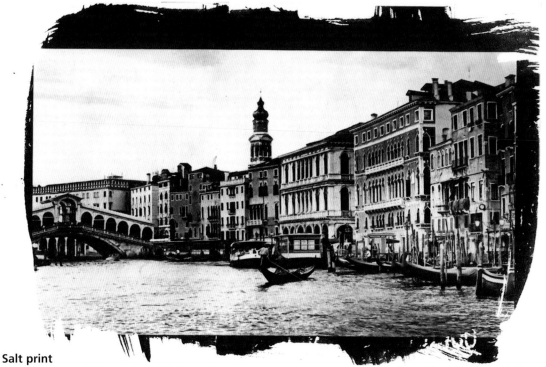

**Salt print**
Invented by one of the founders of photography, William Fox Talbot in 1841. A sheet of paper is soaked in a solution of sodium chloride (sea salt). One side is coated with silver nitrate to make it light sensitive. When it is dry, place the negative on the paper with a piece of glass on top and expose it in even sunlight for several hours.
**Venice** *Nikon F90 35–70mm/Fuji Neopan 400* © Ginny Manning

## Tea staining

This is one of the cheapest processes you can use and the cheaper the tea, the better the effect. Here, the print has been soaked in cold tea made up of two Tetley tea bags. It simply stains the paper – no chemistry is involved.

**Tree roots in the Central African Republic**
*Nikon FM2 28mm on tripod/Kodak Tri-X*

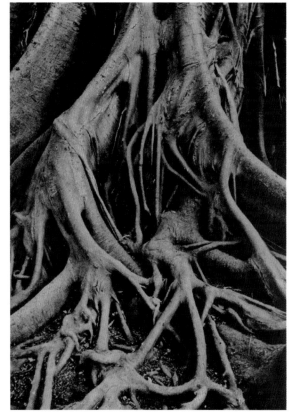

## Sepia tone (thiocarbamide)

This is the best-known tone effect, because it is so frequently used to convey a classic old-fashioned look. One of the reasons you can still see old pictures today is that the image is permanent. The silver bromide image is changed into silver sulphide by the toning solution. Sulphide toners produce hydrogen sulphide gas – the smell of rotten eggs – and today thiocarbamide toners are preferred because they are odourless. You may think there is a uniform sepia brown, but in fact there are hundreds of subtle shades. You need to experiment – the variations of tone differ with different types of paper and with the contrast and detail of the picture. Split toning, where another toner is used as well, will enhance the picture.

Photoshop has a sepia-tone facility, but it doesn't quite have the feel of a perfectly toned print.

**The tomb of John I of Portugal and Philippa of Lancaster, parents of Henry the Navigator, Batalha, Portugal**
*Nikon F2 24mm/Ilford HP5/sepia toner*

### Selenium tone

Selenium toner can be used either to tone the print or to give the black and white print richer blacks, retaining the shadow detail and adding lustre to the whites. There is a glow in the highlights and anything that is metallic. Its other use is to make a black and white print archival (permanent), by replacing silver salts with selenium. The brownish tone apparent on warm-toned papers is much less noticeable, but pleasantly subtle, with cool papers. Selenium toning will increase the life of a resin-coated paper print, especially if it is going to be behind glass, but it works better with fibre-based papers where more tones are possible. It is advisable to have a set of dishes that are dedicated just to selenium because it stains everything. Remember to wipe down your work surfaces after use. It works well on dusty scenes, making this picture the perfect marriage of technique and content.

**Central Ladakh, India**
*Nikon FE 24mm/Ilford HP5/selenium toner*

### Gold tone

The blue effect of gold toning is not easily apparent when used with neutral or cold-toned papers, but this subtle effect can enhance the picture if the subject is right. The blue tone is more noticeable with warm papers. Gold tone is extensively used when split-toning is employed – for instance a salmon-pink tone will be produced when gold is combined with sepia toner.

**Near Loch Seaforth, Isle of Lewis, Hebrides**
Fuji GSW 690 on tripod/Kodak PlusX/gold toner

## Blue tone

Iron blue toner – ferric ferrocyanide – gives a blue cast to the silver areas of a print. The tone can be subtle or very strong, depending on the solution, the time the print is treated and how much of the silver has been bleached. The same principle applies using other metal-based toners that produce different-coloured tones. The most commonly used are: copper, which will turn a print reddish-brown; iron, which will go to Prussian blue; titanium, which will go to yellow; and vanadium, which will go to an orange/yellow. Gold tones will also produce a blue tone when combined with a selenium print on warm papers. There are many ready to use blue-tone kits, so don't be put off. There is nothing complicated about toning, you just need to experiment.

**St Ives, Cornwall**
*Nikon F100 80–200mm/Polaroid Polapan/5 x 4 b/w interneg./blue toner*
© Graham Piggott

## Cyanotype

This contact-print process was invented by Sir John Herschel in 1842. He also discovered that sodium thiosulphate was an effective means of fixing a photographic image on paper, preventing it from fading. This is commonly known as Hypo Fixer. The blue colour comes from the iron compounds that make up the light-sensitive liquid commonly used for architects' drawings (hence the expression 'blueprints').

In a darkened room, brush a prepared solution of cyanotype chemicals onto a piece of sketch-pad paper. Be careful not to use too much otherwise a crust will form and it will flake off. Leave it to dry (it will look yellowish-green). Place the negative onto the paper and expose in sunlight. The process takes about thirty minutes, but you should check every five minutes until you are happy with the blue tone. The longer the paper is exposed, the richer the blue. Wash the print until there is no trace of yellow left. It is possible to produce big negatives relatively easily by printing on acetate with the inkjet printer.

No photography was involved in making this picture. The shell was scanned on a flat-bed scanner, the image converted to negative in Photoshop, then printed as an A4 acetate negative.

**Shell**
© Graham Piggott

## Split toning

Dual or multiple toning is a procedure well worth pursuing. To see a collection of dual-toned prints where the subject of the picture has been matched to a toning effect can be stunning. Three or more tones can also be combined. Many factors influence the look of the finished print – for instance, the same combination of tones will react completely differently when used with different papers and on a straight print or a lith print. The secret is to read up about the process as much as you can and experiment.

There are a few basic rules but, as always, once you know them, you can break them. Bleach for taste – this will dictate which areas are toned by which toner, and whether the colour will be subtle or dramatic. Use archival tones first – sepia, selenium and gold. It is possible to tone an area selectively. This requires patience, but it looks good with the right subject. A lith print, selenium- and gold-toned, is very textural and, if left in the toner too long, will appear to be solarized. The possibilities for different effects are mind-boggling.

**Gothics** *Mamiya RB67 140mm on tripod/Agfa 25/selenium and gold toners*

## Lith printing

This is a normal darkroom process printing ordinary negatives developed in a dilute lith developer, and not to be confused with the graphic-art process of producing high-contrast negatives. It takes a long time for the image to appear, but it then develops very quickly and has to be snatched from the developer. If you leave it too long, unpredictable effects occur in the shadow area. This is a very good process to use with selenium or gold toner.

Lith developer is at its best when it has been used a little – save your old developer and add some of it to the newly made-up solution.

**Autumn steps**
Fuji GSW 690 on tripod/Agfa APX 25 in lith developer

## Bromoil

A bromoil print is one where the silver image has been replaced by an oil pigment – a mixture of linseed oil and black ink. A dark print from a flat neg. on fibre-based paper, well washed and fixed, but not hardened in the fix, is bleached. The pigment is then applied to the moist print with a stipple brush. The process, although simple, requires trial and error and patience. The finished print, although clearly still a photograph, looks old and arty.

**Marienplatz, Munich** Nikon F90 85mm/Ilford HP5 © Kirsty MacLean

# Digital manipulation

Since the introduction of photo-editing software, in particular Photoshop, the use of computers has revolutionized photography. It's rare that an image will not undergo some sort of retouching between being shot and reproduced. This doesn't just apply to digitally captured images – images shot on film need to be scanned before they can be reproduced.

A photographer with a good knowledge of Photoshop knows where concessions can be made at the shooting stage. Picture elements are easily removed or added. As long as the lighting, perspective and exposure are consistent, two shots can easily be merged to create one convincing image. Colour can be fixed too – bright areas of colour in an otherwise muted photo can be toned down, or changed to a different colour entirely. In food photography, there's no need to shoot four different flavours of ice cream when vanilla can be changed to strawberry, mint or lime with clever use of the selective colour tool.

With the ease of computer manipulation, photographers are becoming increasingly aware that the captured photo is merely a step in the process of image production, rather than the final product itself. The inability of film to capture data in the full range of tones the eye can see can be considerably improved by use of multiple exposures, which can then be merged using layers and masks. The computer can mimic time-consuming printing processes such as posterization in the blink of an eye. Images can be selectively blurred, sharpened, lightened, darkened, solarized, inverted, hand-coloured, desaturated, cross-processed, and the list goes on . . . Is this ethical? Although retouching is a big bone of contention in the area of documentary photography, it's hard to argue against it for the vast majority of cases. The intention of a group shot is predominantly to create an acceptable representation of the people within it, not to capture a decisive moment. If someone's eyes are shut in one frame, why not merge this shot with another where their eyes are open? It can be argued that a photograph is a representation of reality as the photographer sees it – and that the computer is merely another tool to be used on the way to achieving that vision.

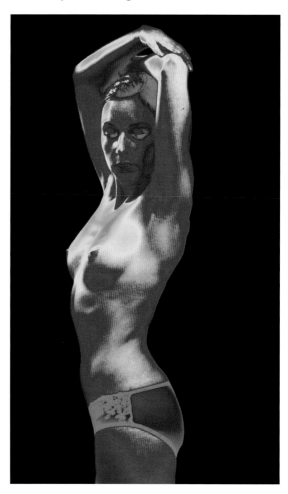

### Posterization
This was possible in a conventional wet darkroom using lith film and filters, but was a long and tedious process. Photoshop has a filter that can instantly create the posterization effect. The image is changed into 256 shades of grey then these in turn are reduced to highlights, midtones and shadow areas that are then coloured. Infinite control of the different colours is at your fingertips.
### Nude in the studio
*Mamiya RB67 180mm /Kodak 100G scanned and manipulated*

## Managing colour

It is sometimes necessary to adjust colours to suit different finishes of digital paper, so the final print matches what you had in your mind's eye. Rag paper has a lovely finish but absorbs colour. Using the selective colour tool, the colours in this picture have been boosted by about 5 per cent, so they still look bright when printed.

**Rovinj, Croatia** *Canon EOS1 28–70mm/Kodak 100S/inkjet print on Permajet Artist Classic*

## Hand-colouring

Hand-colouring is as old as photography. Similar effects can also be achieved on the computer. This picture was shot in black and white, and the neg. scanned as a positive. An overall base colour was applied, and saturated then de-saturated to give the silvery-blue tones. Next, colour was applied to the trees and roadway using the paintbrush tools. This too was saturated and de-saturated. The same was done for the area behind the trees. Keeping the colours subtle gives the picture depth. Kirsty McLean recreated her memory of the avenue of trees. She would have gone through the same methodical process of building up the colour if she had done it in the traditional way.

**Outside Melbourne** *Nikon F4 80–200mm/ Kodak T-max 400* © Kirsty McLean

# 5: LIGHT
## Types of daylight

Whether you work in colour or black and white, all you are ever taking photographs of is light. Fall in love with light – notice what type of light attracts you and enjoy it. There's a special light after a thunderstorm when the air has been washed and the light is clear, sharp and hard. Colours, because they are wet, are saturated and vibrant. All post-rain light is a delight to work in for colour. In fact, light and water are almost always a magical combination. Think of sunlight coming through a tree in a slight wind so that it plays on water beneath: the light bounces off the water and back on to the underside of the leaves.

I like café light; the wet light on a street that comes out of shop windows, especially on a winter's day. Or the shaft of light that comes across the carpet if a door opens as you walk down a darkened hotel corridor. Or a log fire flickering its light around an unlit room (which cannot be satisfactorily captured in a photograph). If you are in a train corridor at night, your reflection in the window appears in a light that Rembrandt would have used – dark and moody. Finally, the hard light of the setting sun reflected in the glass towers of a cityscape is fantastic.

Natural light is continually moving and changing, so it's the relationships of light, form and colour you're exploring in photography. Light itself has colour that changes according to the time of day, the season and where you are on the planet. You will see a colour shift if you take pictures by firelight, moonlight or artificial light. All forms are altered in appearance as the direction and angle of light falling on them shifts. Look at your hand, for example, and then put your palm flat up to the window so that it is side-lit. You will see all the lines and textures; it becomes a different thing. Even the most mundane subject, if it is bathed in beautiful light, will make a picture.

It is fascinating to explore the edges of light – dawn, dusk, through water and so on. Our eyes automatically compensate for a wide range of light conditions, but cameras are not so flexible: they record all the subtle variations at once. It's worthwhile trying to photograph any light condition that attracts you, though some will prove challenging. In order to get the most out of light, you have to understand how to use exposure so the resulting picture is the one you imagined.

### Pre-dawn
Throughout the summer months, after a clear, still, starry night there is a soft, shadowless, pastel pre-dawn light which lasts for about twenty minutes before the sun comes up. Although this light only lasts for a limited time it is good for portraits, watery landscapes and even fashion.
**Skiathos** *Canon 1DS 17–35mm/RAW*
© Martin Brent

### Winter light
This is a location used by professional photographers to shoot fashion catalogues because the light is constantly clean, clear and hard because the weather is fine. They usually work very early in the morning and then late in the afternoon, because it is cooler and more comfortable for the models. The hard light is good for the pastel-painted 1930s buildings.
**Miami** *Nikon F4 35–70mm/Kodak EPP*

## Winter light

More often than not, the weather is fine a day after a snowstorm, and the light is clean and clear. In the northern hemisphere the sun does not get very high in the sky and it is possible to photograph directly into the sun without any problems. An 81B filter has been used to correct the blueness in the shadows that are a feature when photographing the snow.

**Aysgarth Falls, Yorkshire Dales**
*Nikon F3 35mm/Kodak Ektachrome*

## After the sun has gone

Night falls slowly during the summer months in the northern hemisphere, giving a long evening twilight. The French call it *entre chien et loup,* between the dog and the wolf. This is a time of stillness; ponds and lakes are mirror calm and reflect the sky. Good for landscapes, as there is not much difference between the light levels of the highlights and shadows.

**Trégastel, Britanny**
*Nikon F4 80–200mm on tripod/Kodak EPP*

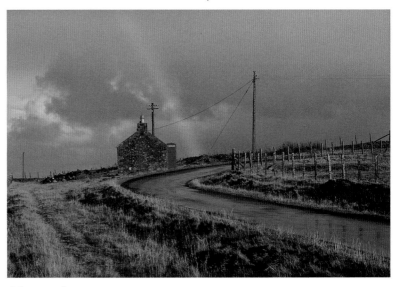

## Sunset

I never tire of watching the sun go down. The only difficulty photographically is how to frame it. I find it quite stressful to see a lovely evening sky with the potential of a good sunset and nothing in the foreground. Sunset is a good time to use silhouettes, and the virtually black shadows in the foreground hide any rubbish. Take the meter readings off to the side of the glowing sun to retain detail in other areas of the picture.

**St Lucia**  *Nikon F5 35–60mm/Fuji Provia*

## After a rainstorm

On stormy days in Scotland or near the sea you can experience three seasons in an hour: the rain stops and the sun comes out opposite the still-passing black clouds – rainbow time. A lovely light to photograph in because you can expose for highlights to make the dark clouds even more dramatic. The red telephone box zinging out makes the picture.

**Lewis, Outer Hebrides**
*Nikon F4 80–200mm/Kodachrome 64*

# Natural light

### Window light

One of a photographer's favourite lights because it is soft, gentle and moulding, window light is especially good for portraits and still lifes. It can be controlled by using curtains to narrow the window, creating a spot effect. Use a tripod, and make sure people are still. The light falls off quickly, so the background is usually quite dark, helping to give the subject volume. Use a reflector to fill in the shadows.

The four musicians lined up by the window naturally adopt the pose. Note how the light falls off from left to right, but how good the moulding is and how the detail of the faces and frock coats are recorded.

**String quartet in Vienna**
*Nikon F4 85mm on tripod/Kodachrome*
© Derek Richards

### North light

North light is favoured by painters, and their studios usually have large, high windows to capture it. They like working in this light because it is consistent in both its intensity and colour. For the same reasons, photographers like working in these types of studios – especially for black and white.

A huge north-facing window floods the life-drawing studio at the Royal Academy. The flat directional light is good for showing the curvature of the body and the texture of the skin. The effects of light falling on a body holds an abiding fascination for painters and photographers.

**Life-drawing at the Royal Academy of Arts, London**
*Nikon F4 35mm on tripod/Kodak Tri-X*

### Direct light

Hard, direct sunlight, whether when the sun is high or low in the sky, is a fine light to photograph in, though be aware of its peculiarities when using it. The high-contrast black shadows can be difficult, especially if they are made even darker by exposing for the highlights in the picture. When photographing people in direct light, look carefully to see where shadows fall: half close your eyes and rotate them to see the effect of the light. Also the subject's eyes may have a problem coping with the direct sun. In general, direct light can be rather bland for landscapes, but it is good for snow-capped mountains, and in woods where the light filters through the canopy.

It has many pluses. You can use a fast shutter speed and a small aperture, and in this light colours are the purest they will be. It is a perfect light for showing hard-edged detail whether the light is used directly or as a side light. It will show the details in buildings perfectly, and you will see the bluest of blue skies because the sun is directly behind you. This is the light in which to use a polarizing filter.

On a very sunny day look for picture opportunities in the shade, which is rather like twilight. Everything is evenly lit with soft shadows, which are very good for portraits.

At altitude, light is more intense than at sea level. This man came to our campsite at 1,500 feet to see if he could have a plaster for a cut finger. I cleaned up the cut and in return he agreed to be photographed. Transparency film is excellent for direct light, as it holds shadow detail.

**Old man in Zanskar, India**
*Nikon FE 105mm/Kodachrome 64*

### Back light

As an alternative to direct light, sunlight also makes a fine back light or rim light. Use a long lens with a good lens hood to minimize flare, and expose for the shaded area. A flattering portrait light, which smoothes out the skin. Use a reflector to put some light back into the face.

**Clare and Maria outside my studio**
*Nikon F4 400mm/ Agfa 100*

# Difficult light

Night photography is often a matter of trial and error. You need to do several shoots to become familiar with its vagaries. When shooting under street lighting or even moonlight, one thing is in your favour: the lighting is consistent. The main problem is contrast and film's ability to record the image in a consistent way. Slow film often requires too long an exposure, while super-fast film can be too grainy. If shooting digitally, choose a slower ASA to avoid noise.

Bracketing is advisable – but bracket with the aperture, not with shutter speed. Use a good lens hood to avoid flare. Look at the lens element to see if there are any reflections in the glass. You will need a sturdy tripod, a lockable cable release, a good meter and a torch – to look around the camera bag, but also as a light source – and an off-camera flash. Torchlight and the flash can be used to fill in the shadow areas, but filter the light source to the colour of the light illuminating the scene.

If shooting in moonlight, the camera meter is good, but will overexpose by a stop or more. The moon moves surprisingly quickly through the sky, so if you need a moon in the landscape, shoot it separately and Photoshop it in.

To track the movement of the stars, put the North Star in the centre of the frame and, stopping right down, expose for five or six hours. The stars will record as concentric circles in the night sky. If you're after earth-bound detail, try double-exposing. Choose f4 for the stars, then at the first hint of dawn, re-shoot at the required shutter speed to get the foreground lit by the pale light. This can also be done in reverse, using the last glows of the setting sun.

**Moonlight**
The full moon gives a surprising amount of light, and you can see a lot of detail in a moonlit picture. I used a hand-held meter to determine the exposure, taking a grey card reading. There will be a colour shift because of the long exposure.
**Fuctal Monastery, Zanskar, India**
*Nikon FM 28mm f8 at 15 mins/Kodachrome 64*

## Street light

This picture is evenly lit by sodium streetlights, neon signs, fluorescent shop lights and car headlights. Matrix metering gave an exposure of an eighth of a second. Using a long lens has packed the neon signs close together.

**Nathan Road, Hong Kong**
*Nikon F4 80–200mm on tripod/Kodak E200*

## Fireworks

For successful firework photography you need a good tripod and a piece of black card. Choose a position to frame the area that will be lit by the fireworks. Wait until the first firework goes off, giving you an idea of how much sky you will need to show – filling the frame is important. Set the camera to open shutter, but cover the lens with the black card. Remove the card when there is a burst of fireworks, then cover up again. Repeat as many times as there are fireworks in different parts of the sky. Don't let them overlap – a case of less is more.

**VE Day display, River Thames, London**
*Nikon F3 50mm/Kodachrome*
© Chris Cormack

## UV light

Reading DNA samples by ultra-violet light required a 40-second exposure. The technician and background were lit by flash, slightly underexposed, with the modelling lights turned off. The length of exposure was determined by Polaroid 667.

**Ciba, Basel, Switzerland**
*Mamiya RB67 65mm on tripod/Kodak EPP*

# Camera-mounted flash

One of the most important technical impacts of recent years, almost lost among the rush to digital, has been the development of computer-controlled, camera-mounted flash. On-camera flash was always pretty crude, but now with the choice of a dozen different flash modes you have fine control and can shoot with much greater confidence, and in situations that would have been difficult or impossible before.

It can be used subtly, where you hardly see the effect other than that the colours are clean, or in a raw way as employed with great effect by Martin Parr (and his many imitators).

There are several accessories that help control and mould the light from a camera-mounted or on-board flash. The built-in screen that pops up is too small to be really effective and it is better to buy a separate attachment. The Omnibounce is a translucent diffusion hood that fits over the flash head. Some people leave it on all the time, but it works best if there are several white surfaces for the light to bounce off. LumiQuest makes bounced diffusion devices, which can be used when there is nothing to bounce off and are very good when you are working with a wide-angle lens in a crowd. Bouncing a raw head off a low ceiling also gives a good light with no hard shadows.

**Direct flash**
This is a hard light, set to match the aperture on the camera. It is very good for getting into the details and keeping colours crisp and clean. With portraits, there is a danger of red-eye and dark shadows. It will be directly visible in windows and other reflective surfaces, and will exaggerate any subject with sheen – including a shiny face. Don't trust in it if you're asked to photograph a wedding reception. A young bride deserves a more flattering light.
**Buddhist monastery, Yunyan, China**
*Nikon F4 35–70mm Vivitar flash/Fujichrome*

## Rear curtain sync

This is selected when you want to give the impression of forward movement, and is usually used with slow shutter speeds, but can be used with shutter speeds up to 1/250 second when the subject is moving quickly. The shutter opens and the ambient light is recorded. Movement appears as a blur then the flash fires at the end of the exposure, freezing the action. If the flash fires as soon as the shutter opens, it looks as if the movement is in reverse.

**Wacky Warehouse children's playground**
*Nikon F5 20–35mm Nikon SB 28 with Omnibounce hood/Fuji Provia*

## Matrix-metered fill flash

Flash is not just used when it is dark. The high midday sun creates harsh shadows and causes people to have 'panda eyes'. Matrix-metered flash fills in the shadows and keeps colours true. This is frequently used by news photographers, with the power output set to minus a third so the flash does not give that burnt-out look. It will freeze any movement even if you have to shoot at a slow shutter speed. I have hand-held at 1/10 second and got pin-sharp pictures.

Here, the girls are in their Sunday best because they are attending a ritual where a long-dead ancestor is taken from the tomb and reunited with living relatives for a day or two of feasting, dancing and singing, to ensure a happy afterlife.

**Famadihana (turning of the bones), Madagascar**
*Nikon F5 35–70mm Nikon SB28 with Omnibounce hood/Kodak E100*
© Kim Sayer

### Tele-flash

If the picture requires it, it is possible to increase the volume of light by manually overriding the automatic computer settings. This is most commonly required when shooting on a long lens. The Nikon SB28 flash knows what lens is on the camera, but the computer sensors don't like a focal length of more than 120mm, so if you are shooting at 135mm on the 80–200 zoom, you have to adjust the automatic settings by increasing the power by 1 stop and opening the aperture by 1 stop. Another effect can be achieved by doing the reverse. If you want to pick out an area of the picture, use a wide-angle lens and set the flash on the longest lens setting. The subject will be in a pool of light and the rest of the picture will be slightly darker. Shooting digitally, you need much less light than with film. Check the preview window and be careful not to overexpose.

**Terracotta warriors, Xing, China**
*Nikon F4 180mm Vivitar 283 with turbo pack/Kodak EPP*

### Flash sync

Rapid movement can be frozen with a fast shutter speed or with flash, but combining them with rear curtain sync really creates a feeling of being in there with the action. Here the flash was synced with a shutter speed of 1/250 second.

**Anse Chastnet cycle trail, St Lucia**
*Nikon F5 28–70mm Nikon SB28 with Quantum Turbo Pack/ Fuji Provia*

Flash is an important accessory, and understanding its potential opens up a new realm of picture possibilities. There are several other effects not illustrated here. It is even possible to take pictures in total darkness: the autofocus illuminator enables the lens to focus even though you can't see anything. This same facility in normal conditions enables you to move with a moving subject, hold focus and correct exposure for the flash, giving you amazing freedom to take pictures.

On the most sophisticated units the flash is able to fire six times in a continuous burst creating a strobe effect, overlapping images of an action.

One small flash head can only light a small area of a big scene, but a number of flashes will complete the job. Sometimes it is impractical or impossible to use multiple lights to illuminate the picture. The solution is to use a tripod, an open shutter and an assistant to hold a card over the lens. Set the camera aperture so it corresponds to that of the auto-exposure flash and then walk around the area manually popping off the flash – painting the area with light. Be careful not to overlap, or you will over-expose that area of the picture.

**Filtering the flash**
The light emitted by flash units is equivalent to daylight, so when you use them in different light conditions, the flash must be filtered to match the light. Here the light source was fluorescent so the flash had a 15 green gel on it, corrected for daylight film with a 15 magenta on the lens. Until the advent of matrix-metered flash, coupled with autofocus, photographing in colour in crowded situations like this, with reflective and low ceilings, was very difficult.
**Cruise ship kitchen**
*Nikon F5 20–35mm Nikon SB28 with Quantum Turbo Pack/Kodak E200 pushed 1 stop*

A Vivitar flash head has a hood that takes various filters – either colour-effect or correction and translucent ones – that correspond with the focal length of the lens being used. The Quantum Q flash, powered by a separate battery pack, is a very useful location light. The desired f-stop is manually programmed and the computer outputs that amount of light even if the subject moves closer or further from the flash. This is a very good light to use with a medium-format camera, or as a background light with 35mm. All these lights can be powered by a separate rechargeable battery pack that bypasses the AA batteries and dramatically increases the recycle time.

Photocell slaves allow any number of flashes to be used together on location, all triggered by the flash on the camera or by a radio trigger. Pocket Wizard is the leader in radio-triggering technology. As camera-mounted heads are so small compared to studio lighting, they can be used discreetly, and they give a lot of light. They fit into tight corners and don't need any mains or electrical power. Triggering several flash heads is one area of photography that is particularly prone to 'Sod's Law'. They can work perfectly when you test them in the studio but fail on the job, and you just have to cobble something together to get around the problem. As often as not you'll find they work perfectly again once you are back in the studio.

### Three flash heads

Another picture from a similar location where there's just no room to use studio flash. The two flash heads, with photocell slaves attached, were positioned so their light would bounce off the walls and ceiling. They were triggered by the light of the camera flash. All three flashes were corrected for the kitchen light. Using a 1/15 second exposure allows the ambient light to register and this eliminates the hard shadows caused by the flashes. For this picture, the flashes were independent. It is possible to link several flash heads together with cables and trigger them with the camera shutter.

**Alastair Little's restaurant kitchen, London**

*Nikon F4 24mm Nikon SB24 + 2 Vivitar 283 heads with turbo packs/Fuji RPD*

## Off-camera flash

The flash head is at one end of a metre-long cord and the other end is attached to the hot shoe. The resulting light has more moulding and there is no chance of red-eye caused by the flash being too close to the lens. The flash is set at a third of a stop over the camera aperture and hand-held. Autofocus allows the other hand to operate the camera.

**Ronald 'Boo' Hinkson, playing on a hot Caribbean night**
*Nikon F5 20–35mm Nikon SB28 with Omnibounce diffuser and SC17 cord/Kodak E100*

## Ring flash

Instead of being mounted on the hot shoe on top of the camera, the flash is a series of tiny lamps around the front element of the lens. This type of flash delivers wraparound light and gives a distinctive shadow around the subject. There is no disguising the fact that this is a flash-lit picture. Ring flash was originally designed for macro photography, where the front element of the lens may only be 40mm from the detail. If your subject looks directly into the lens, you will invariably see the distinctive ring of lights reflected in their pupils and the shadows around the edges. Besides the small 35mm system, ring flash is also available as a powerpack powered light. It comes in various sizes and is a good fashion light.

**Hannah in the studio**
*Nikon F5 28–70mm Nikon SB29/Fuji Velvia*

# Mixed lighting

The secret of shooting in mixed light, which can result in odd colours, is to introduce a light source that dominates the existing light. This is usually flash but could be tungsten spot lights, or HMI lights. If shooting digitally and using flash as the dominating light, you will need considerably less of it than when shooting film. It will also tend to look flat – the contrast of the scene may be brought back using the histogram on the camera's display. Colour temperature can also be altered and corrected in Photoshop.

### Tungsten plus flash

The subject is lit by a single flash head with a soft box and the modelling light turned off. This has kept him correctly exposed, the colour true and frozen any movement. A slow shutter speed of about half a second records the lamps, which appear warm on daylight film. The light reading was taken from the glow of the lamp. The aperture flash reading is balanced with the shutter speed reading of the lamps. It is possible to use daylight-corrected bulbs in the lamps but you may find they appear too blue. Alternatively, you could use strong tungsten bulbs with tungsten film but it would be difficult to control how your subject is lit. If shooting digitally, you will only need a spit of flash on the subject, then manually adjust the colour in the white balance setting. If the camera were to adjust automatically there is a chance it would over-correct, losing the warm atmosphere.

**John Hopkins at his desk**
*Mamiya RB67 65mm/Kodak EPP*

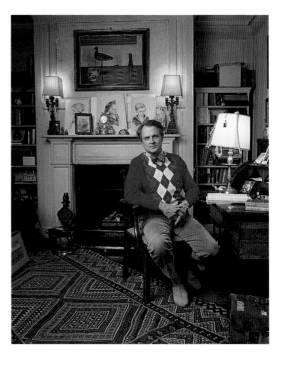

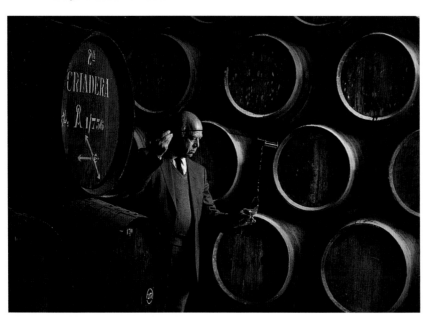

### Daylight plus flash

The bodego, or warehouse, is where barrels of sherry are left to mature, periodically tasted by the master blender. The huge doors of the building were opened, allowing a lot of summer daylight in. Although the light was bouncing off the courtyard rather than straight in, it was too directional – too side-lit. The shadows were really dark so had to be filled in by flash. I used a battery-powered Quantum flash with a small diffuser umbrella. The dark oak barrels absorb a lot of light. The light reading was taken from the front of the master blender's face, the brightest part of the picture. The flash was then programmed to give an f-stop reading about 1 1/2 stops under the daylight. To make absolutely sure, I bracketed both the daylight and the flash.

**Harvey's sherry blending, Jerez**
*Nikon F4 85mm on tripod/Fuji Velvia pushed 1 stop*

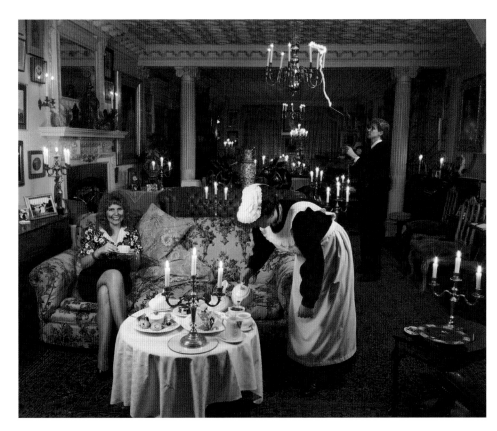

## Candlelight plus flash

Fifty or more candles were used to light the sitting room. A small flash was used to light Judith and her maid, and another for the butler. Candlelight is very warm so I had to add a warming gel to the flash lights to make them appear more like the colour of the candles. The exposure was one second. Candlelight is very flattering – just look across the table at a candlelit dinner, or have a look at Stanley Kubrick's film *Barry Lyndon*.

**Judith Miller at home**
*Mamiya RB67 65mm on tripod/Kodak EPP*

## Fluorescent and quartz halogen light plus flash

An office environment is unwelcoming to a photographer. Computer screens look dead unless there is information on them, and this requires about one second's exposure. This office was predominantly lit with fluorescent light, which can be corrected by making the flash the same colour – adding a green gel over the light and a magenta filter over the lens. The whole room had to be lit with flash heads. There is still a magenta cast in the TV screens on the wall. If shooting digitally, set the white balance to fluorescent and add a green gel over the flash as before. The camera now recognizes the light sources to be the same and the flash will only need to light the subject in the foreground. This picture is easier to do digitally, because you only need one light.

**Reuter's monitoring room**
*Mamiya RB67 50mm with 15 magenta filter on tripod/Kodak E200*

# Studio and location lighting

To be able to light is a fundamental skill of the serious photographer, it is a craft that is a joy to learn and satisfying to apply and will turn the mundane into something special. On-camera flash is fine for what it was designed for, but has serious limitations: it is too small, is in the wrong place and there is not enough of it. Lighting is a big subject and the best way to learn is by seeing. If you want to improve your capabilities as a photographer, you need access to a studio or to be able to black out a room so you can see the effects of different lighting set-ups.

The many brands for the studio and on location include Bowens, Elinchrom, Broncolor, Pro-Photo, Strobe, Speedotron, Norman and Dyalite. As with buying into a camera system, once you are committed to a particular make, you tend to stick with it.

**Louvred hood**
The front of the hood on the main light has a louvre on it (like a blind) and this creates a contradiction in lighting terms – a soft spotlight. This lights the subject and not the foreground, so your eye is on the subject. There are two other lights used in the picture. They have honeycomb grilles, which stop the light flooding. It is essential to control the light even in a hostile location, in order to achieve a successful picture.
**Making Cabinet red boxes**
*Mamiya RB67 65mm on tripod/Kodak EPP*
*Elinchrom pack with chimera hood, Elinchrom hard boxes and grills*

## Hero lighting

It's only a photograph. Why does it take ten cases of equipment to take it? This is the reaction of many people when I turn up to take their portrait. Here, five lights have been used for a 'simple' head shot.

One light (an Elinchrom hard box) is directed on the background; the main light, camera right, is a Whafer soft box as close as possible out of camera view. A third light (a medium-soft box) is further back to create general light and fill in the shadow side of the face. A spotlight with a directional grille is pointed back towards the camera to pick out the jaw line and, when the head is turned, just a flash of light on his nose. Finally, a top light with a small Whafer hood on a boom stand lifts him off the background.

**Michael Jackaman, Chairman, Allied Domecq**
*Nikon F4 135mm on tripod/Agfa 100*
*Elinchrom monoblock and pack lights*

## Reflected light

When photographing shiny or reflecting objects, you don't light them directly, but reflect the light off a big white surface that in turn lights the subject. If you light the shiny object directly, it comes straight back to the camera as a hard patch of light. The principle is the same for table-top objects through to cars in the studio. Here, the main light is a top light through a 4-foot-square soft box, bouncing off two poly boards, lighting the front and side. The subject is positioned on a white paper sweep so the light bounces off the background as well.

**Model of the Tower of London**
*Mamiya RB67 160mm macro on tripod/Kodak E100*
*Elinchrom pack Whafer hood with poly boards and white sweep. This appeared as a cut out*

It is not advisable to mix too many systems together – very few photographers do as there are colour temperature differences, and attachments are not compatible. Different manufacturers broadly produce the same range: a monoblock head or a pack-controlled head with modelling lights. What is more important is what the raw light passes through and its effects on the picture.

Light can be from a raw bulb, or through soft boxes of various sizes; as a spot with a snoot or barn door; bounced off or through umbrellas of different sizes and colours; reflected off a large white area or a big dish; given shape with a mesh or projector, or with louvres and honeycombed grille. I am not dealing with constant source light here such as household lamps, tungsten, quartz halogen, HMI or fluorescent – though many of the same attachments will work on these lights. A photographer interested in lighting besides having an electronic system should also have a tungsten or quartz spotlight.

### Battery-powered packs

Morecambe Bay is a treacherous place to cross at low tide and for centuries there has been a guide to help. To keep a sense of place, he has been photographed at sunset and lit by a battery-powered flash pack with a small soft hood as if he was in the studio. The background is underexposed by half a stop. You can use lighting in broad daylight, but first you must create a big shadow area and put the subject in the middle of it. This is a Hollywood lighting technique where they have to film in unflattering hard sunlight. Lighting outside like this always adds drama to a picture.

**Cedric Robinson, Queen's Guide to the Kent Sands, Lake District**
*Mamiya RB67 90mm on tripod/Kodak EPP*
*Elinchrom freestyle pack Whafer soft hood*

## Umbrella

The room is lit by one flash head bouncing out from a silver umbrella. This is a hard light that is very good for dark wood and for picking out details. A similar effect can be achieved by bouncing the light off a white ceiling or out of the corner of a white room. The light here is balanced with the daylight flooding into the other room.

**Sir John Soane Museum, London**
*Nikon F4 35mm on tripod/Kodachrome*

## Cross lighting

An effective way to show volume is to use two different types of light. Here the objects are lit by a metre-long strip light at the same level as the tabletop. The light is reflected back and over by a white card reflector. Then, with the modelling light turned off, a tungsten spot, again at tabletop level and at 45 degrees to the flash, has highlighted the objects and caused the long shadows.

**Book jacket**
*Mamiya RB67 140mm macro on tripod/Fuji Velvia*

## Beauty light

The light bounces off an internal reflector before it goes out of the front of a 1 1/2-metre silvered dish. A diffuser can be added to soften the light. The dish is placed directly above the camera and a horizontal reflector in front of the model. A white background and sides produce the high-key effect.

**Model test shot**
*Mamiya RB67 150mm on tripod/Kodak EPP*

# 6: CONTROLLING THE PICTURE
## Filters

Filters help create better pictures. They can add atmosphere and drama to a scene. But filters should be used with care. I prefer to see the picture, not the filter. Like seasoning in cooking, a filter should be subtle, not dominant.

Filters can correct or enhance an image. Corrective filters balance the limitations that all films have in certain conditions. Photographers are often disappointed when they see their pictures because they do not look exactly like the scene they remember. Snow may look glistening white to the eye, but in a picture it can appear blue. Fluorescent-lit shops look bright but photograph green. The deserts and wheat fields of our imagination are golden yellow, but in certain lights can appear dull and khaki-coloured.

Filtration can help correct these problems and make snow white, corn and wheat yellow, or a weak-coloured sky deep blue. Film is made for use in optimum conditions, which are present all too rarely. Filters help redress the balance.

Enhancement filtration can make a good picture even better by enriching the colours and heightening contrast for dramatic effect. 81-series (or warming) filters add warmth to skin tone, make greens greener and add colour to stone. I prefer warmer pictures and generally use a warming filter on my lens. This also has the advantage that if something is slightly overexposed it does not look washed out but retains some colour. Neutral density filters reduce light entering the lens, in order to allow slower shutter speeds or a wider aperture without overexposure. Neutral density filters can be used to control the ASA settings on digital cameras, which are rated too high for some types of pictures.

UV protectors absorb ultra-violet light and reduce the blueness of a distant haze. They are also a useful defence against lens damage – I would certainly rather scratch a filter than a lens.

Whatever you put in front of the lens can act as a filter – from your breath to a thick glass ash tray. The

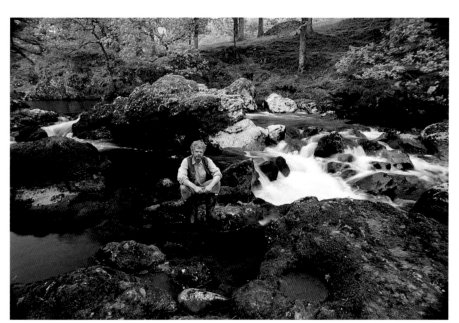

### Polarizing filter
For this portrait I used a polarizing filter and an 81B filter. The polarizer has made the greens greener by reducing the reflected light on the wet leaves. Without it, you would not see into the pool to the arrangement of red stones. The red of the stones is enhanced partly by the filter and partly because of the contrast with the surrounding green. The 81B has kept detail in the sky and in the skin tones of Andy's face. The polarizer in conjunction with the 81B has separated the many green tones.
**Andy Goldsworthy**
*Nikon F4 24mm on tripod/Fuji Velvia*

best filters are made of optical glass and are expensive. Cheaper, but less durable, are solid gelatin and Kodak Wratten gelatin filters. High-quality polarizing filters are neutral in colour. Cheaper ones can leave a greenish cast.

I often use four filters together without difficulty – the better the filters, the fewer the problems.

Digital capture has made a good deal of filtration redundant, as colour correction can be done using the white balance control, or later with the computer. However, it is still worth knowing that certain types of light have a colour that is not always apparent to your eye. One of the filters you can use digitally is the polarizing filter, which saturates the colours. Colour adds mood to a picture and sometimes 'correct colour' is not the best option.

### Polarizing filter

A polarizing filter turns a blue sky dramatically bluer, and the clouds whiter. At high altitude it will turn the sky black. It will cut out reflections on many surfaces, and also works as a neutral density filter. The polarizer is one of the few filters still helpful when shooting digitally.

**Norwich Cathedral**
*Nikon F4 28mm PC on tripod/Fuji 50D*

### Graduated filters

Graduated filters are used to control a particular area of the picture, often to darken the sky. Coloured grads add colour to the sky to make dramatic sunset pictures or make a washed-out sky blue. Grads can also be used to eliminate foreground rubbish so the eye is led straight into the subject of the picture. Because graduated filters alter the exposure, they make the built-in camera meter less reliable. To be safe, it is best to take a reading off the main subject without the filter, then add the filter and bracket around that exposure. This is not necessary when shooting digitally as areas can be darkened later in Photoshop.

**Standing stones of Callanish, Isle of Lewis**
*Nikon F3 35mm Lee 0.6 graduated filter/Kodachrome*

### Star filter

This effect turns a spot of light into a star. You can control where the points appear by rotating the filter. Use sparingly on suitably 'starry' subjects.

**Harrod's**

*Nikon F4 24mm on tripod with B+W star filter/Kodak Ektachrome*

### Custom-made filter

I was commissioned to do a series on the places where famous artists lived and worked. I wanted the pictures to have a Canaletto feel. The only way to achieve this was to have a filter specially made. This one is a mixture of 5 yellow, 15 red and a third of it a 0.3 neutral density. The effect of the filter can be seen in this picture of the chapel on the castle wall in Amboise where Leonardo da Vinci is buried. I have since scanned this picture, fine-tuned the colours in Photoshop and printed it on art paper. You can create any filter you like to help you achieve the picture you imagined.

**Amboise**

*Nikon F3 35mm with 'Canaletto' filter made by Lee filters/Kodakchrome*

### Home-made filter

This is a set-up picture – controlled reportage creating an 'authentic' atmosphere. To emphasize the couple in their private world, the brass pillars on either side of the picture were deliberately kept in, framing them. Selective focus holds the shot against a soft background. Vaseline was dabbed on to an 85B filter to flare and soften the hard points of light dotted around the frame. This further adds to the impression that we are observing a romantic moment.

**Café de la Paix, Paris**

*Mamiya RZ 65mm 85B filter on tripod/Kodak EPP*

© Derek Richards

## Correction filter

Pictures taken on film in fluorescent light have a green cast. Carrying an FLD (fluorescent light daylight) filter helps solve this problem. One of the wonders of digital photography is the ability to correct colour by using the white balance control at the time of capture.

**Durban spice market**
*Nikon F5 30–70mm/Kodak E200*

## Enhancement filter

These filters were developed for the movie business. A red enhancement filter is used here to zap up the colour of the combine harvester, without affecting the rest of the picture which is warm anyway.

*Nikon F4 300mm on tripod with Tiffen Red Enhancement Filter/Fuji 100D*

## Soft filters

A soft filter takes the hard edges out of a picture while retaining focus and sharpness, for example smoothing out any wrinkles and lessening bags under the eyes. Even a young face benefits from the effect of a soft filter – the highlights will have a glow.

The best soft filters are Softar 1 and 2, made of optical glass. Inferior soft filters cause problems, making a picture in which nothing remains sharp. The wider the aperture, the greater the effect with Softar filters.

Excellent effects can also be achieved by stretching a 20 denier black stocking, or a piece of black net, over the lens. Coloured net will give a subtle cast to the image. Another trick is to apply Vaseline round the edges of a lens or filter, leaving the centre spot clear. This softens the edges of the picture but keeps the main image sharp and concentrates the subject in the centre of the frame.

Soft filters can also help create particular effects in landscape photographs, making subjects look dreamy and atmospheric. Landscape soft filters work best if the subject is backlit.

*Nikon F3 105mm Heliopan Softar 2/Kodak Ektachrome*

# Creating movement

Photography by its nature produces still pictures, but there are times when, instead of freezing the moment, you want to give the impression of movement. If you leave the shutter open, movement is captured as a blur. This method has its uses – for example to show a river of night-time traffic through city streets.

Besides the movement illustrated, you can use double exposure, a blurring (or 'speed') filter, or tripod adjustment. In Photoshop, movement can be added to any part of the picture.

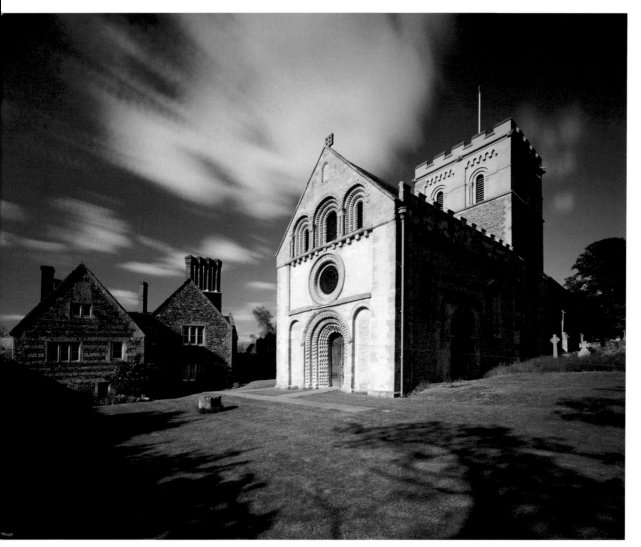

**Cumulative exposure**
The theory is you choose the minimum aperture of the lens and divide that exposure by four or five. Photograph the scene and don't wind on; wait for a few seconds, re-expose and repeat until the total exposure adds up to the meter reading. Here, the building is tack sharp because of the minimum aperture, and the clouds have moved across the sky.
**The church at Iffley, Oxfordshire**
*Ebony 5 x 4 75mm Schneider Super Angulon on tripod with cable release/Kodak Ektachrome E100 SW 8 exposures at 1/125 second* © Denis Waugh

## Flash blur

Set the camera on rear-shutter mode, balance the flash with the ambient light set at a slow shutter speed and pan with the moving subject. The blurred movement is recorded first, then the moving subject is frozen by the flash. Try and keep the front edge of the moving subject against a dark background, since a bright light may show through part of the image.

**Clare in the kitchen**
*Nikon F5 35–70mm Nikon SB28 Speedlight/Fuji Velvia*

## Panning

For the best results you need to shoot on a longish lens, 135–200mm, at a shutter speed of 1/15 or 1/30 second, depending on the speed of the moving subject. You need to be able to see the subject for as long as possible and to keep it a continuous distance from the camera – or locked on in autofocus. Keep the autofocus locked on the front of the moving subject, and the rear end will begin to blur along with the background. With longer lenses use a unipod and you can shoot at a really slow speed, even down to a second. To perfect this requires a good deal of trial and error. Shooting digitally and editing as you go improves technique in no time. Continue to pan after you have fired the shutter, especially with very slow shutter speeds, or your subject may escape the frame.

**Bangkok tuk-tuk**  *Nikon F4 80–200mm/Fuji 100D*

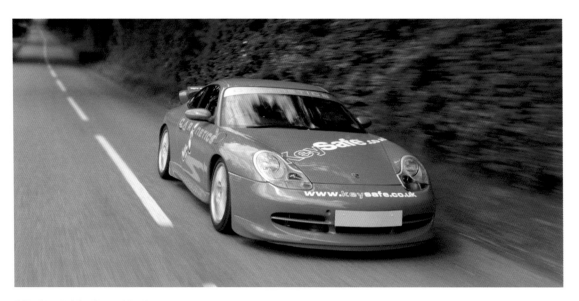

## Moving with the subject

The Porsche was photographed from the back of a Land Rover travelling at 20 mph. Because both are travelling at the same speed, a shutter speed of 1/30 second has kept the car sharp, but the road and background blurred.
*Canon 1DS 35–70mm  © Martin Brent*

# Tripods, releases and remotes

Photography is not always over in a flash. A single exposure can take an hour or more if you want to get creative in low light. Although manufacturers extol the advantages of fast shutter speeds, many of the best pictures are taken at slow speeds, with the camera mounted on a tripod. I use slower speeds much more often than speeds of 1/2000 second and over. Broadly speaking, hand-held photography stops at 1/30 second.

Tripods range from the small Leitz table-top through to the biggest Gitzo that can extend to ten feet. Whatever the make, choose one that doesn't wobble. A single-lock ball head is suitable for both static and moving objects, and faster to use than a three-way pan-and-tilt head. Using a tripod makes you study a composition more fully than when you simply point the camera. When taking a portrait, the camera on a tripod is a constant point of reference for the sitter.

It's a good idea to have a spirit level on hand to make sure you get perfect horizontals and verticals. A cable release ensures there is no camera shake, which is usually caused by the mirror moving up and down when the shutter is fired.

A unipod (monopod) takes the weight of a long lens and allows you to be more mobile. It's a good idea always to have a tripod in the car.

An extra-long cable release, an infrared or radio release, is an essential piece of kit when you can envisage a picture, but there is no possibility of you physically being behind the camera at the moment the picture happens. With all remote releases, make sure the camera motordrive is set to 'single shot' – unless you want to shoot a whole roll of film or fill up a memory card in one go. Set the camera on an auto programme to suit the picture, but set the focus manually. There is no battery drain as the camera is asleep until you click.

## Radio release

The classic Grand National picture: lots of horses flying over big jumps. The camera was mounted onto a custom-made spike pushed into the ground. The jump was chosen with care; the background had to be clean because there would be enough clutter with the horses. The camera motor drive was set on 8 frames a second and was triggered from 50 metres away by a radio release.

**Irish Grand National**

*Nikon F5 17–35mm on spike/Fuji Provia 100 pushed 1 stop*
© Bob Martin

## Infrared release

The camera was mounted on a clamp on a screen near the organist. I triggered it from behind a pillar on the left of the picture. Before the event, the camera was focused on a line of floor tiles. I fired the shutter when the archbishop reached this line. This picture ran as a double-page spread in a magazine and was run on as a poster.

**Enthronement of the Archbishop of Canterbury**

*Nikon F3 35mm Nikon infrared release/Kodak EPP*

## Long-cable release

Peter Bell used a microlite to tend his sheep. Chris Cormack briefed him on the ground as to what the picture should look like and when to trigger the release. The camera was attached to the wing strut and framed up on the farmer/pilot. All he had to do was dip the wing when he was approaching the sheep and press the release.

**Microlite shepherd** *Nikon F90 35mm on tripod head and bracket with long-cable release/Fuji 100D © Chris Cormack*

# Controlling light

Rather than using full flash, it is better to use a reflector to re-direct light where it is needed. Reflected light is usually kinder to the subject because it is soft. It can either be used as the main light or to fill in shadow areas to reduce the contrast levels. Reflectors come in different sizes and colours. White will give a soft light; gold a warm light, like sunset; silver a hard light – good when you need a defining edge. A translucent reflector can be used to bounce back extra-soft light, or you can let the light through it, reducing its intensity. The black reflector doesn't reflect at all, but is used to absorb light. If it is close to the face, or any subject, it will give a black edge. It is often used in studio portraits.

When you work on location, you often have to deal with coloured walls, floors or green grass. A white sheet on the ground will kill or neutralize any unwanted colour that may be reflected back into the subject. A cheap white reflector can be created by hanging a sheet on a line. Photographing your subjects outside in bright conditions can cause them to squint. Hang a black sheet behind the camera, so they look into the black and are more comfortable.

A clean, white studio background should be two-thirds to one stop over the light on the subject – any brighter and there is the possibility of flare or loss of hard-edged detail. Putting the same coloured light onto a coloured background (e.g. red on red) will really pump up the colour of the background. For a really solid rich black background use a black velvet curtain.

If you are lighting a person standing in front of a window and balancing the light on them and the light outside, be aware that there could be a thin black line rimming the person. To avoid this, overexpose the background a little.

**Lastolite white reflector**
The subject is top-lit by the midday sun, highlighting her hair and her hands. The light has been re-directed with a four-foot diameter white Lastolite.
**Iris Murdoch in her garden**
*Mamiya RB67 180mm/Kodak EPR*

## California sunbounce
When the subject is quite small in the picture, it is very difficult to light them without the light source appearing in the frame. Here, an assistant was lying on the ground with a California sunbounce, a 5ft x 2ft silver reflector, directing the light back up into the subject.
**The hereditary bearer of the Scottish flag**  *Mamiya RB67 350mm/Kodak EPP*

# Useful everyday objects

As we have seen, all sorts of things combine to make a great picture: being in the right place at the right time, 'magic' light, or the correct lens. However, there are times when the most mundane of things can be the key to achieving the picture you had in your mind's eye. The following is a collection of everyday objects that I've found come in handy for a variety of shooting tasks.

### Who's Who
If you are asked to photograph someone famous, who has been photographed a lot, they are usually busy and in a hurry. A ploy I have used is to check in advance what their hobbies are. Start chatting right away and get on to the hobby as quickly as possible – the five minutes you were allotted invariably turns into half an hour.

### Chamois leather
Keep cameras and lenses wrapped up when in the dry cold or desert heat. Chamois leather is a perfect insulator. The Tuaregs, in the Sahara, drink cool water from a goatskin gourd.

### Ladder
Take one in the car when going on location. The added height will help with the composition of a picture, raising you above the crowd, or bringing into view the range of hills behind a row of houses.

### Safe shoes
With expensive cameras around your neck and hanging off your shoulder, you don't want to fall. Forget about fashion and be sure-footed.

### Map and compass
Location photographers need to know where and when the sun will be. The ability to read a map is essential, not only to find your way to the shoot, but also for visual information to help you plan the best viewing position, depending on the contours of a hill or the bend of a river.

### Clipboard
When doing a recce, carrying a clipboard makes you look official. Some people have a low opinion of photographers. It's surprising how little effort it sometimes requires to be taken more seriously.

### Gratuity
Sometimes crossing someone's palm with silver allows access to an improved photographic position or a discreet parking space. Rewarding minor rule-bending is the way of the world. It is not unusual to pay a facility fee for a picture. If you think you are likely to be hassled by a gang of children, carry a pocketful of change. To escape, throw the money one way and run in the opposite direction!

### Powder compact
Used on men and women to hide any facial blemishes and shiny foreheads, cheeks and noses.

### Spirit level
The only way to guarantee a horizontal horizon and vertical uprights.

### Whistle
I use one when taking group portraits. People get bored and are inattentive. Wait until everyone is in position. A shrill blast on the whistle makes everyone look at the camera (but use sparingly, as the effect wears off quickly).

### Clamps
Keep with the gaffer tape – they'll solve similar problems.

### Swiss Army Knife
More uses than it has blades/attachments.

### Gaffer tape
An easy temporary fix for so many things.

### Pocket tape recorder
For those times when you can't write or when you think it is better to interview someone to make sure that there is no confusion about important information.

### Tie
For certain places and times, this will be all you need to gain access. If you don't get in, you can't take the picture.

### Torch
It has many uses, from looking in your camera bag at night to mimicking the flash to see if it will reflect off a window. A really powerful quartz halogen torch can be used to paint light onto something.

### Short wave (two-way) radios
Essential when shooting sport from a blind position and a scout can count down the approaching competitor (skiing, motor racing). Or when using a long lens and you need to contact an assistant or stylist near the subject. Also car-to-car, boat-to-boat, etc. Saves shouting into the wind – and keeps down mobile phone bills.

### Leatherman
More robust than the Swiss Army Knife – the choice of the British forces.

### Smile
The universal language. Politeness goes a long way – especially when combined with persistence (don't take 'no' for a final answer).

### Alarm clock
The early bird catches the worm.

# 7: MAKING PICTURES
## Introduction

The first half of this book gave a tour of the basics, demonstrating how each element of a modern camera system contributes to the making of pictures. The second half is for someone who is committed to becoming an image-maker, not just a photographer. By dipping into the major themes of photography, I am trying to open the door on creativity and show some of the possibilities for the serious photographer. It is hard to be certain that you are making something worthwhile when you embark on a creative process, but the possibility of failure is no reason not to try.

A camera is a means to an end, not the means itself. Images are becoming increasingly complex and viewers are becoming more sophisticated in their appreciation of pictures. This forces the creative person to stay one step ahead.

There is always more than one way of taking a picture. Once you have thoroughly mastered the arsenal of equipment and technology, it is a good

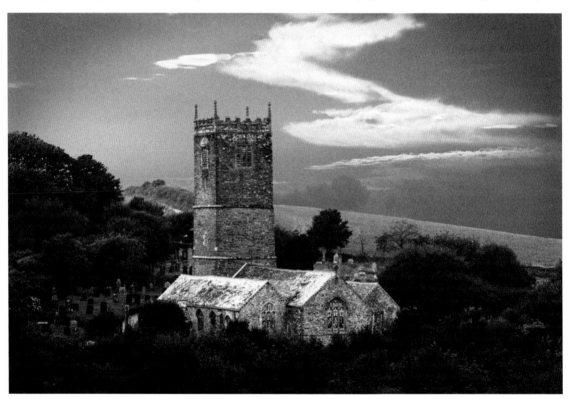

**Lanteglos church, Cornwall**
I wanted a picture that had a wintry feel, with a warm glow coming through the windows, for the parish Christmas card. The first problem: it was August. Secondly, you might imagine that in the evening, if there is a light in the church, you should be able to see it illuminating the stained-glass windows. It didn't. To overcome these problems I photographed the individual windows from the inside, where they were well lit. Then I photographed the church at sunset. All the images were drum scanned. The colour in the landscape was de-saturated in Photoshop to give the effect of a cold, moonlit winter's night, the lit windows were flipped and placed in position on the church exterior, and everything was tweaked to look natural.
*Nikon F5 28–70mm and 80–200mm on tripod/Fuji Provia*

## Ford Focus

Tim Wren has done all types of pho-
tography – news, music, sports – but
it is as a car photographer that he
has made his name. Car photography
is a very specialist, highly paid, com-
petitive area and photographers are
always looking for new ways of pho-
tographing the subject. With the
advent of digital technology, it
became cheap and easy to comp in a
background, keep a car cleanly lit
and, although moving, pin-sharp.
But taking the picture of the moving
car was not straightforward. Then
came the 'rig'. This is a pole, 12 to 15
metres long, attached to the car,
which is manually pulled about 6
feet by a thin cable during a long
exposure. The camera becomes part
of the car, moving with it, and ensur-
ing that the car is pin-sharp but the

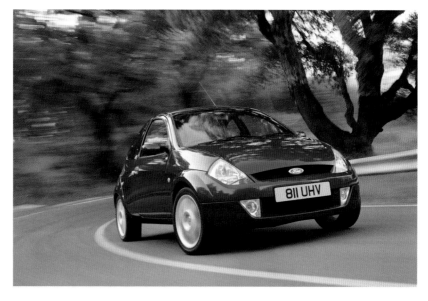

background is blurred with movement. Tim had his rig made by a yacht-mast builder. It is attached to the car by three
cables, two are attached to the underside of the car and one goes over the roof, taking the weight. The camera is at the
end, attached to a ball and socket head.

This picture demands no wind and smooth tarmac. All the cables and the pole are digitally re-touched along with
general cleaning up. The car can be just a shell: Tim has photographed million-dollar prototypes without an engine or an
interior as if they were driving through a convincing landscape.

*Linhoff Technica 135mm 6 x 9 roll film back ND filters/f64 at 8 seconds triggered by 10-metre air cable release/Fuji Provia © Tim Wren*

idea to stop for a few minutes before pressing the
button and think whether there is another way of
approaching the shot. Don't look for solutions just
to show how clever you are. The approach must be
appropriate to the subject to make an interesting
and successful picture. Aim to create a meaningful
photographic image rather than just shooting
what's in front of you.

Faced with a photographic problem there are
many ways of using the available technology to make
a picture. Say you want to take a picture of someone
standing against a blue sky, but today's sky is pale
and watery. Here are just some of your options:

* Use a blue graduated filter.
* Use a polarizing filter to darken the sky.
* Put a blue filter on the camera and a yellow one
  on the flash.
* Paint a blue background and put a blue light on it.
* Photograph a background and pump up the blue
  on a computer.
* Use Type B film in daylight and correct.

* Use flash on the face and correct for tungsten.
* Take a picture of the person and then drop in the
  background in Photoshop.
* Travel to Miami where blue sky is virtually
  guaranteed.

One of the main factors in making, rather than
just taking, pictures is that you need to have control
of as many ingredients as possible. You can't control
the weather, but you can seek out the weather you
want or create it artificially. Each of the solutions
above would look slightly different and have its own
character. The blues would be different: some would
look cool, others warm and natural. But each tech-
nique has the potential to enhance the picture.

The better you understand the technology, the
more you are able to control it to achieve good pic-
tures. Knowledge makes you more creative. Every
choice of photographic equipment or program – cam-
era, lens, flash, film, autofocus, shutter priority, etc. –
has a bearing on the final image. Each has its own per-
sonality which can be used to enhance a picture. You
are not a slave to the camera. It should be your slave.

# Favourite pictures

### 'The Most Honourable Order of the Bath, St John's Chapel, Tower of London' by Julian Calder

'As a boy there was a picture on my bedroom wall of a young knight praying, lit by the rays of the dawn light – *The Vigil* by John Pettie. A typically romantic Victorian painting, it had a lasting effect. I wanted to shoot this picture in the Order's original home in the same style. The set-up would have been hard before the advent of Polaroid as a test medium. It is very satisfying 'building' the picture step by step, going into a location and imposing your vision on it by lighting.

'There were six lights all at different settings – one light on a high stand behind the camera to light the shadow areas, one on the front for the knight at the altar, one on his back and three behind the pillars. Modelling lights were either switched off or on the minimum setting. A slow shutter speed was required so the dawn light registered.

'The image was scanned and retouched, cleaning up the cross, adding more glow around the candlelight – just to make it perfect.'
*Mamiya RB67 with 6 x 8 back 75mm Perspective Control/on tripod/1 second at f11/Kodak EPP*

### 'Ana Botella' by Graham Piggott

'I was commissioned by Spanish *Vogue* to take pictures of Ana Botella, wife of former Spanish Prime Minister Aznar, for a six-page fashion feature. The location was the prime minister's official residence on the outskirts of Madrid. The assignment involved a large team of people: the editor, her assistant, a fashion assistant, stylist and hair stylist, make-up artist and my photographic assistant. The clothes were couture and flown in from Paris. It was a long and exhausting day for all involved: it took two and a half hours just to sort out the clothes, and longer still for hair and make-up. During the course of the day I found that many areas of the residence were off limits for security reasons. This restricted the variation of clothes and locations. There is always a frustrating element in location work, things not being in the right place, sun in the wrong direction and so on. This time, though, serendipity played its part. At the side of the estate there was a new formal garden under construction where I was allowed to photograph. The sitting was coming to an end and I was feeling the need for space and calm after the day's frenetic pace. Time was running out, so I asked Ana to walk in the garden while I took a few rolls of black and white film.

'This picture represents everything I wanted to say visually about the assignment. It is a simple yet elegant contemplative photograph. The lines and shadows in the picture highlight Ana's position of being in the shadow of power. It was a moment of simplicity between her and me, away from the frenzied cast of thousands.'
*Mamiya RB67 180mm on tripod/Kodak Tri-X*
© Graham Piggott

### 'Glendronach Distillery' by Derek Richards

'This picture, for a whisky calendar, required romantic light-ing, which was achieved primarily with daylight. Having five days in the distillery allowed me to plan this picture and wait for an appropriately sunny morning. The wheel-barrow was placed in position and lit with a "pepper" light, a small 150w spot. During the second set-up, the light was moved over the barrow, painting it with light to hold detail. The warmth of tungsten light added to the warmth of the wood. An assistant ran across the set with heavy footsteps to make dust, which shows in the shaft of light.

'I used Kodak film stock all the time, so there were no surprises in the final print. It is important to know how things will turn out, minimizing any corrections or alter-ations to the finished image.

'Several Polaroids were done, but essentially this is a simple picture both in its subject matter and its execution: the light has made the picture. The composition is pleas-ingly balanced. Going through a mass of pictures to pick a favourite, I was surprised to see how many times I include a strong light source in the centre of the picture, which has the effect of anchoring the eye and allowing you to explore the whole of the image.'

*Linhoff 5 x 4 150mm/Kodak EPP*

© Derek Richards

### 'Jigsaw' by Colin Thomas

'Working as a professional photographer, it's easy to neglect my private projects. I take commissions for all sorts of work, turning other people's ideas into photos but there are images that I like to shoot that no one ever asks for.

'When I'm busy with commissions I tell myself I haven't got time to do that personal shot; when I'm not busy, well, I'd better take my portfolio around and try to get some work. Shooting experimental work requires self-motivation, not to mention thinking time. That's one of the reasons I like this shot. It started out as just a scribbled idea, and it's ended up being used all over the world to advertise anything from scalpels to an off-Broadway show.

'When I showed my scribble to a model and a make-up artist they gave me funny looks but they agreed to help me make images of all the "body parts". We shot the original images using a Hasselblad, on colour transparency film. Then I had a selection of the transparencies scanned at high resolution, and spent a couple of weeks trying out dif-ferent compositions in Photoshop.

'It's always worth shooting pictures for yourself. It's great when your own idea works out well, and even better if it goes on to make money.'

*Hasselblad 150mm/Kodak E100*

© Colin Thomas

### 'Magnolia' by Alan Newnham

'I run a studio where we photograph all aspects of food for leading supermarkets' own-brand packaging. These are exceptionally demanding clients, requiring very quick turn-around for pictures. I have been shooting high-end digital since its commercial acceptance as superior to film, and I enjoy keeping pace with all aspects of its continuing development.

'Photographing flowers is what I do to get away from the exigencies of commercial life, and I try and set aside half a day a week to do this. I am my own client, I set my own brief, and answer my own questions. As with all personal work, you apply the disciplines and techniques you have honed doing your commercial work.

'This is one of a series of about 100 flowers shot over eighteen months. This is my favourite of the collection because of the perfectly balanced composition: the white spaces are working as hard as the flower itself. I like to be a purist, so I framed the picture in the camera – I did not want to crop. I used a lighting set-up that I have used many times before: a striplight, very close to the subject. It is a soft light but full of contrast, capturing the smooth texture of the petals while holding form. I wanted to concentrate on the structure and shape of the flower. Black and white is always best for this; colour would have been a distraction.

'The picture was taken on film and the print is selenium-toned. I don't always stick to a classical approach. I also photograph flowers digitally and in colour. Flowers as a subject will keep me busy for a long time. These pictures are taken by me, for me, but they have been commercially successful too.'

*Sinar 10 x 8 360mm/Kodak Tri-X selenium-toned*
© Alan Newnham

### 'Venice Rain' by Martin Brent

This was Martin's first trip to Venice, a challenging place to take a personal picture since it has been photographed so many times before. It was the end of May and he was initially disappointed that it was raining, but he was able to turn the poor weather to his advantage. Having looked at the guidebook and postcards, Martin went directly to Piazza San Marco, took cover under the arches of the Palazzo Ducale and, looking across the lagoon towards San Giorgio Maggiore, waited for something to happen.

As all photographers will attest, patience is nearly always rewarded. After photographing about twelve different people this man came along. His body language showed he was not bothered by the rain, probably a local not a hurrying tourist. The light was breaking in the background, highlighting the church. Using Kodak 100S, a familiar and trusted film, Martin knew he would get a blueness to the overall picture and a dramatic sky. He exposed for the highlights, pushing the film half a stop.

The resulting picture has Martin's hallmark on it, an exaggerated landscape composition, with interest in the foreground, mid-ground and distance. The eye is held within the picture; there is a slight tension between the church spire and the umbrella that gives energy to the figure. In these days of manipulation, where it is possible to cheat to make a picture more perfect, it is often better to be honest and use the disharmony of the composition.

*Canon EOS 1 17–35mm zoom/Kodak 100S pushed half a stop/Epson paper with Lyson ink*
© Martin Brent

### 'Baba's Smoking Hand' by Justin Pumfrey

Justin has been to Bombay several times. The hand belongs to Baba, who has a pitch on Prince of Wales Drive where he will weigh passers-by for a few rupees. Justin sat on the wall and shared a cup of char and a talk with him. He photographed while Baba worked. He took some head shots but was soon drawn to the hands – a subject he has photographed many times. The picture was taken with the lens wide open, to ensure a clean background.

When Justin got back home and looked at the picture he thought there was something lacking, so he added the smoke from a picture of burning incense, to make the composition complete. The two images were drum scanned and comped together in Photoshop, and a sepia tint rather than a tone was added. It was amazing how much detail and information there was in the neg. when it was drum scanned. This picture is on the wall of Justin's home. It reminds him of many things: Bombay, happy times and people. He even gave a copy to Baba, who loved it: 'Mr Justin, you number one photographer.' A camera and smiling face are a passport into Indian life.

*Nikon F4 Nikon 85mm F2/Ilford HP5/Epson paper* © Justin Pumfrey

### 'Rowan Atkinson' by Chris Cormack

Chris Cormack photographed about 100 people in their favourite room for the *Observer* magazine. Most chose a predictable room, such as the sitting room, so it was a delight when Rowan Atkinson suggested a newly finished bathroom which he loved. Bathrooms are usually cramped and have mirrors that reflect the lights. After five rolls of him in his trousers and sweater, Chris pleaded with Rowan to put on the bathrobe that was hanging on the door. He reluctantly agreed and was further persuaded to take off his shoes. Now this was the shot. Persistence paid off.

This is technically quite a difficult picture to shoot. There are no light reflections in the mirrors or window – the flash exposure is balanced perfectly with the daylight outside.

All the work is done before the sitter comes in – in this case while the subject was being interviewed – so you can concentrate on capturing the personality of the sitter. The whole shoot took about half an hour.

White ceilings make so much difference when photographing rooms. The light can be bounced off them – as long as the ceiling is not in the shot. Silver reflective material placed on walls or behind chairs can help increase the light level.

The first five rolls were not wasted. Preliminary shots help develop a rapport with the subject – they are relaxing, you are getting them to a position where they will do what you ask them. And all the time you are tweaking and adjusting the shot.

*Nikon FE 20mm on tripod/Kodachrome 64 lit with Bowens 1000 Monoblock*

© Chris Cormack

# Portraits

There is more to a photographic portrait than a likeness. A good portrait should be an interesting picture on its own account, regardless of who the subject is. Even if you have a limited amount of time with the subject, in most cases it's enough to produce a good image. Once in a while you'll get something special: a picture that says more about that person and their life. At another level, a great photographic portrait can rightly be classed as art.

A portrait needs human interest. It needs to show character, something about the subject, their work or enthusiasms. Ninety-nine per cent of portraits are probably of the face, but there are great pictures which break away from this rule – pictures of a boxer's fist or a ballet dancer's foot.

Portraits can be done in a variety of contexts. An environmental portrait shows the subject with the trappings of his life – the shepherd with his flock and sheepdog, the writer at her desk, craftspeople with their tools and so on. It can be taken out of doors, at the subject's workplace or home, any location that says something about that person.

For a candid portrait the photographer generally has no control over the situation but must wait for a movement, gesture or expression that says something about the person and makes the portrait.

A controlled portrait shows a person in a flattering light, with make-up, clothing and props geared to bring out the best in the subject. Some people can perform well in front of the camera. If they feel comfortable, just let them get on with it and keep taking pictures. Others need cajoling to get the right shot.

Before you start a controlled portrait, decide what you feel about the person and how you want them to be seen. Do a little homework. Try to make a picture that says as much about the person as it can. This might involve a creative trick or use of technology. The technology must be relevant to the subject, though, not just a gimmick.

Lastly there is the snapshot portrait – the kind we all take. Snapshot portraits are personal and simple. Everyone identifies with them. They are usually spur of the moment pictures that hold our memories. Make the composition as good as you can in the circumstances, though, remembering to fill the frame.

With any portrait the subject makes only 50 per cent of the picture. The other 50 per cent is the photographer. A portrait photographer needs to have empathy with people, needs to care about what he or she is doing. Successful photographers are usually interesting, intelligent people themselves. If a picture looks boring it may well be the photographer who is dull, not the subject. The personality of the photographer makes a difference to the way the subject reacts to the camera. One of the most relaxed of all the millions of photographs of the Queen is the one taken by Prince Andrew, her natural expression is of a mother being photographed by her son; a warm informal picture.

If you are photographing someone well-known, look for something that hasn't been seen before. Top people haven't necessarily got where they are by being nice. Find out what lies behind the mask. At a photo call, wait until the end. With luck, the person might drop the public face, revealing a glimpse of the individual within.

Although portrait photography is skilled work, the best results can be deceptively simple. Having plenty of equipment is useful, but in the end you can take great pictures with a simple camera. An effective portrait often springs from reality – a person going about their daily life. Some portraits work just because of the subject: for example, it would be hard to take a bad picture of the Rolling Stone Keith Richards.

Conversely, pop icons of a more recent vintage – encouraged by their teams of agents – make it increasingly difficult to publish interesting portraits via the veto of picture approval.

**William Boyd**
I have photographed novelist William Boyd several times for his publishers and for *Madame Figaro*. It is a pleasure to take a portrait of someone who understands it's in their own interests to get a good picture. They are prepared to put in as much as you, and a 50:50 partnership will always gets results.
*Mamiya RB67 140mm macro/Agfa APX25  Elincrom light with large soft box*

# Lighting

The correct light is crucial to a successful portrait. Portrait painters have the advantage over photographers in that they can look all around the subject's face, see it in different lights and at different times of day. This helps them show the bone under flesh, the body under the clothes. It allows them to make the face look real and human. Portraits painted from photographs look flat and don't get under the skin in that way.

Painters such as Rembrandt, Vermeer, Gainsborough, Reynolds and Sargent were all experts on lighting. At first glance their paintings may appear to have just one light source, but look closer and you see several, revealing the way the painter has seen all around his subject.

**Master of St Cross, Brother of the Order of Noble Poverty and Brother of the Hospital of St Cross, Winchester**
The setting is very important in a portrait – the props, the background, the atmosphere. After I had done a recce a week before, I could see the finished picture in my head. On the day of the shoot the two brothers arrived. Sometimes luck is on your side. In their robes the three men looked as if they had stepped out of a sixteenth-century painting. Setting up the picture, I stood the master on the left, the chair positioned to give him something to do with his hands. The two brothers were on the right, sitting and standing just to vary the composition. I wanted to keep the muted colours so I lit the group with one 5ft-diameter hood on a high stand, so the light fell away before it reached the background. It was nearer the master so it would hold some detail on his black robe. A small light was hidden behind the seated men, to light the wood panelling. I exposed for the faces and used a slow shutter speed so the daylight registered in the stained-glass windows. There is a bag of money on the table, which I purposely kept dark. I wanted the viewer to explore the picture, rather than have all the information available at one glance.
*Mamiya RB67 65mm. The best print of this picture was an Iris print on water colour paper. The matt finish helps the picture, it interprets the atmosphere and gives it the feel of an old master painting.*

# Controlled portraits

A photographer has to be prepared to be a chameleon, to change as the situation demands. Be ready to tell stories, ooze charm or even be dictatorial as needed. Usually, it is best to get on the subject's right side, but just occasionally a little cheek or confrontation can put people on their mettle, force a reaction and produce good pictures. Some prominent people can be haughty and difficult to deal with. Working for a famous magazine gives you some power. Mention deadlines, offer to come back another time, and they will usually climb down. One grand lady rushed in to me saying she could only spare five minutes for the session. I told her I only needed three, which took the wind out of her sails and redressed the power balance. And I did the shot in three minutes.

When you have to photograph someone and there is too little time to build the relationship necessary for a portrait, go for the stereotype and photograph the position: actor, lord mayor, managing director.

If you have a really difficult subject – no cooperation, no ideas – trust in the lighting to get you a picture.

**Christopher Morris**
This type of environmental portrait is an everyday job for a portrait photographer. I photographed mural artist Christopher Morris for a magazine feature on his work. I went to his studio while he was working and had a couple of hours to sort out the picture. It is rare to find your subject in a perfect photographic environment; you usually have to put it together. In this instance, the studio was crammed full of work and I used a higher than normal camera angle to make the background interesting. Once I had the camera set up, I moved things into the frame and got the lighting right with my assistant standing in for the artist. I used a spotlight to give a highlight to his head, rather in the same way as a painter puts a dash of white on a face. Once everything else was ready, Christopher came in and adopted his own pose. The impression of the picture is that I've just walked in and interrupted his work for a moment. In fact, the picture was carefully set up.
*Mamiya RB67 65mm/*
*Kodak EPP*

### Waitresses in Ed Debevic's, Chicago

I was photographing a travel feature on Chicago for a London-based magazine. The restaurant typified the city and the staff were so obliging when I asked them if I could photograph them: they posed without prompting; I just clicked the shutter. Being photographed was a welcome relief from serving customers. It was fun, and it shows.

It was lit with two portable flash units. The side light was raw, highlighting their hair and holding them off the background. A soft box on the front of the girls was balanced with the ambient light of the restaurant.

*Nikon F4 85mm/Kodachrome 64*

### Donald MacDonald

This was taken for a story on Harris tweed. Donald MacDonald was the gamekeeper of a large estate on Lewis and had worn this tweed suit for his work for more than twenty years – the perfect material for the job, he maintained. He took me to one of his favourite places on the estate and went to work checking on the deer high in the hills.

*Nikon F3 200mm on unipod/Kodak Ektachrome*

# Candid portraits

Candid portraits may be taken in the street, at a public gathering, a family occasion, anywhere. The subject does not have to be prepared or even aware the picture is being taken. You may need to shoot a lot of film to achieve the candid picture you want, or you may get it in one frame.

If you want to take a candid portrait of someone you don't know, just ask. Most people are flattered. Some say no, and that is their right, but on the whole people respond well if they see you are serious. Have everything ready before you ask. If they say yes, get

on with it right away before they change their mind or get bored.

When you're taking a candid picture but feel something is wrong, such as their clothing or the position of the subject, don't start making changes right away. Take some pictures first and establish a rapport, then make the adjustments once the ice is broken. Relate with your subjects and you'll get the best out of them. If you're after a critical portrait, it's very easy to take a bad picture of someone when they're off their guard.

**Lord Hailsham**
The secret of the success of this candid portrait was simply having the patience to wait for the right expression, the right turn of the head. Lord Hailsham was appearing in a televised graduation ceremony at Buckingham University. TV lighting is very flat but, fortunately, I was able to find a position at the side of the stage where the light gave a little more modelling to the face. I used auto exposure so I could concentrate on watching for the picture. In this instance I had no preconceived ideas about what I wanted and no control over the situation. But when I saw the picture in the viewfinder, I knew I had a shot.
*Nikon F4 300mm on unipod/Kodak EPT*

**The laugh**
A photograph only captures an instant. There are very few, if any, painted portraits of someone really laughing; an enigmatic smile is all painters have managed. Capturing an animated portrait is what photography does like no other medium. Remember a few jokes – they will often get a reaction and a picture.
*Nikon F5 135mm/Kodak EPR Elincrom studio lighting*

**Re-enactment of the Battle of Bosworth Field**
You will always find portraits to shoot at an event like this, where people are dressed up and about to play a part and surrounded by interesting props. You are behaving as a street photographer – hunting for pictures, hoping and waiting for the right look. The banners, which attracted my initial attention, make a perfect backdrop for this pensive Henry VII.
*Nikon F3 180mm/Kodak Ektachrome*

**My family at Hell Bay**
To millions of people, this type of picture is what photography is all about. Pictures like this are carried in wallets, put on mantlepieces, stuck in albums and kept on cab drivers' dashboards. They are really important pictures, so they should be well-composed and correctly exposed. Take a little time to make sure they are the best they can be.
*Canon Ixus/Kodak Advantix*

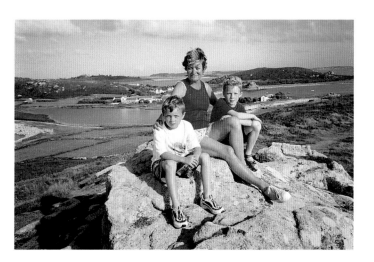

**Sarah's wedding**
*Hasselblad Xpan 45mm/Kodak Portra Nc 160*

# Groups

When taking a picture of a group of people a photographer needs to be even more in control of the situation than usual. The more people in the shot, the more likely it is that someone will have their eyes shut or be screwing up their face. Take charge, get their attention and try and get a group response. Imagine yourself walking into the room and taking all your clothes off – all eyes would be on you. That's the sort of attention you want.

Arrange the subjects first. Juxtapose one to another and try and fill the frame. Look out for clothing clashes. Placing people at different levels usually helps the composition, but watch the size of the heads. If using a wide-angle lens, the head closest to the camera will look noticeably bigger than one only slightly farther away; it exaggerates the differences. All the people should, therefore, be at a similar distance from the camera, unless you want to make one person bigger to emphasize their position or importance.

Ask someone to help you marshal the people and ask them for a few names of people in the group. Direct a few organizing remarks to them. They and the people nearby will be impressed that you know who they are, and will be more inclined to cooperate.

# Children

Taking pictures of other people's children demands the same approach as candid pictures of adults. Get them on your side so they trust you and feel happy with you. Giving children Polaroids to win their confidence is old hat now. Even letting them look on the digital screen soon tires them. Try doing a trick such as making a coin disappear. Enthrall them. In our current climate of distrust, people can be suspicious of a stranger's attentions to children. Be aware of this.

You can take pictures of babies but they won't cooperate with you. Toddlers and slightly older children will cooperate, but not for long. The best trick is to create an environment that diverts their attention so they forget about the camera. Light a big area so they can move around and still be lit reasonably. Remember that children are small, so any detail in the background can be more intrusive than in a photo of an adult.

In a studio session, ask the child to bring a favourite teddy. For a response, get teddy to take some pictures. Stand the parents behind the lens so eye contact is with them. Do or say something funny to make the children laugh rather than constantly asking them to smile.

To take a close-up portrait of a child's face, cover a sofa or chair with a sheet and sit the child down. Switch on the television and get behind it so the child is looking towards you, but not directly at the camera. With luck, he will become absorbed and forget you are taking pictures. Above all, when taking pictures of children, be patient.

**Carter's Steam Fair, Clapham Common**
*Nikon F3 85mm/Provia 400*
© Alan Newnham

**Beauty**

It is quite understandable that someone should want to look their best in a picture – like a model on a magazine cover. These days it is not so difficult; it is in the lighting and retouching, which was once the domain of a few skilled practitioners. With Photoshop and other computer software, many photographers have basic retouching skills. Here, the skin has been smoothed and any blemishes lost, the whites of the eyes cleaned up, the irises coloured and the outline of the lips defined. Hair and make-up artists contribute massively to making a flattering beauty portrait.

*Mamiya RB67 140mm macro/Fuji Astia*

# 'Make me look better'

Few people are completely happy with photographs of themselves (even if they accurately reflect how they look). The portrait photographer is usually required to make the subject look as good as possible.

The perfect heart-shaped face, with a small nose and widely spaced eyes, that always looks good in pictures, is rare. A large nose, a double chin or a bald head can be exaggerated by the camera. Such things are not normally so noticeable in life.

Most professional models have spent hours in front of a mirror and have seen many pictures of themselves so they know a slight raise of the eyebrows or dip of the chin changes the face. Other people generally move too much when they are in front of the camera. Don't worry if an expression looks 'over the top' through the camera. It will give the picture life.

Ask the subject to turn their shoulders away from the camera. This narrows the torso, stretches the neck and defines the face shape.

To prevent a bald head from dominating the picture, use quite a long lens, take the picture from a lower angle, and light it strongly from the side, not from the top. This will accentuate the eyes. To make a face appear less heavy, use a soft light, and ask the subject to look up – this stretches the neck and pulls the skin back to define the outline of the face.

A wind machine blowing out the hair makes people narrow their eyes and look sexy. The hero light – a single spotlight placed high up – is the only way to photograph people with reflective glasses.

Let people wear their favourite clothes. When people feel they look good, they are more confident. Even beautiful models feel unhappy in clothes they don't like or that they know don't suit them. A uniform usually makes people feel smart, but they are reluctant to relax.

Most people look good photographed in a black T-shirt. The lack of reflected light reduces jowls and makes the face stronger. A black roll-neck sets off the face, like a vase does with flowers, and helps present the subject in an unfussy way. Young people look good in a white T-shirt – the reflected light enhances a face that has nothing to hide. If you have blue eyes, wear a blue shirt to emphasize them.

Avoid strong horizontal lines and swamping colours or patterns. Shapeless clothes exaggerate a shapeless body and make people look heavier. A waist-ed jacket is much more flattering and gives the figure a good line. Make sure that clothing works with the background and is in harmony with the surroundings.

There are some clothes that can help a picture, even if they are not things the subject would normally wear. High heels, for example, add glamour and leg length. High-cut swimsuits also lengthen the legs. Expensive fabrics such as satin and silk add a touch of luxury.

For men, a red tie holds the attention and takes the viewer's eye to the face, while a white handkerchief in a dark suit pocket diverts the eye from the face.

If the subject is standing well, clothes look better. Get the feet right and everything else follows. Ask the subject to stand with the feet at a 45-degree angle to the camera, not straight on, and the rest of the body should look good.

Watch out for the hands. If a subject is posing for a long time, veins fill with blood and make the hands look ugly. At intervals, ask the subject to hold their hands up so the blood drains away.

Some people adore being photographed. Others hate it and have to be put at ease if the picture is to succeed. When dealing with someone who is uncomfortable, try and find out about them first. Talk and find some common ground. Offer to take the pictures at the subject's house. If this makes them feel happier the extra trouble is worthwhile.

Some people are photographed so often that sitting bores them. Others are wary and nervous. The session should be a pleasurable experience. Be friendly, use your charm and get the subject to relax. Chatting through the shoot helps them forget a picture is being taken. Some people find music relaxing, but be guided by the subject's taste rather than imposing your own. Other people see being photographed as a social event and like to have a drink – even first thing in the morning.

# Digital capture

This portrait was taken for a book called *One Hit Wonders*. Max Splodge's band Splodgenessabounds had had a hit with the comedy punk tune 'Two Pints of Lager and a Packet of Crisps' twenty years before, and the brief was to meet him in his local pub and photograph him as he is now. The whole project was shot digitally. The small format of the book meant that the file size the camera produced was easily large enough to ensure good-quality reproduction.

Shooting digitally offered a number of other advantages. Time was often an issue, so lighting and set-up usually had to be kept to a minimum. With the digital format no time is wasted reloading film, and if the exposure isn't always spot on, you have the leeway to sort it out on the system afterwards.

A softbox in the pub would have been too cumbersome, so the camera's ISO rating was set to 400 and the speedlight used as the main source of illumination, allowing the mixed lighting in the pub to provide for the background. Max started larking about and playing up to the camera, so it was easy to snap away. If an image didn't work, it could be deleted. As it turned out with this shot, the flash was a little heavy on the arm and face, but it was possible to tone this down using adjustment layers in Photoshop.

After shooting, the initial colour image was converted to black and white, then the contrast adjusted in different parts of the image – much as you would by dodging and burning a print. In the old days, when a client asked you to shoot in colour and black and white, you had to use two cameras and flashes. Invariably the best picture was on the wrong film.

**Max Splodge**
*Nikon D100 18–35mm/RAW file*
© Duncan Soar

# Computer-enhanced portraits

There are times when it's not enough to take a portrait in one sitting. A more interesting picture can be achieved in Photoshop or other computer software. You can make a picture mimic anything from a Rembrandt to a Picasso painting, to a line drawing or a caricature by using different effects. When using any computer technique it must be relevant and skilfully executed.

**The punk**
Making a caricature has always been the realm of cartoonists. However, with the wonders of digital manipulation, it can now be done by a photographer. This picture is made with two separate shots. The hairstyle and forehead belong to a man; the rest to a girl. Both were photographed with a wide-angle lens from a high position. The natural distortions of the lens have been accentuated, making the head much bigger than the feet. The mouth has been enlarged, and the shape of the head altered to match the scream. The background was painted in afterwards. All this was done in Photoshop. It was shot on film and drum scanned, but it would now be possible to create it completely digitally because the latest cameras capture much more information.
*Hasselblad 30mm/Kodak E100 S*   © Colin Thomas

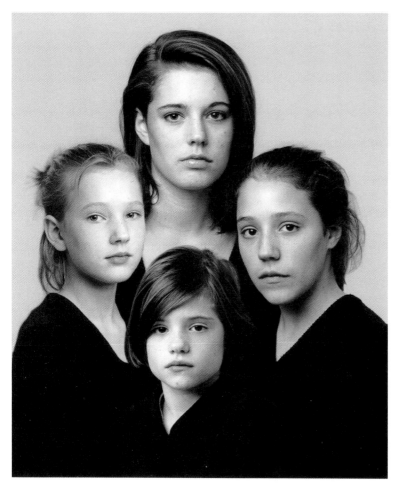

### Four sisters

This is a planned portrait. I knew what the finished picture should look like, a simple form of the film poster. The problem for a portrait like this is that you cannot get the faces close enough as a single group shot – there is too much space between the heads. Each girl was photographed individually and then comped together. The light source, a metre-square soft box, was the same for all the girls, but was moved for the two girls on the left and right. I wanted the outside of their faces to be in shadow, so the picture was bright in the centre.

For the finished picture I had to adjust the size of their heads to make it look 'natural', even though great care had been taken making sure they were the same distance away from the camera when they were photographed.

It was shot on film and initially put together using Polaroids. The negs were scanned and retouched and adjusted in Photoshop and then outputted as a poster on Lamda matt paper using colour inks.
*Mamiya RB67 180mm on tripod/ Ilford FP4*

### Charles Eddington, Professor of Biology at Cambridge University

According to the theory of flight, a bumble bee shouldn't be able to fly. With this computer-controlled model, Professor Eddington demonstrated why and how it does.

It was not possible to photograph him and the moving robotic bee: much easier to do this as two separate pictures. The professor was conventionally lit against a black velvet back-ground, to absorb all extraneous light. The robotic bee was lit both with studio flash and a tungsten spotlight. The flash froze the body and wings at the end of its cycle of movement. The shutter remained open for the full cycle – about 15 seconds. The wings, lit by the tung-sten spot, are recorded as a blur. The two images were scanned and comped together in Photoshop. The bee is slightly enlarged.
*Mamiya RB67 160mm macro on tripod/ Kodak EPR*

# Portrait masterclass

## HM Queen Elizabeth II

This portrait of the Queen was taken to commemorate her Golden Jubilee year. It is in the National Portrait Gallery.

I wanted to photograph her as Sovereign, the present holder of an ancient title. The symbols of monarchy were essential – the imperial crown, the sword of state, the royal coat of arms and the throne.

I initially photographed her in the Robing Room in the House of Lords, after she had delivered her speech at the State Opening of Parliament, an occasion that is timed to the minute and where everyone is on edge. I was given six minutes. The resulting picture was OK, but it was too formal. There was not enough time to develop a rapport; to have any control. I wanted her smiling and relaxed as befitting her Jubilee.

You don't often get a second chance to take a picture like this, but I was asked to do it again. This time, the Throne Room of Buckingham Palace was the location. The sword of state and imperial crown come from the Tower of London, the cloth on which they sit from the House of Lords.

The lighting was quite complicated. The picture needed a high light level in the dark area, and for the reds, without killing the detail in the white gown and gloves. The gold braiding and diamonds needed to sparkle. The crown was lit with a spot so the colour of the rubies, emeralds and sapphires would register. Another spot was angled onto the back of the throne highlighting the 'ER' motif. The Queen was lit by an Elincrom Octa 5ft-diameter soft box as close as possible without appearing in the frame. There was a 15ft arc of white sheets on camera right, and another white sheet on the floor between the camera and the red velvet robe acting as a reflector to knock out the colour of the carpet and keep white light bouncing around.

A lot of Polaroids were taken in setting up, considering the angle, etc., using the Queen's dresser as a stand-in. After the original sitting, I photographed several other people with the coat of arms, which I also photographed separately, both sharp and in various degrees of focus. Although correctly exposed, they were all too bright and would have been overpowering unless it was darkened. When the two images were being comped together it looked better to use an optically unsharp image of the background rather than to de-focus it in Photoshop. Being able to position the background perfectly in relation to the Queen was something that would have been impossible in real life. Cecil Beaton used a painted background of Westminster Abbey for his famous coronation portrait – would he have used computer technology if it had been available in 1953?

This was not a six-minute portrait – it was very relaxed and unhurried. This picture was selected, as having the right balance between the importance of the monarch and the warm humanity of the incumbent.

This is one of many portraits I have made of title-holders. I try to include four elements in them – relevant location, uniform, symbols and history. They are all in this portrait. Any professional photographer is honoured to be asked to photograph the head of their country. In my opinion, the best way to photograph anybody is to be yourself: you are just a photographer doing a job to the best of your ability. Don't compromise. Use a good and trusted assistant. Take a back-up set of lighting with new bulbs and check anything that has a battery – it's best to put new ones in. If something is going to go wrong, it will on a day like this.

*Mamiya RB67 with 6 x 8 back 140mm macro on tripod/Kodak EPR Ektachrome 4000 pack and Octa 2000 pack spotlight/chic pack and two heads on background*

# Family

When photographing your own family, it's often important to distance yourself and remain objective. There are of course occasions when a snapshot is perfect, but family milestones take a lot more planning. It is important to be both quick and unobtrusive. Don't expect them to be patient while you go off and find another piece of kit – you wouldn't treat your other subjects so offhandedly. When photographing your children use a long lens – an 80–200mm zoom – and just let them get on with it, without interruption. It is not unkind to photograph your children when they are really cross or upset, because they will laugh when they see the results later.

**Tuscan field**
Driving in Tuscany we suddenly came upon this field of wild flowers just crying out for a picture. My wife changed into a yellow T-shirt to go with the flowers. It was taken on an 80–200mm lens at 200mm to condense the perspective. Fortunately the sun was in the right place. It is not often that you see a stunning picture possibility from the car. If there is a chance of a picture, stop, get out and walk around.
*Nikon F4 80–200mm/ Fuji 100D*

**Birth**
There are occasions when it is impossible to become a detached observer. My son has just been born and is held for the first time by his mother. You know it's going to be an emotional experience, so make sure everything is set up beforehand: chosen angle, pre-set focus, meter reading and shutter correct and enough film. I did not want my wife looking at the camera – that would come later. The Leica is perfect for this type of photography: quiet, reliable, unobtrusive. The doctor and midwife were a little taken aback to see me taking pictures throughout the birth.
*Leica M6 35mm/Kodak Tri-X processed in Rodinal*

**Baby Rory**
My younger son was very perky after his bath. I set up two studio lights in the bedroom and bounced them off the ceiling to give an even light irrespective of the direction I was photographing from. He was free to move wherever he wanted to and I didn't have to worry about repositioning him.
*Nikon F4 35–70mm/Kodak Ektacolor*

**Sam's new shoes**
Sam was really proud of this pair of shoes and of having just started to walk. When I watched him, it reminded me of an old Start-rite children's shoes advert.
The white paper background is lit by two flash heads; the floor is made up of two 8 x 4 white laminate sheets, which pick up the light from the background to give a clean, bright surface. The slight sheen of the laminate results in a soft reflection with minimal shadowing.
*Nikon F4 35–70mm/Agfa 100*

### First day at school

A milestone for which I had had plenty of time to prepare.
Nervousness and excitement is evident in the faces of both boys.
*Mamiya RB67 180mm on unipod/Agfa APX 100*

### Holiday

Holidays are important to cement a family. Away from the daily
grind, everybody has time for each other. I always try and take a
definitive picture of each holiday. Here, I had to ask Clare and the
boys to walk along the path to the beach into the patch of sunlight
about five times.
*Nikon F4 80–200mm/Fuji 100D*

### Family reunion

It's rare to have such a large family gathering and it is important that everyone is visible so that it's a record of everyone who was there for years to come. Place everyone in units and choose a location where they are well lit but don't have the sun in their eyes. Remember to use a whistle to attract their attention when you are ready.
*Mamiya RB67 127mm/Kodak Ektacolor*

### Waterskiing

It's important to record events that are significant for your children: in this instance, Sam's first time on waterskis.
Let the children tell you what they want you to take.
*Nikon F5 300mm/Kodak E100S*

# Nude

Nude photography is not about sex. It is an exercise in form, texture and lighting. Unlike a pin-up picture, there is rarely eye contact between the subject and the camera. Often the face is not visible at all. Nude photography, like life drawing, is open to a wide range of interpretation. Good results come from very different approaches. I prefer to light a nude like a sculpture, conveying the muscle and bone beneath the skin.

Pornography is distinct from genuine attempts to be artistic, but there is no defining line. Some pornography is technically well photographed, and some 'fine art' nude photography is very badly photographed. *Playboy* centrefolds are technically beautifully photographed – but are neither art nor porn.

What you are trying to do is make the body look better than in real life. Choose a pose that hides imperfections and emphasizes good points. Use warm filters to remove blemishes. It is very important to chose the right sort of body for the picture you want to take; there is no point trying to hide ribs with lighting – better to use someone more curvy.

Nude photography is a really hard subject to get right – which is probably why so many photographers like to try it.

Very high heels are good for the leg shape. Even if the shoes are not in the picture they influence the shape of the whole body. The model shouldn't wear underwear for at least an hour before the shoot, so there are no tell-tale marks on the skin. A full-length mirror in the studio is helpful to reassure the model about the pose to be photographed.

If you want the skin to glow, use moisturizer. If the look should be matt, don't apply anything (although compact powder may be required for the face and shoulders). A slightly cool studio will give the skin goose pimples, which work well in black and white. Models generally go to the gym to maintain good muscle tone.

There are very few perfect bodies, so concentrate on the good features. With lighting and careful posing you can hide and disguise less favourable features.

The shooting angle is important. A higher angle will emphasize the upper part of the body while a lower angle will emphasize the legs. A wide-angle lens will emphasize or even distort the part of the body that is closest to the lens. Concentrate on getting the pose right first, you can leave the expression to the last. Look at the viewfinder, checking that there are no ugly conflicting details. Refine the pose: a turn of the wrist, a pointed toe or a slight lift of the shoulder will finally make the picture.

**Nude as sculpture**
This is an exercise in lighting and treating the body as if it were a piece of sculpture. The first thing to do is to look at the model from all angles. When you agree on a pose, ask an assistant to hold the light and move it around while you watch the effect. When it looks right, fix the light on a stand and fine-tune everything.

The picture was photographed in colour and desaturated in Photoshop. Working in Photoshop allows you to control tones finely and to explore the margins between black and white and colour.
*Mamiya RB67 180mm/Kodak E100G*
*Lambda print*

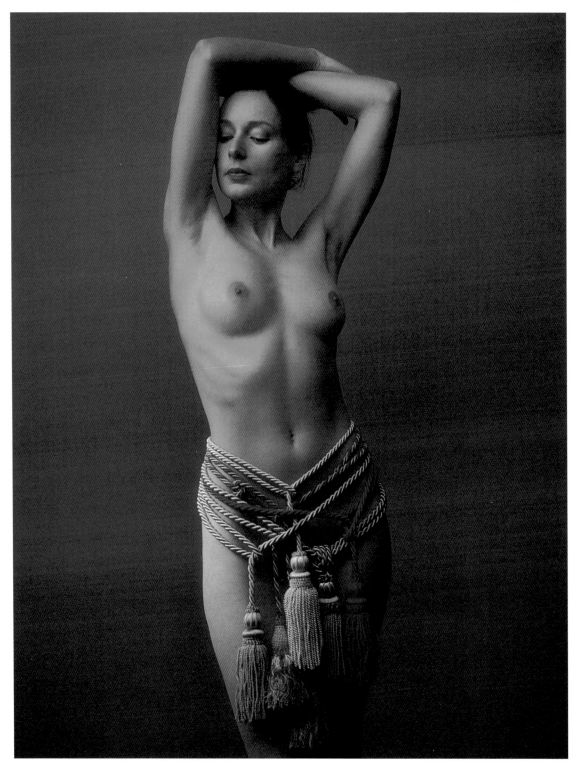

**Studio nude**
*Mamiya RB67 180mm with Softar 1 and 81B filters/Kodak E100*

# Nude in landscape

The nude in landscape is a subject many photographers have tried, because it combines a wide range of photographic subjects: form, shape, texture, contrast, scale and composition. It can be photographed on fast, grainy film or on slow, grainless film, and each is successful.

As in classic nude photography, the photographer is dealing with the shape of the body and the way light plays on its form. But the main point of the picture is to show the soft curves of the body and how they contrast with the texture of the landscape.

I had been to this location in Devon when looking for a place to photograph an ad for gas cookers. It wasn't right for that subject, but I knew it would be a perfect setting for a nude. The model was cho-

sen because she had long legs and is an actor. She understood how her body should relate to the rocks. The time of day was important for each picture, because of the tide as well as the direction of the sun.

All the pictures were shot on wide-angle lenses, to give just enough 'involvement' with the model, and emphasize her relationship with the contours of the surrounding rocks. The natural light did not present any problem in exposing the film, but I bracketed a stop either way in order to get the perfect neg. There was a considerable range of exposure between the highlights on the body and the details in the dark rock shadows. I shot on four different films, including infrared, to produce a set of pictures that could be reproduced in several different ways.

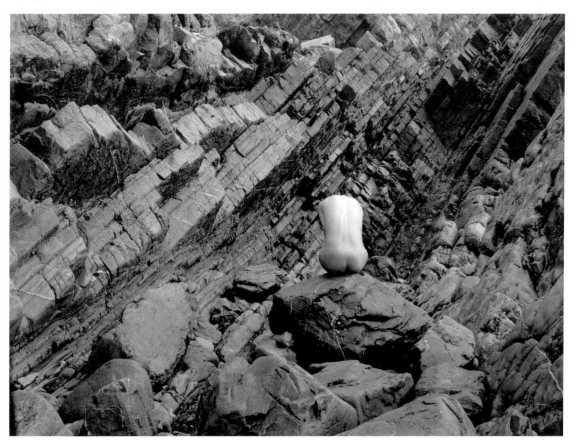

*Mamiya RB67 180mm on tripod/Agfa APX 100*

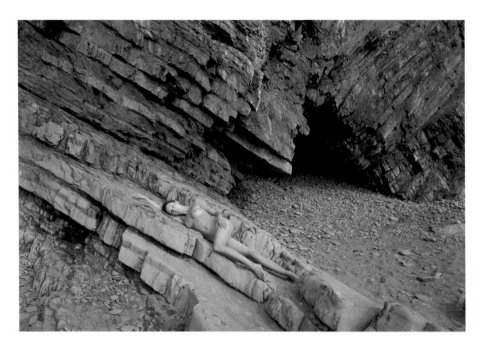

*Fuji GSW 690 II on tripod/Agfa 25 Lambda print Neg. scanned, body toned in Photoshop*

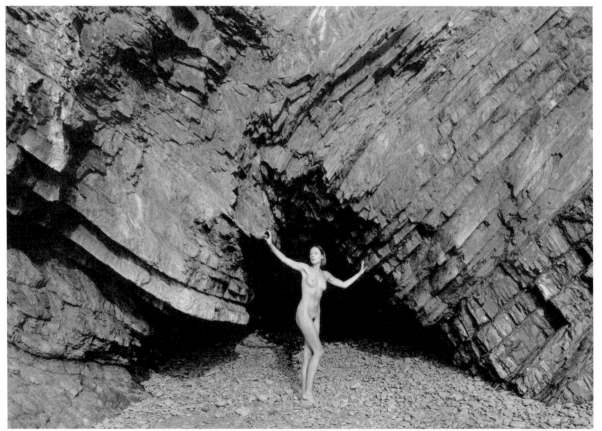

*Fuji GSW 690 II on tripod/Agfa 25 printed on Ilford Gallery*

# Landscape

A successful landscape picture is more than a beautiful view. It needs a strong sense of place and should capture mood and atmosphere as well as an impression of the scene. For me, a good landscape is a portrait of a place and as such should convey something of my feeling for it. A landscape must have a quality that allows you to look at it time and again, and still feel moved.

Only rarely will all the elements be there ready for you. More often, it is the human input and skills that make the difference. You have to make the picture by singling out a section of the landscape, trying different positions, waiting for a good light and choosing the right film, lens and filtration. Good pictures are usually the result of thought and planning, not luck.

Interesting weather adds character to a landscape. Bright sunshine and blue sky can look too much like a postcard – just a pleasant record of the place. The landscape photographer is always hoping for the magic light that makes a scene: the intense colour of light after a storm; dappled sun speeding across a field; the freshly washed look after rain.

**Near Glenlivet, Highlands of Scotland**
Taken for a story on whisky – water being an important ingredient. I used an ultra-wide 18mm lens on a very small tripod – almost on the ground. The purpose of the picture was to capture the clean clear drops of water within the landscape. Finding the right location was important so it could be as sharp as possible from a few inches to infinity while keeping the feeling of moving water. I took a lot of pictures here on various films and at various shutter speeds in order to find the shot I was after.
*Nikon F3 18mm with polarizing filter on tripod/Fuji Velvia*

The time of day makes a vital difference to the success or failure of a picture. Very bright light can make a scene look flat. Generally, you do not want the sun behind you but at right angles to create shadows and highlights and give form and shape to the landscape. As a rule, it is better to have the sun low in the sky than high overhead. But there are always exceptions. Late afternoon and evening light are warmer than morning light. But in midsummer and in hot countries the morning light can be hazy and pinkish, promising warm sun to come.

When you first arrive somewhere, weather and light conditions may not be right. If you have time, wait. The landscape doesn't change but the light does and, as it changes, it affects the shape of the landscape. On the other hand, if the light is right when you arrive in a place don't hang around. Such scenes are not static and that moment of perfect light may be all too fleeting. It helps to be familiar with the place you are photographing. I like going back to places I know well to take pictures in different seasons and weather.

A landscape needs a focal point to hold the eye in the picture, something like a tree, a house or a figure. A focal point can also give a sense of scale to emphasize the sweeping grandeur of a place. A wide-angle lens, such as 20mm, is good for providing a sweeping view while holding foreground detail.

**Farndale, North Yorkshire**
More often than not, landscapes are taken on a wide-angle or normal lens. Famous landscape painters never had the pleasure of looking at the world through a really long lens where the perspective is foreshortened and the elements of the landscape are stacked up on each other as they are here. Taken for one of James Herriot's Yorkshire calendars, the picture shows the whole dale.
*Nikon F3 400mm on tripod/Fuji 1000*

**Towards Bodmin**
High-sided hedges that obscure the surrounding countryside are a typical Cornish feature. As you drive along, you see fleeting views and glimpses of the countryside through gateways, so the gate is an important feature of the picture. Taken in high summer at midday with the sun behind the camera, I used a stepladder to get a higher angle so as to align the top of the gate within the field. Raising your viewpoint by a few inches can completely change the relationship of the elements in the picture.
*Nikon F5 20–35mm with polarizing filter on tripod/Fuji Provia 10*

For a graphic landscape picture, I look for leading lines such as hedges, rocks or fences to take the eye into the centre of the picture. Something in the foreground may make the picture – you may even be standing on it. Look at shape, form and texture and how they interplay; how much sky there is in relation to the land; how big the foreground detail is compared to the background. Move around and try different angles and positions. Moving just a few feet can alter the appearance of a landscape dramatically. Be aware of every millimetre of the frame as you plan.

Landscape pictures do not always have to be landscape format. Square and even vertical formats can work equally well. A square format lends a particular harmony, balancing foreground detail, mid-ground and background interest, and holding the eye in the picture.

Familiarity with the arsenal of photographic equipment can help the landscape photographer capture the essence of a place. Understanding the characteristics of different film, for example, is important. Fuji exaggerates blues, greens and yellows, and heightens reality. However, this can also make a picture look chocolate-boxy. Agfa has more subtle contrasts and is thus preferable in many landscape situations.

Black and white can work for landscapes when colour does not. A grey winter day can make a dull colour photograph but a successful black and white. Nowadays, electronic manipulation can get rid of unsightly pylons and poles that frustrate photographers. You can even add elements that are not really there.

**Uluru, Red Centre, Australia**

Martin Brent set out to shoot a sunset over the former Ayers Rock (it's illegal to shoot the sunrise side for commercial purposes, bringing a whopping A$32,500 fine). You have to have a commercial licence to photograph Uluru professionally and have to pre-arrange and attend a short course about its history and meaning to the Aboriginal owners. It's worth it.

A subject already shot thousands of times can be hard to tackle with any originality. Martin decided to wait until the sun had virtually gone. For just a few moments the sun will bounce back off the horizon, giving an effect almost like sunrise behind the now front-lit subject. He knew that the red earth would be enhanced by the very warm light and the bounce back would throw enough light back onto the surrounding landscape to prevent it blacking out, as so often seen on shots of the rock. It was a risky scenario as one cloud in the wrong place would ruin the bounce-back. A little bit of luck is often the secret ingredient of a great shot.

*Canon 1DS 17–35mm/RAW file to Apple Powerbook, running Capture 1 DSLR*
© Martin Brent

**Monterchi, Tuscany**

On holiday you can't always be in the right place at the right time – you sometimes have to settle for a great memory rather than a perfect shot. We had a lovely view of the Tuscan hilltop town Monterchi on our way to see Piero della Francesca's *Pregnant Madonna*. I wandered around until I found an even better view down a side track. I would have loved to have been there at dawn with the mist hanging off the ground and the first rays of dawn picking out the town.

*Nikon F4 80–200mm on tripod/Kodak EPP*

**Amhuinnsuidhe, Isle of Harris**
There are places where you have to go searching for pictures and then there are places where pictures are there wherever you turn. The Hebrides fall firmly into the latter camp. This picture and the one opposite are at either end of a favourite walk. I was carrying just one camera and a tripod when I came across this boat at low tide. There are plenty of textures, tones, shapes, leading lines and every element combines together to make the ideal black and white landscape. I used a custom-made 1-stop orange grad over the sky to hold cloud detail. The best print of this is an Iris print on watercolour paper.
*Fuji GSW 690 on tripod/Ilford Pan F*

**Birmingham car park**
Landscapes are not necessarily pictures of wide-open plains with distant mountains. There is also the urban landscape, familiar yet often unnoticed by most people who live amongst it. A multi-storey car park is not a place of romance and beauty, but even the most forgettable location can have a photographic charm. Here, the photographer has enhanced the monochromatic nature of the structure by adjusting contrast in Photoshop. Shooting it devoid of cars, removing the purpose of its existence, allowed him to focus on the elements of the design.
*Canon 1DS 28–70mm/RAW file*
© Martin Brent

**Uig, Isle of Lewis**
I have photographed this location on several occasions. For this picture, I shot it three times in one day and comped the images together. The first picture – the left-hand side and the waterfall – was taken at about 10.00 a.m. The sky and distant background is from midday and the right-hand side from about 6.00 p.m. Several further layers were created in Photoshop to highlight areas of sunlight and some extra patches of heather were added to the foreground. Having this control allows you to create the picture as you imagined it.
*Fuji GSW 90 on tripod/Fuji Velvia*

The grandest landscape can seem hopelessly diminished once translated onto a tiny piece of film. A long lens such as a 300 or 400mm compresses the perspective, so the individual elements are banked up and appear closer to the viewer. This increases the sense of vastness, especially if there is something there to give scale.

Filtration is a useful tool in landscape photography to control the sky and get rid of unwanted elements in the foreground. A polarizing filter can separate what is lit in the picture and what is not.

A tripod is another essential. Often, the landscape photographer needs to use slow shutter speeds, slow film and a long lens, which is impossible without a tripod. Using a tripod also allows the photographer to establish a position in the place and helps create a better relationship with what is before the camera. And if you have been walking and carrying heavy equipment for a while, it takes time for your heartbeat to slow down and your body to steady once you stop moving. A tripod gives the stability you need.

A final equipment tip – if you can, carry a stepladder. Sometimes, just being able to get a couple of feet higher can allow you to get a better angle than you had before and avoid tension elements in the composition of the picture.

A landscape photographer needs a warm coat, good boots and a lot of patience. Be prepared to walk quite a distance – the good shots are not always waiting ten paces from the car. Most successful landscape photographers are keen walkers and climbers who are prepared to carry their camera equipment with them all day.

# Landscape masterclass

## Swaledale from Crackpot Hill, North Yorkshire

For eight years I photographed the Yorkshire Dales for the publishers of the James Herriot books. I knew the area and this view very well, having walked and driven around the Dales in all seasons and weathers. As a general rule, most of the best pictures had come from leaving the car and walking, but in this case the view is right from the roadside – not even a wall to climb over. Many of the best pictures also happened when there was interesting weather, after rain (which there is a lot of), or in the early morning or evening when the low angle of the sun gives the undulating hills and farmland three-dimensional moulding. It was these conditions that achieved a sense of place. The midsummer, midday, brightly lit landscapes, although pleasing, looked too bland.

I woke up early this particular morning to see everywhere was covered with the first dusting of winter snow – the weather forecast had been right. I went straight to the location and set up. I took a few shots as insurance, then waited for sun to light up the valley, but before it had enough heat in it to melt the snow.

I shot in both black and white and colour, no filtration in black and white but an 8IA in colour to correct the blueness of the snow, especially in the shadow areas. Both images were fine, but the graphic shapes of the barns are more pronounced in black and white, and your eye goes on and on down the valley picking them out.

The neg. was scanned in CMYK and outputted as an Iris print on art paper. A little work was done in Photoshop to level out the contrast in the shadows and far distant hills – rather as it would have been painted in with a bromide print. The framed result looks very good on the wall. It is one of those images you can look at afresh from time to time and see something new in it.

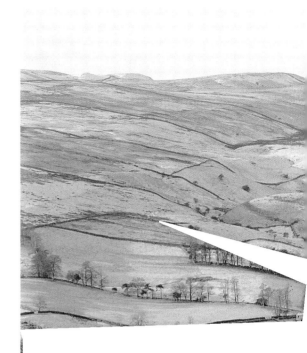

*Fuji GW 690 II on tripod/Agfa 25*

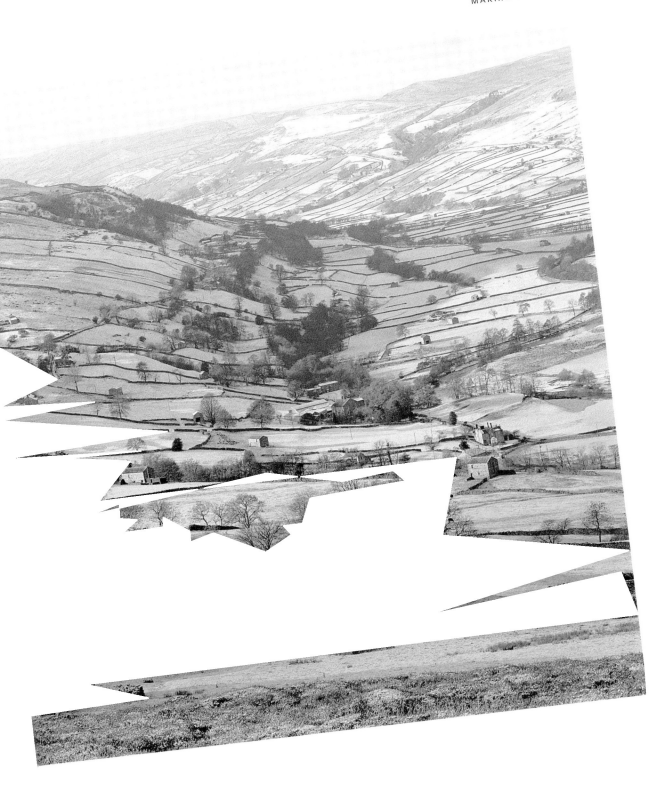

# Travel

For most people, travel equals holiday. They want to come back with a few choice images that sum up their trip. There is a difference, though, between taking pictures on holiday and being a travel photographer. There is no reason why you shouldn't take good pictures on holiday, but you don't have to be a slave to the camera. Travel photography on the other hand is not a 'holiday'; it is hard work. If you get up early and stay out until it's too dark, hanging in there even when there seems no picture to be had, something will happen. The clouds will part; a magic light will turn the commonplace into something dramatic; a perfect face will appear in front of the lens or you will stumble on an unexpected detail. You will be rewarded: its in the script. Good photographers create their own luck.

Pictures may feature a magical land of exotic sunsets and glorious landscapes, or the horrors of extreme poverty and dirt. They may be romantic and glamorous or show a harsher reality – the contrast between an advertising approach and reportage. Photography can sanitize images if you want it to. A shanty town can be made to look quaint and colourful when you can't see or smell the squalor inside the houses.

I think that too many travel pictures perpetuate myths and clichés. There are endless pictures of Ireland showing a donkey and cart on a lonely road passing a white, thatched cottage. Such scenes don't really exist except in the imagination of the travel industry. Everyone has seen pictures of the soaring Hong Kong skyline with a red-sailed junk in the foreground. You can hire that junk to be there for £500 an hour. It's the only one.

I do try to be truthful about a place, but sometimes I want to control as much as possible – organize people to be in the right place, wearing the right clothes.

Photography does increase your powers of observation. It makes you look properly at what is before you. The more I travel, the more I find that it is the similarities in different parts of the world that interest me rather than the differences. A plough I saw being used by a farmer near Meknes in Morocco looked exactly like one in the Swat Valley in Pakistan. The two farmers could never have met, but the ploughs are the same because the work is the same. A carpet dealer I photographed in Istanbul was so like a Chinese jade seller in Hong Kong and both were little different from a camera dealer on 42nd Street in New York. The delight about travel is the realization that we all belong to the same world, have the same joys and problems. Remembering this helps you get on with people all over the world, and good human relations makes for good photography.

It is best to be an independent traveller if you really want to take great pictures. You need to be able to make your own schedule, be free to get to places

**Library of Celus, Ephesus, Turkey**
*Nikon F3 28mm/Kodachrome*

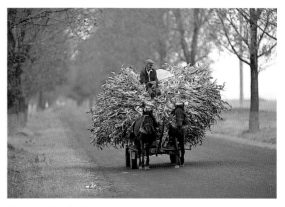

**Harvest time in Romania**
*Nikon F5 300mm on unipod/Fuji Provia*

Twelfth-century stonework,
the Nunnery, Isle of Iona, Scotland
*Nikon F5 35–70mm on tripod/Fuji Velvia*

Call to meditate, Chiang Mai, Thailand
*Nikon F5 35–70mm/Kodak EPP*

Grave of a patriot, Boston, USA
*Nikon F4 35–70mm/Kodak EPP*

Houses in West Tisbury, Martha's Vineyard, USA
*Nikon F4 35–70mm/Kodak EPP*

first thing in the morning or late in the day when the light is right. Bus tours are not conducive to good photography – especially when the guide takes you to his cousin's shop or restaurant for two hours! A photographer needs to be able to take his time, wander about and discover the pictures that are always there if he has the patience to look.

Read up on your destination beforehand. Look at magazines such as *National Geographic* and flick through travel books in the shops to get an idea of the photographic possibilities. Browse the internet for up-to-date information and to make local arrangements in advance. Be prepared to spend money to get the pictures you want. Splash out and hire a cab or a driver for a day to get to more inaccessible places than you could on public transport. Get the necessary jabs, and take a basic first-aid kit.

When on a travel assignment, go when the light is clean and humidity low. It often helps to go off-peak before the seasonal hordes of tourists. Get up early, work late and rest at midday when the light is too glaring for photography. If you are travelling on your own, keep the hotel informed of your movements. Ask for a room with a view – it doesn't always cost extra – and whether you can take a look at the view from the hotel roof. Learn to introduce yourself in the language of the country you're visiting – it helps break the ice.

As with street photography, don't waste time on the move, but pick a good location and wait for pictures to happen. Sometimes you are in a fortunate position, surrounded by picture opportunities. Don't panic! Take a long, hard look and go for one of the possibilities, then move on to the next. Remember that detail often says more about a place than the whole.

Sometimes it's best not to look like a photographer. Be wary of carrying silver flight cases, which may attract the attention of both officials and thugs. If you are travelling over bumpy roads, don't let the driver stow any equipment in the boot. Have everything with you, on your knees. Security X-rays at airports don't generally harm film – only ask for film to be hand-checked if the equipment at an out of the way airport is antiquated.

Applying photographic disciplines helps ensure that you obtain memorable pictures. Finally, whether on holiday or assignment, aim to capture more than just the postcard view: strive for a picture that has soul.

Travel photography is about people, where they live, what they do, what they wear and eat and how they enjoy themselves. It is also about landscape, buildings and history – all reasons to travel and take pictures. I know photographers who take the same subject wherever they go. One photographs wild grasses in black and white and another the shop fronts of food stores with all their goods on display. Travel truly has something for everyone.

**Summer evening, Thwaite, North Yorkshire**
*Nikon F4 85mm with polarizing filter on tripod/Fujichrome 50*

**Abandoned
garage,
Lake District**
*Nikon F3 50mm
on tripod/
Kodak EPP
lit with
Metz flash*

**Cliffs of Moher, Co. Clare, Ireland**
*Nikon F4 20–35mm/Kodak EPP*

**Mont St Michel, France**
*Nikon F3 300mm on tripod/Kodak EPP*

Using a high quality digital camera such as the Canon 1DS for travel assignments can make a lot of sense. Travelling with film has always had its risks and difficulties – from early X-ray machines to heat exposure and humidity, as well as the sheer bulk of roll upon roll of film.

However, digital also has its drawbacks, one being the technology itself. Electronic things go wrong and fail, they don't like hot, humid or cold conditions, so a great deal of care must be taken and you should always carry a spare camera of the same or similar resolution. Cost, is of course, a consideration: a couple of digital SLRs is a huge investment in an area that traditionally doesn't pay that well.

Power-digital cameras use up their power supplies very quickly indeed, so you must charge plenty of packs before you leave. You cannot always guarantee a power supply to recharge your cameras – although a power inverter which plugs into a car cigarette lighter socket gives you a 13 amp power socket, and is useful to carry.

As with all expensive cameras, you will always attract a lot of attention in poorer countries. Be aware that your camera alone can represent years of earnings for some, so do all you can to make your kit look old and tatty (without actually damaging it).

Several 1GB-minimum flash cards are a must. 1GB equals approximately 36 shots on the RAW

**Festival, Menorca, Spain**
*Nikon F5 80–200mm/Fuji Provia*

**Papa Ouzo cheers**
*Canon DS 17–35mm/*
*RAW file © Martin Brent*

setting and you will not always have time to transfer the data to a laptop before the card is required again. You can get CF cards up to 8GB now, but these are not recommended, because you don't want to lose up to 300 images should the card ever fail or get damaged. Always keep your shot CF cards separate from the main kit bag: in the event of losing the bag, at least you won't lose what's already been shot.

It's good practice to spread a shoot over more than one card, back up as soon as possible to the laptop (if not shooting tethered), and burn everything to CD as RAW files every evening of a shoot.

The one big advantage of shooting digitally is you can show your subject their image immediately, which builds huge rapport where no common language exists. People all over the world break into a huge smile when they see their image on the LCD. For building bridges you can't beat it.

# Travel masterclass

## Choiseul, St Lucia

This picture for the St Lucian Tourist Board came about because I did my homework. It is a typical travel photographer's shot, aimed at conveying a sense of place. One of the jobs of a commissioned travel photographer is to encourage people to visit or learn about new places.

I had a good driver and guide who had extensive knowledge of the island. I wanted to get away from tourist haunts and to see ordinary St Lucians going about their daily lives. Charlemagne picked me up at about 4.30 a.m. and we drove to the south of the island, arriving at dawn. The men were pulling in the net on the beach, but had only a few fish for such an early start. People went on their way and a few went to the village boatyard for a smoke and a chat.

The clean, bright light of the early morning sun was perfect for the colours of the boats, trees and sky. I was glad I didn't leave after the catch. A picture was happening in front of me. All I had to do was position myself in such a place as to make a balanced, peaceful composition, to reflect the mood. There was not a tourist in sight. I used Kodak E100 VS, a film that saturates the primary colours. The colours could also have been enhanced in Photoshop, something the holiday companies regularly do for brochures.

*Nikon F5 20–35mm zoom with A2 filter/Kodak E100 VS*

# Expeditions

This is serious travelling: trips to mountain ranges or the poles, trekking in wild landscapes. Such expeditions usually appoint a photographer, whose responsibility it is to take pictures and record the trip – even when most members have a camera.

It is vital on such journeys that everyone understands that taking pictures really is the photographer's main function. It is more important than taking his turn at the washing-up or erecting tents. The other members of the expedition may resent him at the time but will thank him for his dedication later. An expedition photographer needs to be very organized and has to be able, sometimes, to dictate what people do for the sake of the pictures. He needs a strong personality and the tenacity to follow the job through, even in the most difficult conditions. Sometimes the route of the expedition may have to

be changed for the photographs. When a special landscape epitomizes the trip, the photographer may have to demand that the schedule be slowed down in order to get some once in a lifetime pictures.

Plan ahead and decide what pictures you will definitely need to take: a breathtaking establishing picture with the 'wow' factor for the armchair traveller, portraits of people such as the cook and leader going about their tasks, pictures of members of the expedition wearing or using sponsored products in dramatic backgrounds. Remember you will probably want about 60–80 pictures if you are going to give a lecture – a whole Kodak Carousel. Take great care with captioning, and log details every day. Even after only a few weeks, details of pictures can fade from the memory.

**Crossing the river**
Taken on a three-week trek across the central Zanskar Plateau, finishing in Leh in north-west India. The plateau can only be crossed in late summer, when you are able to cross the braided river in relative comfort. There was a routine: up at dawn, have breakfast and off, leaving our two guides to pack up the mules. They would catch us up in mid-morning and we'd walk for six hours. Such a vast landscape, at altitude, demanded a picture that showed the scale and terrain.
*Widelux/Kodak Ektachrome*

**Mani stones**
We would walk past these mounds of lovingly engraved stones in the middle of nowhere. Buddhist tradition holds that they should always be passed on the left, so on the return journey, you will have circled them completely, in deference to the wheel of life.
*Nikon 24mm/ Kodachrome 64*

As an expedition photographer you are responsible for the cameras. Never let them out of your sight. If they need to be loaded onto mules, you load them. Make sure all your equipment is robust and well packed at all times. Don't overload yourself. A shooter vest and pouch can be more practical than a camera bag.

You will need several lenses, including one long lens and one wide angle, and a reliable flash unit. On this trip, the four of us took Nikon camera bodies and we shared a range of lenses. We walked with just a small camera day-pack and pouch. If possible, add a tough, reliable compact. You can take it to the top of the mountain when you might not be able to carry anything else. Take plenty of film and batteries. If you are in cold conditions make sure the batteries are kept warm. If dust is likely to be a problem, pack equipment in hermetically sealed cases. The Royal Geographic Society in London and equivalent organizations in other countries are usually happy to advise people embarking on expeditions. They also sometimes hold seminars on expedition or travel photography.

Think about any special conditions you might encounter. For example, do not take electronic cameras to very damp atmospheres or underground. Keep pictures simple and direct. Every shot should have a purpose. Show how hot or cold the weather is and the difficulties it can impose. Above all, don't let physical discomforts get you down or spoil a location for you. Not until you have experienced the extremes of hot, cold, wet and exhaustion, and survived, do you realize that it wasn't that bad after all. Pack a treat for yourself – something sweet like a tin of peaches – as a reward. Be positive about the conditions and you will always find something to enjoy – and something to photograph.

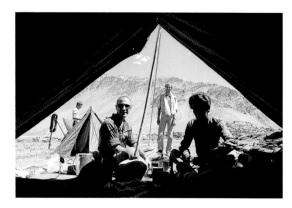

**At camp**
We always tried to find an attractive campsite, even if it meant we stopped in mid-afternoon. There was no point pitching a tent in the dark (because we couldn't take a picture!). The people have been carefully arranged but told to look natural.
*Nikon FE 24mm/Kodachrome 64*

# Cities

Cities are huge subjects. They combine travel, street and architectural photography, all of which require a wide range of skills, which are covered elsewhere in this book. Pictures can show streets, buildings, people – preferably a mix of everything. Essentially it is the atmosphere of the place you want to capture. Look for a symbol that says where you are – two city gents having a pint in a Victorian pub; a nun dashing across a cobbled street in the Vatican – such pictures can capture something of the particular spirit of a city. Every city has at least one iconic building: Paris, the Eiffel Tower; London, Big Ben; Moscow, St Basil's Cathedral. New York had the Twin Towers. One reason why their destruction on September 11th was so traumatic even to people who have never visited New York was the power of that landmark to convey the thrust and pride of the city.

The challenge for a city photographer is to take a picture that is not a postcard-style view but a personal interpretation. If the iconic locations defy reinvention, look elsewhere for something of particular interest to you, such as a lesser-known building, a market scene or a close-up of city life.

There is something going on in a city twenty-four hours a day. Plan your day so you can take pictures of your different subjects at the right time in the right light. When you first arrive, get your bearings. Find out about the place, what is happening and where. Check what times markets start, where the shops are, the cultural events and historical locations on offer, where people go at night. Have clear aims in mind and pursue them. Avoid tourist sights

**Blanche metro station, Paris**
I wanted to cram as much as possible into the picture for a story on art deco. It needed bustle and symbols in it rather than to be just a close-up of the metro signage.
*Nikon F2 135mm/Kodak EPP*

**Bank of England, City of London**
There is a mythology surrounding the Bank of England; it is in the news so regularly. The very low angle has made the doors look as if they belong to an impregnable building and the reflected sunlight has picked out the bas-relief that is not normally noticed.
*Nikon F3 20mm/Kodachrome 64*

**Tiananmen Square, Beijing**
A very dusty city in the autumn, and this is one way of dealing with it. Every city has its quirky problems – too much traffic, smells, not enough space – but people adapt and get by.
*Nikon F4 80–200mm/Fuji Provia*

**Michelangelo's *David*, Florence**
Museums and cultural activities are often at the centre of city life. For many people, they are the major reason for visiting a city. The top light on Michelangelo's *David* makes it look so alive, it is hard to believe it is marble. My pictures give me more pleasure than postcards or books on sculpture.
*Nikon F4 135mm/Fuji 400*

– you will only see visitors there, not locals. If you want to photograph a place that is popular with tourists, go at dawn.

Don't forget your own city – you don't have to travel far to take city pictures. You may even get a better picture of a place if you know it well, although over-familiarity can make you blind to the wonders around you.

By photographing digitally you are able to control the difficult colours of night-time, and readily adjust for brightness and contrast.

Be ready to take the unplanned picture that leaps to your eye, but make time for a planned picture, for which you may need a heavy tripod and special lens or a particular camera. Changes of lens and viewing angle add a vibrancy which mirrors the bustle of city life. Work with the graphic elements and juxtaposition of shapes, but remember that cities are about people. Once you put people among the graphic elements, the pictures come to life.

Downloading a number of images onto the computer and comping them together can be an interesting way to convey a city's varied history and its life. Done well with several contrasting pictures, this is often more effective than a single image.

Whether photographing abroad or on your own doorstep, pre-planning is the secret for good city pictures. Browse guide books and the internet, so you know when and where to go. Then keep your eyes peeled once you get there.

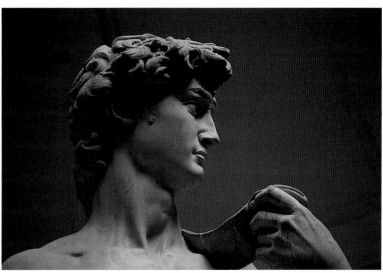

**Imperial Palace, Tokyo**
It is announced over the radio and on TV that the cherry blossom is perfect and a slight wind will blow it off the trees. Many people dress in their traditional clothing and take time off work to go and see it. Here, the gardens of the Imperial Palace are a magnificent sight. Plan to be in the right place at the right time. The composition, with the boat looking small at the bottom of the picture, gives a sense of scale.
*Nikon F4 80–200mm/Fuji 100*

**Lake Michigan, Chicago**
Brunch on the day of a Chicago Bears game. When I looked through the viewfinder at this picture, I was instantly reminded of Henri Cartier-Bresson's picnic on the Seine – an iconic image. In such a visual world, it is hard not to be influenced by remembered pictures.
*Nikon F4 35mm/Kodachrome 64*

**Sydney by night**
This was shot from the Sydney Harbour Marriott, looking across the city to the financial district. Exposure was a good 5–10 seconds at a 100 ISO setting. Increasing the shutter speed wasn't really an option, as noise does become a problem with this kind of subject.
*Canon 1DS 17–35mm/RAW file*
© Martin Brent

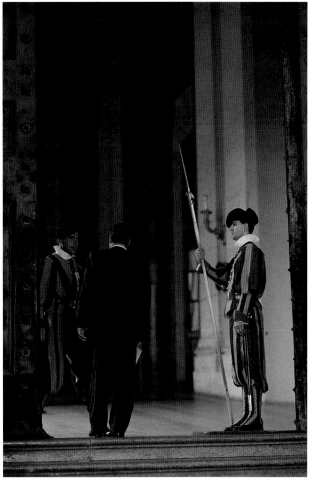

**Swiss Guard, Vatican City**
The captain of the Swiss Guard is the keeper of the doors to the papal chamber. I could not get close physically, but set up in the shadows in St Peter's Square and waited until there was a visitor. Even though the guard's face is but a detail, his authoritative expression is apparent. Note his right leg too. The motor drive is useful for pictures like this – you wait and wait and, all of a sudden, there is action. Shoot in quick 4- or 5-frame bursts to make sure you have the picture.
*Nikon F3 400mm on tripod/Fuji 400*

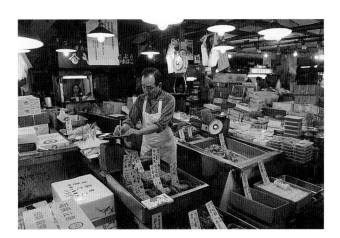

**Tokyo fish market**
Markets start early, 5.00 a.m. in this case, so you need to get ready the night before. Check and double check that you have what you need. It is sometimes better not to use flash, which can result in too clean an image, but rather to push the film. The less than true colour gives a sense of place and it feels like early morning in this picture.
*Nikon F4 35mm on tripod/Kodak EPT plus 1 stop*

# City masterclass

## Bombay commuters

I went to Bombay (Mumbai) to photograph the city during the monsoon season. It was my choice – bad weather makes for interesting pictures. As usual, you are looking for an establishing shot. I had been commissioned by a British magazine and thought it would be good to find an image that would be familiar to London business people. The Victorian railway station was perfect; the cars, buses, traffic lights, rush hour and even the rain look so like London.

I checked out the station on consecutive days for an hour or so at a time. I found two dryish positions where the 'stage-set' looked good, and waited for the actors to perform. It was all about composition, waiting for the players to fill the spaces within the picture. I took pictures with several lenses and used Kodachrome 200, a very good film in its day with a fine, gritty grain that suits busy urban locations. Kodak E200 pushed one stop is a good alternative. The 'grain' when shooting digitally is not quite the same as film, but you can still achieve that urban feel.

*Nikon F4 35–70mm/Kodachrome 200*

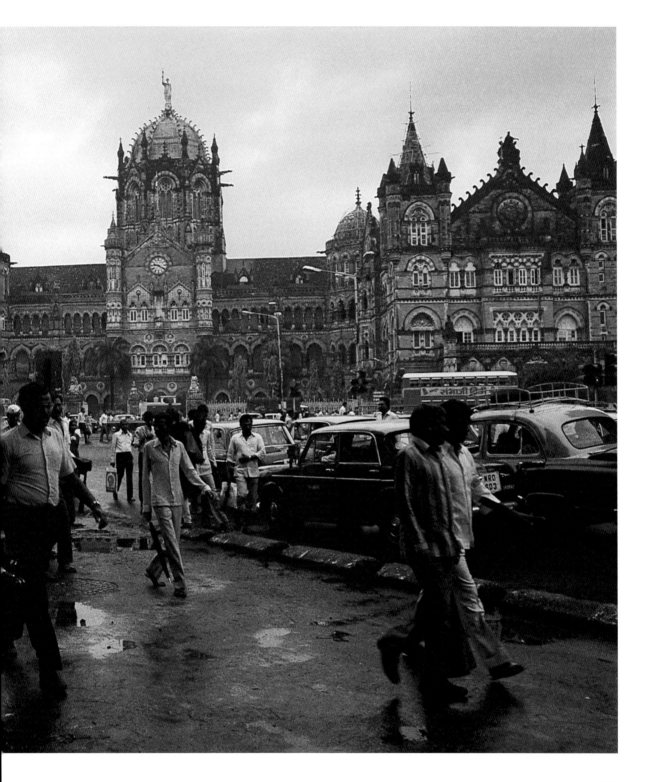

# Architecture

Like a portrait of a person, a portrait of a building should flatter its subject. It should also convey something of the building's character and location.

First, choose your position for the best possible view of the building. For a tall building, you may need to move back some distance and fill the frame using a long lens. Find out what time of day and in what weather conditions the building looks its best – the right light can make even the most mundane building look better. Photograph a gleaming skyscraper against a bright blue sky, or a Renaissance building in the warm light of late afternoon to accentuate its golden stone and highlight all the details of the masonry.

When photographing old buildings, try and enhance their historic character. A Scottish castle will look more atmospheric photographed in mist and rain than in bright sunshine. For single houses in a country landscape, bring out the empathy between building and setting – show why this is a wonderful place for a house. Walking around a city it is impossible to miss the juxtaposition of many different styles of architecture. These contrasting shapes and materials always make good pictures, especially when photographed on a long lens where the perspective has been foreshortened.

Unless you want to make a particular point of it, scale is not important and you don't need people in the picture. But a successful architectural photograph does need visual strength and careful framing.

**Queen Anne house, Wiltshire**
By including the tree and its filigree branches in the composition, the symmetrical style of the architecture has been emphasized. I waited for the sunlight to fall only on the building. A 0.6 neutral density filter over the bottom half of the picture has darkened the shadow area even more.
*Nikon F4 85mm on tripod with 0.6 ND filter/Kodak Ektachrome*

**Sacré Coeur, Paris**
The distinctive dome of the basilica leaps out of this image.
Looking down the street has enabled me to use a long lens to
foreshorten the perspective and juxtapose the different styles
of architecture. This happens a lot in cities and it is a pleasure
to search out and use the contrasting shapes and designs of
buildings to make graphic pictures.
*Nikon F4 80–200mm/Fuji Provia*

**Dublin door**
The centre of Dublin is famed for its Georgian architecture
and it is extraordinary how many different styles and colours
of doors there are. A door is an important feature of a build-
ing and I have collected several hundred pictures of them in
my travels over the years.
*Nikon F5 28–70mm/Fuji Velvia*

The Taj Mahal is considered to be one of the most
beautiful buildings in the world, but it is not an
interesting building to photograph. There are only
two good angles from which to view it, and there's
no detail when you get close up. A Gothic cathedral,
in contrast, has fascinating shapes and angles and a
wealth of exterior detail.

Photography reduces buildings to two dimen-
sions, so they have to be lit as well as possible to
bring out their form and detail. Buildings should
look architecturally sound – a perspective-control
lens keeps the verticals vertical so the building does

not look as if it's about to topple over. A building is
also a sum of its parts, so look out for the details
often created by skilled craftsmen. Always carry a tri-
pod and a polarizing filter. The tripod allows you to
use slow shutter speeds when shooting at night – or
in daylight when you want to capture anything that
moves as a blur, to accentuate the solidity of the
building. The filter reduces reflections and can dark-
en sky, adding contrast and a hard edge to help the
building stand out. Try shooting ruined buildings
covered with creepers using black and white infrared
film. They take on a ghostly appearance.

### Downtown Boston
Modern architecture is an exciting subject for any
photographer. The graphic shapes, hard lines, reflective
surfaces and the way they interact with each other always
makes for an interesting composition, and they can be
photographed in daylight or at night – there aren't many
subjects you can say that about. A long lens will help
foreshorten the perspective, packing the shapes together
in an abstract way. As always, explore the environment
to establish the best angle for shooting.
*Nikon F5  80–200mm/Fuji Provia*

### Mosel castle
The last rays of the setting sun create a romantic light – the
perfect light for this castle on the Mosel. You can also create this
light using Photoshop, though some might call that cheating.
*Nikon F3 300mm/Kodachrome*

**Royal Palace, Stockholm**
The light in which a building is photographed is very important. For example, a hard midday light is good for a steel and glass building and for reflecting the setting sun bringing the design of the building to life. Here, the warm tones of the late summer sun are sympathetic to the hues of the stone.
*Nikon F5 80–200mm/Kodak EPP*

**Financial Times building, London**
This is an example of an effective technique. The building was photographed in the daytime and underexposed by 1 stop. At twilight, when the interior lights were switched on, the same frame was re-exposed for the artificial light. By doing this, the outline and structure of the building registers, but you can also see inside. 5 x 4 sheet film is the most economic way of doing this traditionally. It is possible on medium format, but you will only get one image per film back. It is now much easier to do digitally. The pictures are shot separately and comped together in Photoshop. The most important thing is that the camera must not move for either exposure, because the two images have to line up perfectly.
*Horseman 5 x 4 90mm/Fuji Provia* © Paul Grundy

# Interiors

There is more to a building than its outer shell. Interiors are a popular subject for magazines and there are many devoted exclusively to the subject. The best interior pictures can make a room look inviting, somewhere you would like to be.

When taking a picture of a room, don't try and capture the whole thing. Estate agents' pictures have to concentrate on showing square footage, but an interior photographer looks at lifestyle. An interior picture can be treated like a big still life, a piece of 3-D design. Find the most interesting part of the room and dress that up, if necessary taking things from other parts of the house to build up a composition. Styling an interior picture in this way is a skill on its own.

The lighting must be right if the picture is to have atmosphere. Avoid flat light. Use daylight-corrected bulbs or double the wattage of existing lightbulbs. All the bulbs should be new, so the light is even. Light dark corners by bouncing hand flash off the ceiling. If the interior lights are in the picture but are too bright, so they would overexpose during a long expo-

sure, switch them off halfway through the exposure.

On a bright day, a shot taken near a window can have too much light and look burned out. If this is a problem, hang a white sheet over the window to cut down the natural light and make it easier to balance the lighting in dark areas. Making the foreground out of focus gives depth to a room, but make sure there are no large items or bold colours in the bottom third of the frame.

A normal lens is usually best for interior pictures. It is wide enough to include everything without distorting the verticals, and eliminates rubbish. It doesn't influence the picture too much and allows the ingredients to work for themselves. A tripod is essential – once you've set up the camera angle, you need to be free to move things into or out of the shot. It also allows long exposures. Remember that you don't have to take the picture from a conventional angle or height. Sometimes a low camera position can make a room look more attractive. Look for the details, these too add to the atmosphere.

**The hall of the Grosvenor House Hotel, London**
The symmetry of the design and the grand furnishings, typical of an old hotel, make this picture. Six flash heads and a 5-second exposure allow the hotel lights to glow invitingly.
*Mamiya RB67 50mm on tripod/Kodak EPP*

**Bedroom in the Marble Arch Thistle Hotel, London**
The room was beautifully lit, but not for a photograph. The light levels had to be increased with two flash heads and a tungsten strip light to mimic the room's existing light. It was important that the discreet, warm, welcoming atmosphere be replicated – even exaggerated. First impressions on arriving in your hotel room are very important.
*Mamiya RB67 90mm on tripod/Kodak EPP*

**Sir John Soane Museum, London**
A fascinating location, with every available space cluttered with objects. In order to give scale and to emphasize that the museum is crammed full, I kept the warden in the picture and lit him. Your eye now has something fix on and can then explore the room, rather as you do in a museum.
*Nikon F4 35mm/ Kodachrome*

# Architecture masterclass

### 'Michelin Building' by Paul Grundy

'When shooting architecture, I try to impose the qualities I like about a particular building or interior into the image. Many architectural photographers have a passive approach to their subject: they wish to record, rather than interpret the thing in front of them. I prefer to produce images that play on the perceived reality of the subject.

'A clean, straight-on shot of the Michelin Building on London's Fulham Road is impossible. Quite apart from a lamp post right outside that prevents a clear view, you can't stand far enough back to shoot with a normal lens, and the building's geometrical curves are massively distorted when shot with a wide angle. It is also north facing, so never gets full light. It is a building that changes its appearance through the day and into the night, with various features at their best at different times. This image compresses time to bring together each element when it looks best.

'This front-elevation image is made up of eight separate shots. The main frame of the building consists of two shots, each with the camera lined up on the tyre light at each end of the elevation, taken as the late-afternoon light models the reliefs and tiles. The arched, stained glass window was shot at noon. Below this, the Michelin Tyre Co. sign is taken from a night shot when the sign is artificially illuminated. The large square central window was shot at mid-afternoon. The main entrance was shot on a late-winter afternoon, so is lit artificially from within. Bottom right (van) and left (oyster bar) were shot at the same time as the main exterior, but exposed for the interior. I shot in colour, for a greater range of tones, colour correcting and matching in Photoshop before printing in black and white.

'I wasn't trying to create an "honest" picture, but to do something far more exciting: to capture the essence of this charming and extraordinary building, much loved by Londoners and visitors. Confronted by any large space that cannot be lit, I always ask: how can I control the image? Time is the key to interpreting such a subject. It's like there is a palette of different light, and I dip in and use the bits I need.'

**Frame:** *Horseman 5 x 4, 90mm*
**Stained glass:** *Horseman 5 x 4, 240mm lens*
**Other:** *Pentax 6 x 7, 165mm*
*All pictures shot on Fuji Provia 100 and printed on a Epson 1290 printer on Lysom Darkroom Archival paper*
*© Paul Grundy*

# Nature

Photography is used more and more to encourage both city and country dwellers to appreciate nature and the environment – and to show how governments and industry abuse nature. Photographs can make people more aware of how beautiful the world is and think twice about defiling it. One of the joys of photography is that you can make a picture out of very little. A pile of leaves, a detail in a stone wall, peeling paint, the texture of grass and rocks – things you would barely look at in the normal course of events – can be made into visual statements.

It is pleasurable and soothing to go out for the day with a camera to take pictures of the natural world. Keen photographers will walk into remote places at unsociable hours to take memorable pictures. It doesn't have to be a new place. Returning to the same area can be rewarding time and again when you are there to see pictures. Having the camera can make you more aware of nature and encourage you to take a closer look at details. The next time you go for a hike and leave the camera at home, you're sure to miss it.

It shouldn't be a problem to carry a backpack all day, but adding camera equipment can make it a heavy chore. Digital cameras are much lighter than film cameras and the new generation of zoom lenses, covering a focal length of 28–200mm, will cover most picture requirements. Several memory cards and a spare battery take up much less room in your pocket than film.

**Swaledale, North Yorkshire**
Coming to the end of a day's hike, it was easy to get the composition perfect. The sheep, the light and the graphic sweep of the stone wall all say Swaledale.
*Nikon FM2 180mm/Fuji 100D*

**Yorkshire stream**
I saw this stream marked on an Ordnance Survey map. I walked over the hill and down into the wooded gully. It was a morning of milky pale sunshine, a rather flat day but perfect light for being in woodland, with little contrast and good definition between the leaves and grasses. Usually when photographing nature you have to make order out of chaos, looking and searching for a position that gives the right structure to the picture. It's quite all right to take a twig out of a stream or move a dead leaf or some grass from in front of the lens, but that's about it. Don't tear off a branch because it is in the way. Tie it back, or change your position.
*Nikon F4 35mm/Fuji 50D*

You can treat the car as a big camera bag, returning to it for extra equipment as needs arise. But before you are off for a day's hike you have to be selective in what you intend to carry. Out walking, having too many options becomes a hindrance. The camera you are carrying dictates the type of picture you take, and this assists your decision-making. When you are driving, pictures come upon you too quickly and then they're gone. When walking, a picture builds slowly. You can compose as you walk; the elements slowly rearrange themselves with every pace you take.

There are plenty of pictures waiting to be taken. All you have to do is see them and frame them. With such images, the skill is more in the recognition of the picture than in the taking.

**Maple leaves**
This detail of Japanese maple leaves on the ground in an arboretum was just as impressive as the trees themselves in their full autumn colours. I scanned over the carpet of leaves until I found the right group. The tripod-mounted camera allowed me to do some final adjustments to the pattern of the leaves in the viewfinder.
*Mamiya RB67 160mm macro on tripod/Fuji Velvia*

# Gardens

A garden is a miniature landscape and can be photographed in the same way. There are many full-time garden photographers, because it is an absorbing subject but not a difficult one. You don't have to know about plant care or bug repellants to take successful pictures, but some knowledge of the subject will help. Most gardeners will tell you there is no best time for a garden, only better times. Photographically, spring is a good time when there are many shades of green, and flowers and shrubs are in bloom adding a variety of colour. In Britain, we are fortunate to have many grand gardens and parks that have matured over the years. These were designed to be seen at their best from certain angles – sweeping lawns, lakes reflecting autumn leaves, avenues of trees in blossom with bridges and follies giving the landscape focal points, all combining to create interesting pictures. Don't forget the details too: a gate surrounded by flowers or the gardener's potting shed.

We are also fortunate to have private gardens where days and weeks are lost to the creation of a personal retreat. Winter is not normally thought to be a good time to photograph a garden, but many a picture can be made of frost-covered lawns, or hedges and trees transformed by settling snow.

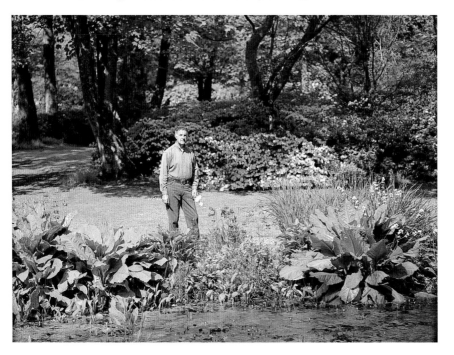

**Gigha, Western Isles**
The warm waters of the Gulf Stream make the Western Isles of Scotland a very interesting area for gardens and shrubs. Tropical forest flame trees grow here. The garden at Archmore House was developed by Sir John Horlick to indulge his passion for rhododendrons. The best time is mid-May when there is every colour and every shade of green you can imagine. Malcolm MacNeill has been working in the garden for forty-four years.
*Mamiya 7 80mm on tripod/Fuji 100 RPD*

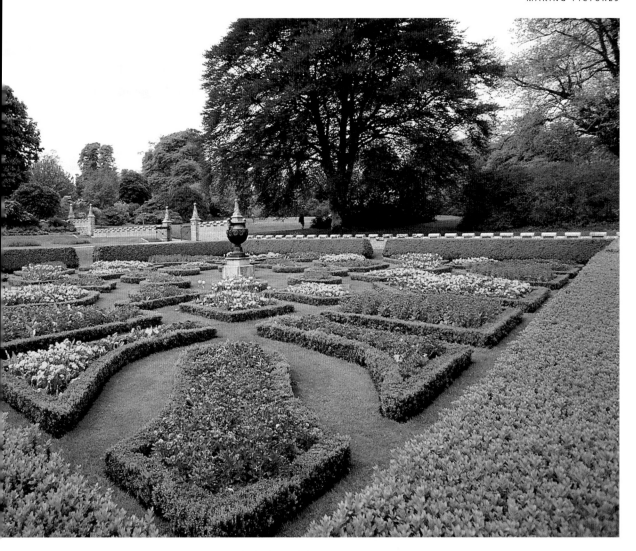

**Lanhydrock, Cornwall**
A National Trust garden kept in immaculate condition. The wide-angle lens has empha-sized the layout of the formal part of the garden, which is well known for its bluebells and azaleas.
*Nikon F4 20–35mm/Fuji RPD*

**Sissinghurst, Kent**
There is a lot of green in a garden. To make more of the colour, use a wide aperture and focus on the subject. Out of focus fore-ground colours lead the eye down the path to the urn. A good garden is designed to have many views, some obvious and some that surprise you.
*Nikon F4 80–200mm/Kodak EPP*

# Flowers

The ideal conditions for photographing flowers in their natural habitat is bright, pale sunlight in still air in the morning, before the heat of the day. In strong sunlight, either cast the flower in shadow created by placing a silk hoop above it, or redirect some light into the shadow area with a Lastolite reflector. A ring flash will hold the flower crisp and sharp but it will look flat; an off-camera flash will retain its form and delicate texture. Selective focus concentrates the attention on one flower head, turning the surrounding flowers into soft shapes, but reinforcing the flower's colour.

The most useful outdoor lens is the 105mm macro focus. It gets close in without crowding the flower, while the flash is far enough away to minimize the danger of overexposure. Autofocus is really helpful, especially if the flower is moving in the breeze. Look out for any tiny bugs living in the flower, especially if the picture is to be enlarged. You can create your own dewdrops using a hand-pumped water spray. And you may want to wear kneepads to make working at ground level more comfortable.

**Tiger lily, St Lucia**
The mid-morning sun lights the top of the flower and the leaves. The background is a black Lastolite hoop, to eliminate distracting detail and make the red zing out. A white reflector bounces more natural light into the body of the flower.
*Nikon F5 105mm macro on tripod/Fuji Velvia*

**Roses**
Alan regularly goes to Covent Garden market to buy flowers that look interesting that day. He buys them in bud, takes them back to his studio and waits for the first bloom, so they are perfect to photograph. Although the arrangement looks very casual, as if they have just been thrown down, in fact it is very considered and controlled. Each rose and leaf has been checked through the viewfinder to make sure it is contributing to the overall composition. The colours of the roses have been artificially aged, desaturated in Photoshop by 10 per cent.
*Sinar with Sinar 54 digital back 210mm tethered to Apple Mac G5/ Iris print*
© Alan Newnham

**Snowdrops**
To keep the snowdrops looking delicate, even though close up they look architectural, Alan had to rely on getting the composition just right. The picture is cropped in the camera viewfinder. The balance between the flowers and the space that surrounds them is perfect.
*Sinar 10 x 8 360mm/Kodak Tri-X Selenium-toned*
© Alan Newnham

# Wildlife and pets

The experienced wildlife photographer usually works alone, undertaking independent research to find interesting new locations. For the enthusiast, there are now specialist photographic tour companies that take small groups on organized trips to game parks and reserves in Africa, India, America, Norway – anywhere there are special animals. Such trips are generally led by an experienced wildlife photographer with good knowledge of the region and local guides. It is possible to stay longer in one place than you would normally be able to with a general tour operator – but there is still no guarantee that you will meet a tiger or a killer whale. Photography has educated people about the importance of wildlife in our world and about the need to protect it. It is estimated that a large tusked elephant is worth many times more in tourist dollars than the worth of its ivory.

**Goldfinch**
As is the case with a lot of small bird pictures of this type the set-up was stage-managed to some extent. The set-up was in a friend's garden where a flock of up to twenty-five goldfinches were visiting to feed on black sunflower seeds from feeders. Although some shots were taken of the birds on the feeders, a more natural-looking shot was achieved via the introduction of a few teasel heads. Unfortunately they were devoid of seeds, so in an attempt to lure the birds away from the feeders the teasel heads were loaded with niger seeds, which are very small and dropped into the teasel head without being noticeable on the resulting pictures.

It took a few visits before the goldfinches were landing on the teasels and feeding on the niger seeds. The background to the shot is a canvas hide cover draped over the garden fence about 15 metres away and thrown out of focus by the use of a long lens and wide aperture. The photographer was concealed in a portable hide about 5 metres from the bird.

The shot was taken in the winter and so the sun was low in the sky, providing the shot with attractive warm lighting and the bird with a catchlight in the eye.
*Canon EOS3 500mm on tripod/*
*Fuji Sensia 100*
© Mark Hamblin

**Gemsbok, Whipsnade Zoo**
The animals at most modern zoos are in good condition and kept in natural-looking surroundings – no more small concrete pens with bars. You don't have to go on safari to get great animal pictures, but be prepared to wait for the animals to adopt a photographable position. A long lens at a wide aperture will give you many options.
*Nikon F5 300mm on unipod/Fuji Provia*

**Bessie the boxer**
Bessie had just had puppies and was a very attentive and proud mother. Photographing animals in the studio is rather like working with babies – you need to be completely set up and ready to go because you may only get the chance of a few pictures. Bessie is lit with a beauty light – a one-metre silvered dish. This is a very good wraparound light. The flash does not upset animals.
*Mamiya RZ 180mm/Agfa  APX 100/Lith print*
© Rob Lawson

**Seal pup**
I was with a university research team on the remote island of Sula Sgeir in the North Atlantic. We were careful not to disturb the helpless seal pups, left on their own while their mothers were away feeding.
*Nikon F3 135mm/Kodak Ektachrome*

**Monty**
This is just a snapshot of a well-loved pet. Knowing the dog's ways, it was easy to set this picture up. Always carry a camera. Beware of fill flash, the red-eye effect (often white-eye in animals) is pronounced.
*Canon Ixus/APS Advantix*

# Safari

Being on safari is a magical experience. The first time I saw an elephant in the wild I was so thrilled that I didn't even think of photographing it. Even now, after several safaris, I find there are great moments that are better remembered than caught on camera.

Safaris are not cheap. In order to get good pictures, I think you have to be independent of the crowd. Travelling in a combi bus, packed with people all eager to get snaps, is not conducive to good photography. The most successful safaris I have been on were camping trips led by an experienced guide, who really knew the parks and who could identify 200 types of bird. This is a very different experience to staying in a safari lodge or hotel. You are independent, close to nature and on the animals' time scale, not the hotel's. You get up at dawn when it is light and cool, as vultures and other birds wait in the trees for the thermals that will enable them to circle the sky. You go to bed when it gets dark and listen for the activity of animals near the camp.

On these safaris we travelled with two Land Rovers. In one was all the camping equipment – food, tents, and so on. The other was stripped down, so we had a good view and could take pictures without any problem. We would arrive at a waterhole, set up the equipment and wait. It is far better, if you have the time, to let the animals come to you. When the animals are used to your presence you are able to get closer to them.

There are also times when you have to be very quick, ready to take pictures as soon as you get out of the car. I kept the tripod fully extended so I could take it out and set it up fast when necessary. It is best to be as quiet as possible. Animals have become used to Land Rovers, but they are alarmed by unnatural, metallic sounds, such as the clink of a tripod against the vehicle or the sound of the shutter (if you're that close).

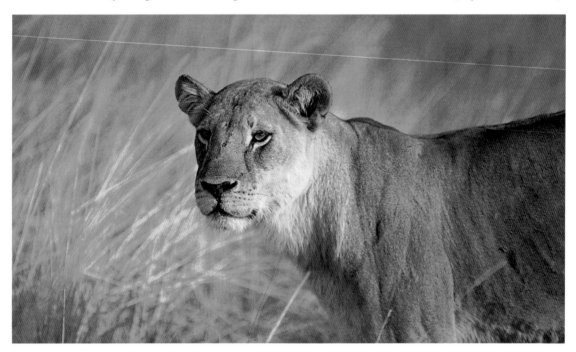

**Gomo Gomo Game Lodge, Kruger National Park, South Africa**
We came upon the lioness by chance en route to our campsite. We approached slowly in the Land Rover and I shot from the roof. The late afternoon light is perfect for the tones and highlights in for the lion and the savannah grass.
*Nikon F4  400mm f 2.8 with 81A filter on unipod/Kodachrome 64*

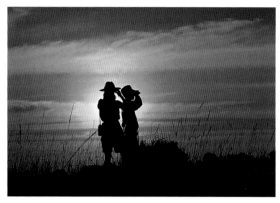

**Chobe National Park, Botswana**
We arrived at the waterhole early, parked under the trees not far away and waited. Eventually, at about 4.30 p.m., twenty or so elephants came along to drink. We drove around them and photographed from all angles. It may not be a dramatic picture but it reflects something more important than drama – the everyday cycle of behaviour in the savannah.
*Nikon F4 80–200mm zoom/Kodachrome 64*

**Devil's Island, Okavango National Park, Botswana**
Getting kitted out in khaki safari clothes is part of the fun. This picture captures that mood and acts as a catalyst for other memories of the trip. It may be just a snap, but it is still important to make it as good a photograph as possible.
*Nikon F4 35–70mm zoom/Kodachrome 64*

When on safari you are in 'big country' and your normal lens is probably a 200mm. You will rarely find a use for a wide angle. I take an 80–200mm zoom and long lenses, such as 400 and 500mm, with extensions. Take several cameras, to avoid changing lenses in dusty conditions, which can be fatal with digital cameras. A tripod is essential and should have a quick-release head rather than a screw attachment. A unipod with a tilt bracket is also useful: the camera can be pointed upward to photograph birds high up in trees. You will need canned air and a sable brush to blow dust from equipment, a set of screwdrivers in case camera screws get loose after a few days bouncing around in Land Rovers, and superglue and gaffer tape to mend anything that breaks.

Everybody thinks of Africa as being always bright and sunny. In fact, when you go on safari the light is often hard with little colour, and you need faster film than you would expect – take plenty of 200 and 400 ASA. In the heat of the day animals are usually resting and most activity occurs when light levels are low: at dawn and dusk. You are often faced with difficult lighting conditions and need to use fast shutter speeds. Watch where the sun is – an experienced guide will get the vehicle into the right position for shooting. Most guides are good

photographers and understand that photography takes time. Because the light can be dull, try to keep the sun behind you so that your pictures are well lit.

Don't go mad at the first sight of an elephant when it is just a dot on the horizon. Take the time to absorb the experience for a few days and then start taking pictures. An old gamehunter's tip that works just as well for photographers is to scan the scene, looking for shapes that don't fit in – birds in trees, ears sticking out of the grass, a silhouette that is not like a rock.

You have to be closer than you would imagine. Powerful binoculars (12 x 50) are necessary, because you often need to use them in low light. Take a torch with a red filter to see animals at night. Their eyes gleam back and they cannot see red.

Don't feel you have to keep up city personal hygiene standards. Natural body smells don't alarm animals, but perfumes and deodorants do and they carry for miles.

Watch your back all the time when walking – especially near waterholes – and don't get between an animal and the water. You don't need to be a specialist to take good pictures of animals, but you do need a little knowledge of how animals behave and infinite patience. Relax and let yourself become part of their world for a few days.

# Wildlife masterclass

## 'Buzzard Feeding on Rabbit Carcass, near Tregaron, Wales' by Mark Hamblin

'Although buzzards are predators they will also take carrion when available, a trait that can be exploited by photographers wishing to photograph these charismatic birds. A common technique is to collect road-kill rabbits during the summer and keep them in the deep freeze until the autumn. They can then be thawed out and used as bait in order to attract buzzards to come within photographic range. At the time this picture was taken, the area around Tregaron in mid-Wales was one of the best locations in the country for buzzards and was regarded as a relatively easy place to entice them down.

'A permanent wooden hide stood on the hillside overlooking suitable buzzard habitat. Road-kill rabbits were then staked out using tent pegs to hold them down at about 15 metres from the hide. The rabbits were secured to the ground to prevent buzzards or other scavengers flying off with them. In order to prevent detection I entered the hide before dawn under the cover of darkness (if buzzards see a person enter the hide they may be too suspicous to come down so close to it).

'Over the course of five days several buzzards fed on the rabbits, providing plenty of opportunity for portraits of the birds as well as some flight shots as they hovered over the bait. However, on my final day I decided to attempt a completely different shot which included the background as part of the picture. By using a wide-angle lens positioned close to the rabbit, the buzzard could still be shown relatively large in the frame, but the sweeping Welsh farmland also became an integral part of the picture.

'Obviously, I couldn't be behind the camera, so instead, the camera, lens and motordrive were fitted inside a soundproof wooden box sited on top of a bean bag resting on the ground. The shot was framed to allow space for the buzzard on either side of the bait and the lens pre-focused manually on the front of the rabbit. The exposure was set to automatic but with +2/3-stop compensation to allow underexposure because of the brighter sky. The motordrive was then wired up to an infrared trigger/receiver which was fitted to the top of the box, pointing back towards the hide.

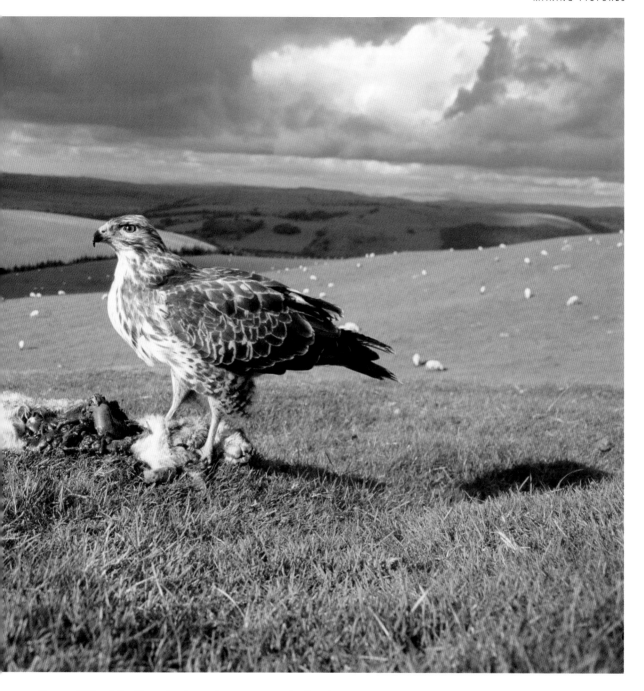

*Olympus OM2n, Zuiko 28mm, Sensia 100, f8 at 1/125 second, infrared trigger/receiver* © Mark Hamblin

'When the buzzard first landed close to the rabbit it appeared rather suspicious of the 'new' contraption close by. Eventually it began to feed. The bird heard the motordrive from within the box and jumped back several metres. Fortunately, it quickly returned and after the second shot didn't appear perturbed by the noise. Over the course of the next ten minutes I fired off all thirty-six frames and then waited for the buzzard to finish feeding before retrieving the film.'

# Close-up

There is a whole world to be seen and explored when you fill the viewfinder with a tiny object  like the head of an ant or a detail of fine engraving. There are a number of ways in which this can be done.

Some zoom lenses have a close-focus facility built in – press a button and twist the focusing collar and the macro capability of the lens is engaged. The main drawback is that this only works at the widest focal length. It is a compromise, but it works.

Ultra-wide-angle lenses focus down to eight inches and will throw the background out of focus in a dramatic way with sweeping graphics. The featured detail is seen within its environment. You can play with scale: the relationship of the subject to the background often makes the picture. You must focus carefully, frequently checking the preview button. Ring flash will light the foreground if the camera is crowding the subject.

Going closer in, most people start with a close-up filter, which is screwed to the front of the lens. Nikon make the best, which only distort when the aperture is wide open. Available in two magnification strengths in 52mm or 62mm sizes and also for specific focal length lenses, they can be used together to multiply the magnification. They are so slim you can always carry a set in the camera bag. You never know when they might come in handy.

It is also possible to achieve close-ups by reverse-mounting the lens. This involves attaching the front end of the lens to the camera with an adapter ring, and is probably the least expensive way into close-up photography. Although all computer-controlled functions are lost, the meter will still work in manual and aperture-priority mode.

**1 Euro coin**
*Nikon F5 105mm  plus Nikon extension rings on tripod/Fuji Velvia*

**Embroidery**
*Nikon F4 105mm macro/Fuji RPD*

**Damsel fly**
*Nikon F5 200mm macro on tripod/Fuji Velvia* © Simon Stafford

A macro lens is specially designed to focus closely. They come in various focal lengths for both 35mm and medium-format systems. Autofocus helps when you are shooting bugs and anything that moves. Macro lenses are extremely sharp and also double as general lenses. I carry a 105mm macro lens as part of my everyday 35mm camera kit. It is my most-used fixed-focal-length lens. The Mamiya 140mm macro is perfect for head shots and detailed still lifes. These lenses are extremely versatile.

Extension rings come as a set of rings of differing depths that can either be used singly, all together or in any combination that will give you the desired magnification. They are hollow, so the optic quality of the lens remains unimpaired. TTL metering and the automatic diaphragm are still controlled by the camera. You can shoot hand-held with the aid of a unipod – either let the autofocus lock on or, if manually focused, gently rock backwards and forwards on the unipod until the in-focus light comes on; combining this with flash will certainly hold it sharp.

For really impressive magnification, use the bellows focusing attachment. The lens is fixed to one end of the bellows and the camera body to the other. This is a precision instrument and should always be mounted on a tripod. Focusing is done by racking out the bellows. As the lens is some way from the film plane, there is a loss of light and this has to be compensated for, either by long exposures or by flash. The effect of the flash falls off very quickly, so the lit subject stands off a very black background.

If a tele-converter is added to a lens, it retains its close-focusing capabilities – for instance, a 200mm lens with a 1.4 converter will focus closer than a 300mm (its nearest equivalent). This is especially useful to know if you are photographing small birds. Tele-converters are either x1.4 or x2 and have optical glass – effectively another lens. There is no loss of quality, but you do lose 1 or 2 stops of the lens's widest aperture.

# Still Life

Still life has always been a great subject for artists and photographers. In the course of our daily lives, we probably see more still-life images than any other type of picture – think of advertisements and all the products on display in shops and markets. We take these images for granted, but still life is a skilled, often unsung, area of photography.

Photography can make something out of nothing. It can turn the ordinary into something special – a humble, found object taken out of its environment and photographed in the studio has unexpected grandeur. Seeing the picture, and having the patience and the lighting skills to create it, are the key factors that make a successful still-life picture.

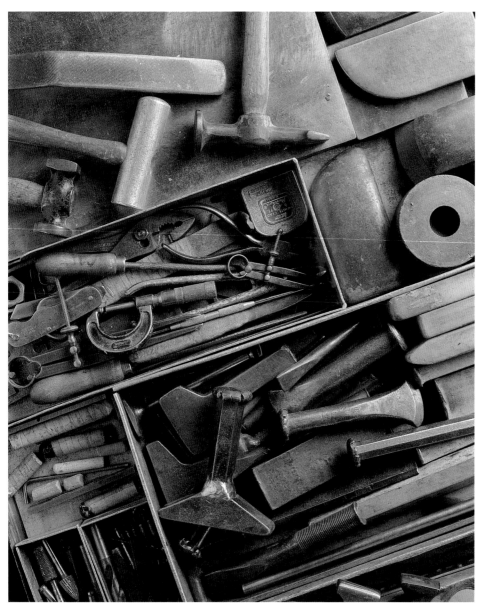

**Panel-beater's kit**
Everyday things have a charm of their own. The panel beater at Aston Martin had gone to lunch and left his kit next to the window. The natural daylight was perfect. All I had to do was a little rearranging and put a reflector on the side opposite the window. *Mamiya RB67 140mm macro on tripod and ladder/Fuji Velvia*

Still lifes don't have to be pin-sharp throughout. Selective focusing – just concentrating on a detail – is the fashion, and this, rather than showing the whole thing, often gives a more interesting interpretation of the object.

There are few working environments that can beat a good studio. They should have high ceilings, lots of space and controllable daylight. Hopefully, they will have a good atmosphere with good music. They should be clean and they don't always have to be black. In this space, you should be able to take a portrait against a separately lit background, to build and recreate a room set or do a complicated still life. Your studio should have space to store all the accumulated props and bits and pieces. Studio and still-life photographers have infinite patience and are prepared to spend the time to make everything perfect before taking the picture. 'Oh, that'll have to do' is not something you are likely to hear.

**City trader's desk**
Although contrived, still-life pictures are about arranging all sorts of objects in a natural way. There is a long tradition of reconstructed pictures of dead writers' desks, complete with an old manuscript, quills and ink; or a musician's score and a violin. You are trying to create an atmosphere as if the person has momentarily left the room.
*Mamiya RB67 140mm on tripod/Fuji Velvia*

**Shells**
When you are out for a walk, how often do you admire something? Go one step further. Pick it up and bring it back and photograph it under controlled conditions: good lighting and a sympathetic background. Alan Newnham found these shells and was struck by their vibrant colour. Back in the studio, he focused on just the detail of the front shell, concentrating on its construction.
*Sinar 5 x 4 300mm on Cambo stand/Fuji Velvia*
© Alan Newnham

**Muffins**
About twenty muffins were freshly made in the studio by a home economist. The one at the front was broken in a deliberate way, the better to show the tasty inside. Crumbs were carefully placed to fill the gap in the composition. There are no accidents in still-life photography.
*Sinar 5 x 4 with Sinar digital back tethered to Apple Mac* G5 © Alan Newnham

Food photography is a specialized area of still-life photography and relies heavily on the skill of the home economist/stylist/cook and not just that of the photographer. The studio usually has one or two fully equipped kitchens and a cupboard full of relevant props – china, cutlery, cutting boards, etc.

People may have differing opinions on British cooking, but one thing there is no doubt about is that British food photography is the best in the world. There are many myths surrounding the food in pictures that may have been true in the past, but mashed potato is no longer used for ice-cream, cream is not white emulsion paint and the golden brown of a roast turkey is not there as a result of boot polish!

The camera gets so close to the food, it has to be real!

The obvious intention is to make the food look mouth-wateringly attractive. This sometimes requires capturing the definitive moment of an action – after all, there can be movement in a still life, for example olive oil dripping from a fork or vegetables steaming the moment they come out of the pan.

**Bread basket**
Such a familiar sight in any restaurant. Although simple, this makes a great picture. The lighting shapes the rolls and picks out the texture of the basket. The highlighted area in front of the basket has been chalked in, using ordinary blackboard chalk. This trick is used to boost the effect of the lighting in a small area.
*Sinar10 x 8 300mm on Cambo stand/Fuji Velvia* © Alan Newnham

# Sport

There are great pictures to be had at small, amateur and recreational events where there is just as much endeavour, commitment and skill on display as in professional sport but minimal security – no passes, no barriers – allowing easy access. The same skills are needed to capture the moment at these events.

Autofocus, the motordrive and instant viewing have made capturing the moment much easier.

Before these innovations, follow-focusing was a rare skill with a 400mm lens or longer. Besides being able to read the game, it is necessary to hone your focusing skills, especially when the action is coming straight at you and at speed. Learn to watch the game through the lens and, even at the most dramatic moment, don't take your eye from the camera.

**Skateboarding**
It is not difficult to get really close to the action at a skateboard championship. This type of individual sport is all about showing off and as a result makes great pictures. There is a moment when the skateboarder is neither going up nor down but hanging in the air, and using a 1/1000 second shutter speed has kept him there.
*Nikon F5 35–70mm/Fuji Velvia*

**Long-distance swimmer**
I was in an inflatable alongside Sandra Keshka. She was in the water for twelve hours, repeating this movement thousands of times, and I wanted to capture her triumph over the strain of repetition. It had to be a close-up picture of her determined face and expressionless eyes. The inflatable was travelling at the same speed as she was. Using a slowish shutter speed there is movement in the water. I took this picture about twenty years ago and it remains one of my favourites.
*Nikon F2 105mm/Kodachrome*

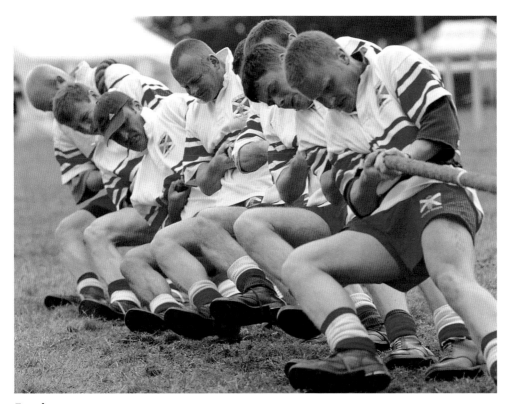

**Tug of war**

For a few minutes, the teams put all their strength into the pull. You can see the effort in their faces and in every inch of their bodies. This is about teamwork, so you see similar strain in every one of them. I chose my position with care so I could see them all and waited for the united 'pull', using the motordrive in quick bursts.

*Nikon F5 80–200mm/Kodak E200*

**Fishing at the chateau at Saumur**

There are some sports that are not about action and energy, but rather about patience and calm persistence. I got up at dawn to see the fishermen already in their positions, hoping for an early bite. I hoped they wouldn't catch anything, as I wanted to record the tranquillity and lack of action in the scene against the stunning backdrop.

*Nikon F4 35mm/Fuji RDP100*

Why buy a sports magazine featuring events that were over several days ago? To see astonishing close-ups of winning moments and the drama and agony of effort and endeavour. The sports fan has been an early beneficiary of cutting-edge photography for many years. The latest technology has always been employed in this area and sophisticated cameras are launched to coincide with major sporting events. It is now possible to transmit pictures instantly from the ringside and picture editors are in continuous communication with photographers as events unfold. This puts enormous pressure on the sports photographer, who still needs to have luck on his side – the winning goal could always be scored at the opposite end of the pitch. Sports photography is very competitive; you have to think, plan and use creative guile to make fresh pictures at each assign-ment. Top photographers say you have to keep rein-venting yourself.

Most sports photography is shot on digital SLR systems. Sports like basketball and ice hockey are also shot on neg. with medium-format cameras where the stadium is lit by a number of flash heads linked and triggered by radio. The large neg. allows the picture editor to crop into the action.

Remember that not all sports pictures are about action – sometimes a picture is needed to work with a headline; and the majority of an athlete's time is spent away from the limelight in dogged training. As with all photographic subjects, pursuing a precon-ceived idea may make you miss the obvious shot happening right in front of you. And usually there is no going back for a second chance.

### Jennifer Capriati, Australian Open

Every top player has a trademark shot and that's what you should concentrate on. Looking through film he had shot, Bob Martin was struck by the muscle roll of Jennifer Capriati's backhand return. He wanted to get this picture perfectly. He chose a place in the photographers' area where she would be back- and top-lit by the hard Australian sun and this has held her off the background. This is an example of how, even after photographing more than 200 days of top tennis, it's still possible to come up with a fresh picture. Autofocus allows just about anyone to get a decent action shot, but it is knowledge of the game, the players and the stadiums that contributes to a truly successful picture. Shooting on Fuji Velvia pushed 1 1/2 stops has increased the contrast, turning the blue signage background almost black. This does not happen when shooting digitally. Television cameras always get the best positions at major sporting events but this is the type of picture that successfully competes with television.
*Canon ID 400mm f2.8 on unipod/Fuji Velvia pushed 1 1/2 stops*
© Bob Martin

### Valsheda in rough water, Solent

Taking photographs on the rolling sea is very uncomfortable – you have to contend with a camera with a long lens bashing into your forehead while you are trying to keep yourself steady and the horizon level. You need the help of another professional in racing conditions: a skilled boat driver who is familiar with the local conditions, the wind and the currents, and knows where to position the boat to get the most dramatic pictures as the yachts go past. A press pennant on the rib of your hard-hulled inflatable will allow you to get in close to the boats and reassure their crews that you know what you are doing and are not a danger. Rather than chase around after the action, go to a chosen position and wait. Sit astride the middle seat as this is a good platform to shoot from even in a pitching sea. Keep your cameras in front of you, protected in freezer bags. Remember to carry a towel in order to wipe away the spray from the sea.
*Canon 1D 70–200mm/Fuji Provia pushed 1 1/2 stops*
© Bob Martin

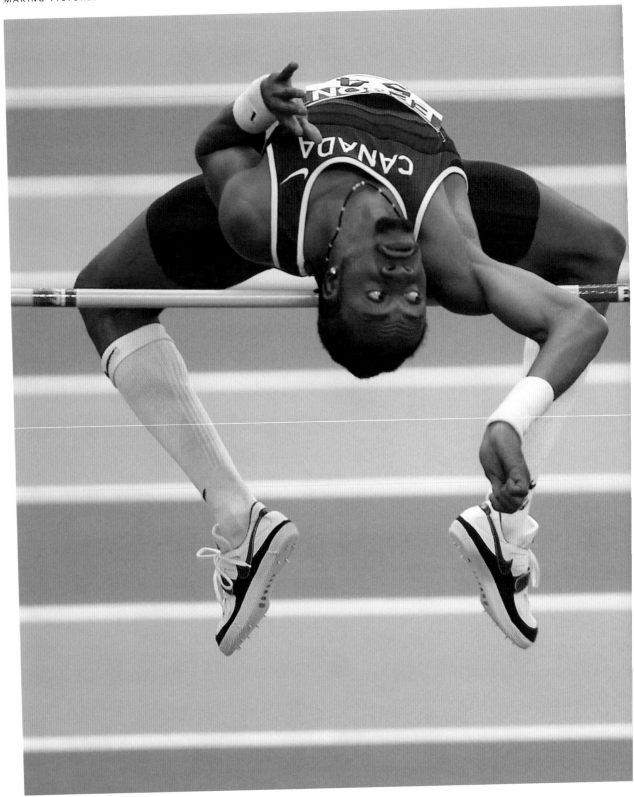

# Sport masterclass

### 'World Indoor Athletics Championships, Birmingham' by Bob Martin

'A new track had been laid which I had not seen before. I am always looking for a good graphic background to work with and this was perfect. I could have photographed several sports but chose the high jump, which meant I had to shoot from the public stands. Fortunately, I found a good seat for an hour, before having to move to a corridor. Everything is right with this picture. The red shirt works well with the blue background, the face is well lit, and the body, frozen at the moment of clearance, is what sports pictures are all about. I'm a photographer who likes to shoot from the crowd, or with a remote camera somewhere in the stand. I am always looking for a different view or angle, to give my pictures a competitive edge.

'The stadium was lit with HMI lighting, a good light for film, and no problem when shooting digitally. Any colour cast can be corrected and there is far less grain than film when rated at 640 ASA.

'I took a light reading off an 18 per cent grey card and manually set and tweaked the white balance. I still carry a colour temperature meter so I know exactly what the colour of the light is. Shoot all the card as a RAW file and edit later on the laptop. When transmitting to magazines, send JPEGs first, then RAW files. This picture ran as a double-page spread in *Sports Illustrated* four days later.

'At an event like the Olympics, I'd carry around thirty 1GB cards, to be collected periodically by messengers for viewing by picture editors. Some photographs will download onto a Compac i-pack for immediate transmission worldwide via mobile phone. Nowadays, the picture department can talk to you while you are track-side. In addition to a mobile, I carry a short-wave radio to talk to messengers, assistants and other photographers – perhaps to check a light reading.'

*Canon 1D 400mm f2.8 on monopod 1/1000 second/RAW file*
© Bob Martin

# Photojournalism

However powerful the pictures on today's television news, they are fleeting images. Often there is a corporate agenda and we don't know whose truth we are watching. When a news crew arrives to do a story, there's an added atmosphere. People play up to the camera and where there is one crew, several more will appear. At news events, there is still a place for the single photographer who has patience, endeavour and courage and who is able to tell the story in a set of pictures, or even in one single picture, that people can trust. These pictures can have a profound effect and often become the iconic images of the time. This is in the tradition established by the generation of photographers who worked in what now looks the idealized world of *Life* magazine. In my opinion, this is a standard to which we should still aspire.

Photojournalism deals with news and headlines but needs words as well. Reportage can stand alone. It documents daily life, the smaller, more mundane events, which can still make great pictures. Such pictures can become historical icons. I have a keen interest in history and I believe that it is the photographer's duty to document the times we live in. I find it strange that young photographers want to emulate their elders rather than document their own lives. Thus you see regrettably few pictures of contemporary teenage life.

The ease with which a digital image can be retouched or altered has become a problem in all photography and especially in photojournalism, which deals with facts and truth. The viewer is now cynical having been exposed to political spin and selective news-handling. There is little harm in manipulating a fashion or a beauty picture, but the viewer expects a news photograph to record the truth. Reputable newspapers have sacked photographers for cheating with their pictures and editors have lost their jobs over the veracity of pictures they have published. It is vital that standards in photojournalism are upheld, as one dishonest photographer undermines the integrity of all conscientious photographers.

Despite having a technical armoury, the photojournalist must never forget his or her human skills. A photojournalist needs compassion, not just curiosity. Never take advantage of people. You must have a good eye for a picture, be alert in order to anticipate what is likely to happen next, be in the right place for the picture and stick with it until the picture happens.

Many photographers covering the Afghan war in 2001 chose to shoot digitally as there were no labs anywhere near the action. The process proved fit for the task, heralding a sea change in colour news photography. Now, the vast majority of news pictures are supplied digitally. Pictures can be transmitted instantly via satellite, and using a mobile phone the photographer is in constant communication with a picture editor. There are two major drawbacks to this instant provision of images: the pressure on photojournalists to deliver pictures means they may not have time to consider and build a relationship with the story; and a lot of time is spent downloading and transmitting images instead of taking pictures.

Newspapers frequently put up more pictures in an online story than they can print – and these are often the more hard-hitting images. Photojournalists can also increase coverage without printing and scanning costs by submitting digital images to web-based magazines.

In these celebrity obsessed times, many magazine assignments are concerned with personalities. The same principles of photojournalism apply whatever the subject and, although many purists despise celebrity photo-stories, they are often very well shot and are, like all good photojournalism, a comment on our age.

Using the old journalistic maxim of 'who, why, what, where, when?' is a good starting point when you are looking for pictures. The story opposite, collecting seagull eggs in the Faroe Isles, was taken by Adam Woolfit for *National Geographic* twenty years ago, but it is still resonant today. Photojournalists understand that their pictures need to work with the accompanying text. Purists don't allow their pictures to be altered, but for magazine stories, space should be left in the picture to accommodate headlines.

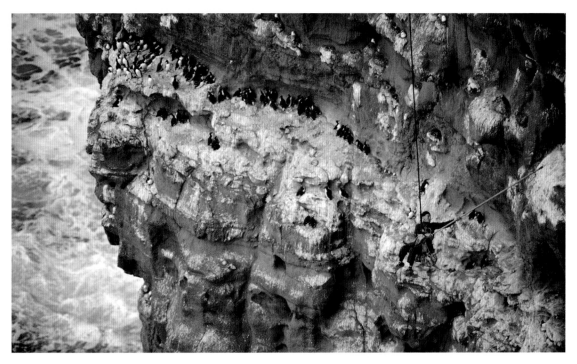

**Establishing shot**
Usually a double-page spread, opening the story. This story on egg harvesting in the Faroes was taken by Adam Woolfit
for *National Geographic* twenty years ago.
*Nikon F 500mm/ Ektachrome* © Adam Woolfit

**Action**
What is going on
and who is doing it –
usually an environ-
mental portrait.
*Nikon F 28mm/
Ektachrome*
© Adam Woolfit

**Detail**
The reason for the
story – the eggs. All
that endeavour for
something so small.
*Nikon F 35mm/
Ektachrome*
© Adam Woolfit

Photojournalists are often accused of being heartless. People ask how they can worry about lenses and picture composition in the face of suffering. But for a photographer who spends much of his or her life looking through a lens, it is second nature to take a well-composed picture. This is not callous behaviour, just an automatic reaction. A well-composed photograph can speak more directly and affect those who see it more deeply than a hastily put-together picture or badly composed news footage.

### The big news event

At a big news event, such as a royal funeral, there will be hundreds of photographers penned up together. There is an amazing amount of energy generated in the run-up to the main event, which is generally over very quickly, and there are no second chances. There is a lot to remember when shooting a big news story, so you have to really concentrate and do as much preparation in advance as possible. Don't take too much equipment with you: choose two lenses and stick with them. Ideally, use a different camera body rather than change lenses, but remember to check that the meters on the bodies are the same. Use a tripod – it helps you establish and keep your position in cramped circumstances. Don't try and cover the event from every angle, but go for the big picture which, more often than not, comes with a long lens.

**Funeral of Diana, Princess of Wales**
*Nikon F4 600mm on tripod/Kodak EPP*

### Solo assignments

There will always be places where only the lone operator can work. Being an unobtrusive and detached observer, you can go into situations that require tact and trust. It is easier for those responsible for granting access to deal with one person who does not require any special arrangements to be made on their behalf. This was for a story on Christmas Day in a major London hospital.

**Emergency room**
*Nikon F2 50mm/Kodak Tri-X*

## War

In war, the military controls access to combat. Those photographers who wish to remain uncensored choose to work outside military restrictions and concentrate on the impact of the war and its effects on the people and countries involved.

As war in Iraq broke out, Gary Knight crossed the border with a fellow photographer, both disguised in army fatigues. They stumbled upon a US Marine battalion, who offered to help them reach Baghdad. As he got to know them, the soldiers encouraged him to take pictures that told the real story of battle. Two years earlier, in Afghanistan, Gary had shot on film, carrying processing chemicals into the country from Pakistan and making prints in a disused photo lab as Kabul fell. Roughly half the photographers in Afghanistan had made the switch to digital; by the time of the Iraq war in 2003 only a tiny minority shot on film.

**Lt Col Bryan McCoy, Commander of the 3rd Battalion, 4th Marines, directing fire from the frontline at the battle for Baghdad Highway Bridge**
*Canon EOS 1D*
*24–85mm/JPEG*
© Gary Knight/vii

# Photojournalism masterclass

## Aminata – 'The Crying Girl' by Michael St Maur Sheil

'This photograph was taken during an assignment for Anti-Slavery International to document the problems of forced marriages and child labour in West Africa. It is traditional in Africa for children to work, usually within the family unit. But in recent years there has been a growth in commercial trafficking whereby agents, usually women, will approach a family and offer to take a child to give them a job or training in a city. Such a proposal is typically accompanied by the offer of cash. In the context of impoverished and often malnourished rural life, it is hard for parents to refuse what seems a golden opportunity to be rid of an extra mouth to feed, while at the same time gaining what appears to be advancement for their child.

'The reality is that children, some as young as six, are taken from their homes and moved to wealthier countries in the region – Gabon, Côte d'Ivoire and Nigeria being major destinations for trafficked children. Upon arrival they are generally made to work as domestic servants and market traders. This can mean an arduous eighteen-hour day cleaning homes and preparing food in the morning and evening, while working in a marketplace during the day.

'There are reports of rape, often during transportation between countries. In my short visit, I saw enough children with scarring to suggest that beatings are commonplace.

'"The Crying Girl" photograph was taken in Libreville, the capital of Benin. Aminata was found sleeping under a bench on the streets. She was brought to a rescue centre in ragged clothing, covered in grime, and clearly traumatized. She was uncertain about her age, but appeared to be around ten or eleven. She came from Sokode in Togo, where she lived with her mother and "many brothers and sisters". She was collected from her home by a woman named Fatima, and taken by road to Lome. From there she was put with a group of people – among whom she was the only child – and finally put on a boat which brought her to Gabon.

'According to her story, Aminata had been made to work selling cakes in return for food. She received no money, and bore scars that indicated she had been beaten. I was present when she arrived at the rescue centre, but the picture was taken twenty-four hours later.

'She had been washed and her hair freshly braided (a fashion essential among the girls at the centre) and she wore a new dress. At the root of her distress was her earlier discovery of a packet of biscuits. She had been living off scraps for months. When she spotted the unguarded biscuits in the centre's kitchen, she took them and ate greedily. I found her sitting under a tree, clutching a biscuit, tears of guilt and fear streaming down her face. She was expecting to be beaten for her theft.

'I sat close by as she sobbed and photographed her. I made no effort to comfort her. I checked the exposure, changed the lens. I did what any photographer does in these situations: I simply kept the camera between myself and the subject. You cannot intervene, you just have to try and capture the moment – that instant that tells a wider story – all the while remembering the wise words of Eugene Smith, "Don't bruise the already bruised."

'I knew I had a powerful shot, but it was several weeks before the media took notice. After many rejections, an interview with the BBC World Service sparked interest in the story, and suddenly everyone wanted pictures of trafficked children from West Africa. Aminata became a symbol of that miserable trade on newspaper front pages and TV news bulletins around the world. No words are needed to tell of her despair: the innocence of her face and the fall of her tears are simple testament.'

*Voigtlander Bessa-R 50mm lens/Tri-X rated at 200 to retain smooth detail* © Michael St Maur Sheil

# Street photography

Street photography can be anything that captures the human condition – the kind of candid reportage usually, though not exclusively, taken in cities. It is a record of people going about their daily lives.

Although they are not usually commercial, street pictures are greatly appreciated by people who like photography and often fill galleries and book retrospectives. This subject used to be predominantly black and white, but colour is increasingly used. I think people will eventually look at the colour street photographs of today with the same affection now reserved for the black and white street images of the 1950s.

Street photography is about serendipity, not hard news. The place does not have to be beautiful or interesting, because it is the atmosphere and human behaviour that counts. The perfect subject for 35mm, it is also an area in which digital comes into its own – with instant editing, it's never been easier to pack up and go home, confident that you've got the shot you came for. I enjoy street photography because you are totally independent, almost cocooned in your own world as you hunt for pictures. You have to be alert and attuned to what is going on, and at one with your cameras, which become an extension of you. It is good practice to have a couple of lenses ready and pre-focused, so that you can take advantage of any fleeting opportunity.

You don't need a purpose with this sort of photography. You may have something in mind, but it does not need to be specific. When you arrive somewhere, you need to get into the mood of the place but remain slightly apart from it. You are involved, but as a bystander. You may need to be on the street for a long time, but always be ready for surprises – you never know what you are going to see.

When I am out in the streets I take the attitude that I have as much right to take pictures as other people have to be there. Be purposeful and don't dither, and the chances are that people will accept you. If someone does get annoyed, try smiling back. But if people seem genuinely uneasy or are likely to suffer in any way if your pictures are published, don't take them. Always respect religious beliefs and places of worship.

Be sensitive in areas that have many tourists. Local people may resent being treated as zoo animals – subjects for the amusement of a prying outsider. Always work alone. You are much less of a threat that way.

**Da An Park, Taipei**
City parks are another wonderful location to catch people in a variety of activities. The Tai Chi master and pupil were completely oblivious of me. I waited for them to make the same movement and concentrated on the pupil's face.
*Nikon F4  80–200mm/Fuji 100D*

Subjects are usually bored with you sooner than you are with them. The best way they can put off the photographer is to start posing for the camera – precisely what you don't want. Encourage them to get on with their work and ignore you. Don't forget that if you do want to sell a street image, you must get any subjects to sign a model release form.

Street pictures can encapsulate a moment in our daily lives that, in time, may have historical relevance. Such pictures say more about the photographer than his equipment, which can be fairly basic.

Too much equipment hampers your movements – two bodies and two lenses should be adequate. A sophisticated compact is also useful. It allows you to blend with the crowd and shoot in a loose, relaxed manner.

It may seem easier to do street photography abroad because you tend to notice things more in strange places, but try it at home too. Familiarity with surroundings can help you capture interesting subjects. One of photography's great gifts is that it teaches you to observe what's going on around you.

**Campo de' Fiori, Rome**
Markets are a natural theatre with colourful sets, interesting lighting and many character actors and showmen. Walking around, the stars soon become apparent. Once you have chosen your performer, choose the best place to photograph them. Don't be put off – they will have seen it all before and, as long as you are not interfering with their business, they will have no objection to you taking their picture – you may even bring in some extra trade. Have patience and persistence. Everything will come together but, although you are concentrating on the foreground, remember to pay attention to the background. You want to be involved with the picture, so use a wide-angle lens. Inevitably this will show a lot of background detail.

Don't just concentrate on the market traders: the customers are also worth looking out for. You will soon spot the likely contenders and they are usually too busy shopping to worry about you.
*Nikon F4 20–35mm and 35–70mm/Fuji 100D*

# At work

Work has been one of the great themes since the beginning of photography. Robert Howlett's famous portrait of Isambard Kingdom Brunel in front of a ship's giant braking chains was taken at the doomed launch of the *Great Eastern* as long ago as 1857. In the 1920s, Soviet Russian art and photography made heroes of the workers. *Fortune* was the first magazine to feature creative pictures of the work process regularly and it still does today. Photographers are always looking for new techniques to record the wonders of invention and the magic of production.

It is a privilege to see skilled work, to witness the endeavour, concentration and dexterity of a surgeon, a panel beater, thatcher, solicitor or even a robot. In all work, there is a moment that encapsulates the job. The challenge is to identify that moment and either capture it, light it or re-stage it for a meaningful picture.

**Dunlop tyremaker, Lagos**
Everything in the factory was dark and gloomy so it had to be lit. The flash would also freeze the peak of the action and the worker's expression. While this man put all his efforts into making the tyres, I wanted to be mobile, so I put the flash on a small stand attached with a long sync lead.
*Nikon F2 35mm/Kodak Ektachrome*

**Chicago Mercantile Exchange**
The colour temperature meter gave me the correct filtration to put on the lens to capture the mass of colour. I set up my tripod in the viewing gallery and used a slowish shutter speed (1/15 second) to convey the feeling of bustle and movement and the intensity on the faces of the people working in what appeared to be a madhouse.
*Nikon F4 180mm on tripod/Fuji 100D*

**Sotheby's auctioneer**
Country house clearance sales take place over several days, so I had ample time and opportunity to observe the auctioneer doing his stuff. Watching him for a while I noticed that he got really excited when he liked the object he had sold and had achieved a good price for it. He hunched his shoulders, banged the gavel and looked at the buyer all at once – that's the shot.
*Nikon F4 80–200mm/Kodak Ektachrome*

### Ciba research chemist

I had a week at the Ciba plant, so spent the first day going around the site checking out photo opportunities. For this picture I had time to think of a way to show the petri dishes and the face of the chemist, and bought a metre-square piece of glass to shoot through. The ceiling and walls out of camera sight were lit by electronic flash, giving an even overall light. The modelling lights were turned off, so the room was dark, and I was able to use an open shutter at a four-second exposure so the light of the monitor screen registered. Correct light balance was checked using Polaroid Type 669.
*Mamiya RB67 65mm on tripod/Kodak Ektachrome 64*

# Photostory

## The King's Troop – A year in the life of the Royal Horse Artillery

Getting the single stand-alone definitive picture is a major aim of every photographer, but there comes a time when the urge strikes to do a thorough job on a subject. Over a prolonged period you have the opportunity to vary the rhythm of the pictures to build the story as you go. All stories need an establishing shot: an image that sums up the subject and informs the whole. If this doesn't happen by chance, you have to hunt it out and make it.

The King's Troop, Royal Horse Artillery carries on the riding traditions of the British Army from its permanent barracks in London, performing gun salutes and other ceremonial duties in the capital and around the country. I spent nine months with the Troop for a book commission. In order to do my job properly, I had to learn their terminology, routines, rituals and history. I became a familiar figure at their barracks and summer camps.

Spending so much time with a subject takes certain pressures off you. You don't have to get all the pictures at once, but can concentrate on a single shot on a given day. It is important to photograph details, the small-information pictures that illuminate the wider story. A greater choice of pictures makes the designer's job easier and the book or magazine story much richer.

The modern photostory, the descendant of the great black and white photo-essays of *Life* magazine in its heyday, continues to develop. The range of technology available allows for an ever-greater variety of shots. On this project I used lenses from 18mm to 1200mm, four different camera systems – the whole arsenal. Inside knowledge of how the day's events will unfold means you can always be in the right place at the right time, with the right kit in your bag.

**The gun salute**
There are six or seven gun salutes a year in Hyde Park. I went three times. The first time the wind was blowing the smoke the wrong way. The second time, the position didn't work. The third time I reverted to this position and the wind blew the smoke in the right direction: one gun perfectly enveloped in smoke.
*Nikon F5 with 300mm on unipod*

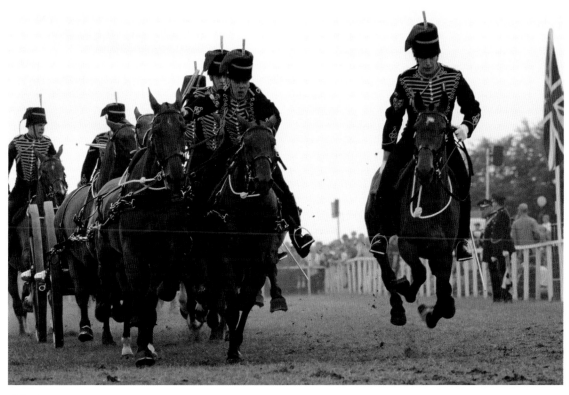

**Galloping away**
I was lying on the ground alongside the railings. I pre-focused on where the horses would fill the frame. The motordrive was on continuous mode, shooting short bursts as six guns came towards me one after the other at full gallop. I wanted to freeze the action to capture the horses' hooves off the ground, the dirt flying and the feel of the trembling ground. *Nikon F5 with 300mm at 1/2000 second*

**Training for the musical ride – or draft parade – at Wormwood Scrubs**
This is about seeing the moment one day, then bringing along the camera to make the picture on another. As soon as the gun teams parted, it had to be a panoramic shot. Shooting low on open ground, a soldier stood by to protect me, hand on my collar, ready to pull me out of danger should anything go wrong. *Hasselblad X-pan with 45mm at 1/250 second/ Kodak E200 rated at 320*

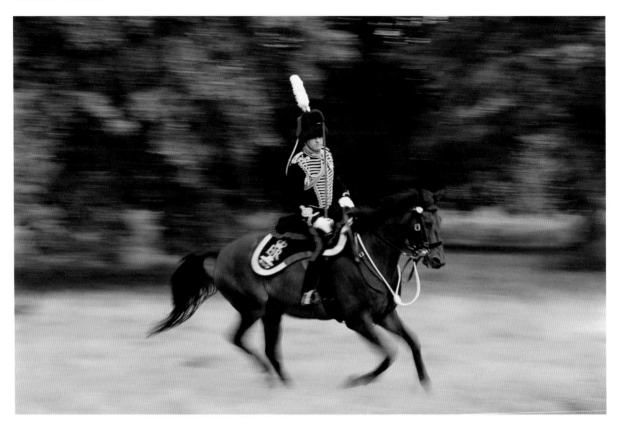

### The Commanding Officer
The mess was full of traditional, static, seated portraits. I wanted to do something different – an action picture with lots of movement. The CO cantered around in a circle while I stood in the middle, panning the camera and shooting at between 1/15 and 1/30 second. The best pictures were where the background was dark.
*Nikon F5 80–200mm on unipod/Kodak E200*

### Morning inspection
There is a routine to most working days and it is from here that the structural pictures for a photostory will come. The Equitation Instructor inspects the horses in their stalls every morning. I shadowed him, waiting for the right expression on his face – and the horse's.
*Nikon F5 20–35mm/Kodak E200 pushed 1 stop*
*Matrix metered fill flash*

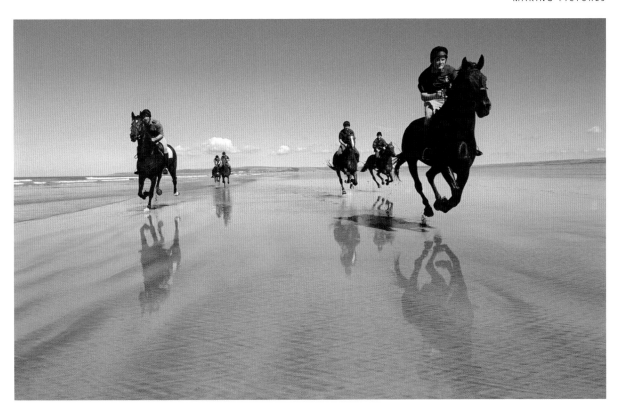

## On holiday

In September, the troop leaves the confines of the London barracks for two weeks on the coast. Every other morning, they go for a gallop on the sands, abandoning military life and enjoying their freedom. The camera is about six inches off the ground and the horses are coming straight for me. The picture was retouched in Photoshop to remove two people from the background who were a distracting detail.
*Nikon F5 20–35mm/Fuji Provia*

## Details

Always look for details. Not only do they make good, stand-alone pictures, but when they are juxtaposed with a wide shot they add interest to the design of the printed page.
*Nikon F5 80mm macro/Kodak E100*

### 'Bliffing'

If you spend time on a story, you soon learn the language and vernacular peculiar to all close-knit working communities. These are worth documenting. Here, the soldiers are bliffing – cleaning the leather and brass of the gun harness. A little direction from me, to fine-tune their authentic working positions, made a clean, interesting composition.

*Nikon F5 28–70mm/Kodak E200*
*Fill flash SB28 with Quantam Turbo pack*

### The saddler's toolkit

In a story like this, people are obviously the principal subject, but there also needs to be still lifes that make good pictures. Specialist tools are an obvious choice. These are the tools used to make the special piece of harness in the middle of the set up.

*Mamiya RB67 90mm/Fuji Velvia*
*2 Elinchrom packs and soft hoods*

### Boots

Because you are telling a story, there will be certain pictures that are obvious, and some that are less so, but are nonetheless essential as they are illustrating something that is key to the story. The gun crew riders wear steel attachments on their boots to protect their legs from the gun shafts. The styling is unchanged through history (the same boots are worn by the Royal Artillery soldier on the war memorial at Hyde Park Corner).

*Nikon F5 28–70mm/Kodak E200 pushed 1 stop*

### The blacksmith

The troop comprises many specialists working in interesting locations – the vet, RSM, blacksmiths, wheelwrights, saddlers, tailors and riding instructors – each of them perfect for an environmental portrait. The blacksmith's forge provides repetitive action (so you can refine your shots and get them perfect), physical endeavour, smoke and fire – all of which make for a good picture

*Nikon F5  20–35mm/Kodak E200 SB28 flash*

**After a draft parade**
Once you are an accepted and familiar sight among your subjects, you have perfect working conditions. Pictures just happen in front of you and the secret is to be in tune with what's going on – to be able to anticipate and recognize when a picture will occur. Be technically ready constantly: check the light and that the camera is set on the correct shooting mode and has the right lens attached.
*Nikon F5 80–200mm/ Kodak E200*

**Builth Wells County Show**
During the summer, the King's Troop gives displays at various county shows. As sometimes happens when you are hunting for pictures, one occurs right in front of you. In this case, all I had to do was to wait for the distant show jumping horse to be seen between the heads of two girls and this gives the picture its depth.
*Nikon F3 20–35mm/Kodak E200*

**The end**
Just as you need an establishing picture, you need a picture to end the story, and here it was easy. At sunset, the Troop flag is lowered and the 'Last Post' is sounded by the Bugle Major. There are no spoken orders in the King's Troop; everything is given by bugle calls and by hand signals.
*Nikon F5 28–70mm on tripod/Kodak E200*
*2 Elinchrom Freestyle packs and 2 heads*

# 8: WORKING IN DIFFICULT CONDITIONS

Bad weather makes for good pictures. Don't be put off from taking pictures when most people would prefer to be taking shelter. Probably the most important thing to contribute to a successful picture in difficult conditions is what you are wearing. As long as you – and your camera – are comfortable and protected, you can concentrate on the picture and not worry about yourself.

## Rain and snow

The camera can be protected in many ways, but modern cameras are well built and can withstand a certain amount of rain and snow. You should always check the front of the lens for water drops and dirt, as they will impair the picture.

Matrix-metered fill flash will work as long as the sensor is clear and it will make really good pictures of suspended raindrops or snowflakes. An underwater camera like the Nikonos V is perfect to use in wet weather.

If you are using a long lens from a fixed position, you can use a specially designed rainproof cover over the lens and the body. A long exposure in the rain will result in a soft picture and the colours will be pastel. It is like shooting through a white net filter.

Snow is no real problem – only don't rely on the meter. Use a grey card reading or use the meter and open up by two stops (or shooting digitally, check in the preview window).

**Dabawallahs in drizzle, Bombay**
Dabawallahs sorting out and dispatching office workers' home-cooked lunches is a sight unique to Bombay. Photographing in light rain, my left hand and the camera were in a clear plastic bag with a hole cut out for the lens and kept secure with a rubber band around the lens hood. Not very sophisticated, but very effective – and cheap.
*Nikon F4 80–200mm/Kodachrome*

**Central Sulawesi jungle, Indonesia**
Tim Motion was searching for the mysterious monoliths of Tamadue, in constant humidity of about 90 per cent and mid-day temperatures touching 40 degrees. The team hacked their way through the undergrowth which seemed to close in behind them. Leeches even tried to burrow through the lace holes in their boots. The jungle is very dark with occasional floods of brilliant light. When these occur, you have to make use of them.
*Olympus Omi 24mm  on unipod/Fuji RDP100*
© Tim Motion

## Tropical humidity

Shooting in tropical climates is no problem as long as you do your utmost to keep your equipment dry. Ninety per cent humidity can cause problems for unprotected film, lens coatings and especially electronic contacts, but you have to be in the jungle for at least three weeks for it to be a serious concern.

Consider using manual cameras: all battery and electronic contacts are extremely vulnerable to sustained, intense damp. A Nikonos V is a good standby camera in these conditions. Store all photographic equipment in hermetically sealed cases, with silica gel in them. Dry out the gel in an oven or in a tin over a camp fire and store film and a protected flash in one case you open only at night when it is cooler. A cape is essential to keep you and the bag on your back dry. Use hand towels to wipe away sweat on your hands, arms and face, and the lens hoods to stop sweaty arms touching the front of the lens.

**North Sea shipping lanes**
I photographed this ship from a Messerschmitt Bölkow helicopter. We were flying in a force 9 gale and conditions were terrible.
Nikon F3 180mm/Kodachrome 200

## At sea

The sea and most cameras don't mix, but waterproof compacts are ideal for marine photography. Although most modern cameras are water-resistant, it is a good idea to keep your camera wrapped in chamois leather in a plastic bag for extra protection and you must be extremely careful when loading film. Pelican waterproof cases are essential and a UV filter will keep the spray off the front elements of the lens.

Pictures taken from boats tend to have a certain similarity because the photographer is usually positioned safely above the waves. Ideally, you want to be a short distance away from your subject on a fast inflatable. The spit of light from automatic flash is useful for freezing spray to enhance the atmosphere of sailing. If a storm is forecast, pre-load all your cameras and remember that in rough weather, you may only get one chance at a shot.

## From the air

A helicopter is the ultimate photographic accessory. From only 100 feet up, the world looks a very different place. The graphics of a scene are immediately apparent, inviting exciting compositions, and there is no litter visible to spoil it.

Taking photographs from the air is not easy. The first essential is a good and patient pilot who is prepared to fly slowly. Make your instructions clear and precise and use flying terminology wherever possible – this makes communication much more straightforward. Brief the pilot before you take off, being careful to explain exactly what you want and the approximate angle you need to be to the subject.

Once you are airborne, the high viewpoint will flatten everything, so use light to create depth, enhancing a 3-D effect. The light needs to be interesting to lend moulding and character to the subject and the best light is usually early morning or late afternoon. Judging the right exposure can be difficult. As you pass contrasting landscapes such as dark forest and light water, the overall light conditions are unaltered, although the meter registers constant change. If you use autoexposure directly off the ground there is a danger that the picture will be incorrectly exposed, so take an incident light reading with a hand meter or a grey card reading with the camera. This will ensure correct exposure even if you

are shooting digitally. Alternatively, shoot negative film and adjust the prints.

With the helicopter doors open, the noise can be so deafening that you cannot hear the camera shutter, so keep checking your camera controls. Hovering for too long will cause the helicopter to vibrate. If this happens, move on and then return to your site. You will need to shoot at least 1/250 second because you are travelling at speed, and remember that the closer you are to the ground, the faster it is going by.

For 35mm, you only really need two lenses: 35–70mm and 80–200mm, although if the subject is right a 300mm or 500mm lens will give you a very dramatic picture. So will a wide angle if the pilot can fly really close to your subject. If you are shooting on a medium-format camera with a fixed lens, you need to instruct the pilot while you are looking through the viewfinder until the composition is what you want. When you are shooting film, wear a shooter's vest for carrying it – a bag could fall out. Take a plastic bag to carry exposed film and tape it in front of you. A roll of gaffer tape is useful to tape your seat buckle down if you have the door off. I had a close shave once: I was wearing a cumbersome survival suit and my seat buckle flipped open while I was leaning out over the freezing North Sea. You are always guaranteed to get a good picture from the air.

**Charing Cross station, London**
Ask the pilot to fly at a constant height (it is a requirement over cities anyway) and you'll only have to focus once. In good light the lens is stopped down to F11.
*Nikon F5 80–200mm/Fuji Provia*

**Andy Goldsworthy at the North Pole**
I spent three weeks on Ellsmere Island and at the North Pole with Andy to record his ice sculptures. The coldest temperatures were around -45 degrees. I took a Nikon F1 with a sports finder, two Nikon F3s with manual lenses and a Fuji GSW690. I also packed a Weston meter in case the in-camera meters failed, but in fact they were fine. The in-camera batteries also withstood the cold. Spare two-hour batteries for a video camera lasted less than ten minutes before dying, despite my best efforts to keep them warm in a bag next to my skin. *Nikon F 85mm/Kodachrome 64*

## Extreme cold

While shooting, never allow bare skin to come into contact with metal. Silk gloves are warm and allow free movement, while sticking plaster over the bridge of the nose and eyebrows prevents painful ice burns. Spare cameras should be wrapped in chamois for insulation. When shopping for warm clothes, consider parachutists' gear. 'Thinsulate' one-piece suits intended for high-altitude jumps are snug without being bulky. Dress in layers, ensuring the outer layer is windproof. A beard offers additional protection from wind and cold, and traps warm air between a balaclava and the skin, providing extra insulation.

If you have a warm hotel to go back to, take care to avoid condensation: before you enter the building, put your cameras into a bin liner and inflate it using a small bicycle pump. Allow the air-filled bag and cameras about half an hour to warm up. See off any lingering spots of condensation with a hair dryer.

I found that in the cold and wind I could only work around four hours a day. Doing a recce to plan the shoot saves a lot of time. Motor drives don't work, and you have to be careful winding film: the film becomes brittle, and the sprocket holes can easily rip. The tabs on 120 film won't stick. Another good tip is to glue insulating foam on to a tripod leg for carrying, to stop the cold metal drawing warmth from your hand. Charcoal-burning handwarmers can keep batteries warm, but are soon extinguished by extreme cold, so are rarely of use for their intended function.

Eat well, and drink lots of liquids – hot drinks whenever possible. It's surprising how quickly you dehydrate at very cold temperatures. Save drinking alcohol until you're toasting the end of a successful shoot away from the cold – preferably after a deeply satisfying warm bath.

## Sand and dust

Of all working environments, these pose quite the greatest threat to both equipment and pictures. Fine blown dust gets into everything and if one is working in a desert the rough nature of the dust grains can cause serious damage, especially to lenses with rotating focusing and aperture rings.

Wrap up your cameras in chamois leather – against heat as well as cold – and store within a self-seal plastic bag. Take a large sable paintbrush and cotton buds to keep the equipment dust free. Cans of air are not recommended as they push sand and dust further into the camera. If you're not prepared to sacrifice a trusty SLR, buy a second-hand underwater camera or even a compact. Digital cameras will suffer from dust on the imaging chip – so avoid changing lenses.

The threat to film comes from sand getting into camera backs or onto the velvet light traps of film cassettes, resulting in scratches along the length of the film. Keep it in either 35mm film tins or in plastic boxes to keep dust out – never loose in your pockets.

Tripods are at special risk. Any sand on the lower leg will be carried up inside the upper section and will rapidly clog the telescopic action. The best tripod to use is a Benbo where the upper section goes down into the lower section and is thus not at risk from dust on the bottom leg.

Equipment should be carried in a case with a waterproof seal. All film changing should be undertaken inside a vehicle. All equipment – even your clothes – should be placed inside heavy-duty bin liners. On no account should cases be kept in the car boot as the aerodynamics seem to suck dust in through the rear door. Never leave a camera bag or any equipment on the ground in desert areas or on the beach. Any wind will blow fine surface sand all over it.

There will be times when you have to operate away from a vehicle. Wear the cameras around your neck and a light chiffon scarf which can at least protect the cameras from the worst of the blowing dust.

**Tunisian desert**
'Coming back from the oasis I could see the approaching sandstorm. I wrapped all my spare camera equipment in bags and a towel and zipped up the camera bag, keeping out a Canon EOS-3 and lens. I carefully loaded a new roll of film and wound it on, then walked alongside the camel train waiting to be engulfed by sand. I took about six frames before the camera started to make grinding noises.

'I put the camera in a plastic bag and brought it back home. Rather than rewind the film in the camera, I took it out in the dark room, to avoid scratching the film. The picture won Image of the Year in the Travel Photographer of the Year Awards, 2003. The camera was ruined – the ultimate sacrifice when making a picture.'
*Canon EOS-3, 28mm–78mm* © Martin Brent

# Photographers' biographies

## Adam Woolfit

Adam has been a photographer all his life and for thirty years contributed to *National Geographic* and other leading magazines. He has immersed himself in computers and digital cameras since the early 1990s and has written on digital matters for *BJP*, *Image* magazine and *Photo District News* in New York. Adam was founding member and chairman of the UK Digital Imaging Group and a prime mover behind IDEA (the International Digital Exhibition and Awards). He was chairman of the Association of Photographers and recently accepted an honorary fellowship of the British Institute of Professional Photographers.
www.adampix.com

## Martin Brent

Martin shoots for advertising and travel. Recent assignments have taken Martin to Australia, Jamaica, Switzerland and Greece and won him Image of the Year in the 2003 Travel Photographer of the Year awards. A self-confessed equipment freak, he enjoys experimenting with all photographic formats.
www.brentimages.com/www.martinbrent.com

## Duncan Soar

After abandoning a career in publishing to pursue his hobby, Duncan Soar studied photography at the London College of Printing and assisted a number of London-based photographers before setting up on his own. In 2003 he photographed ex-chart topping artists for a book entitled 'One Hit Wonders'.
www.duncansoar.com

## Derek Richards

After studying at the Regent Street Polytechnic School of Photography in the sixties, Derek went on to become a successful advertising and corporate photographer. He specializes in photographing people and locations and has, over the years, had much commissioned and private work published. He has travelled extensively and has pictures in a number of photolibraries around the world
www.derekrichards.co.uk

## Graham Piggott

Graham studied photography and graphic design at Exeter College of Art. After graduating in 1990 his first job was photographic assistant to Julian Calder for a year, before working with Lord Snowdon for seven years. His clients have included the London Stock Exchange, Spanish *Vogue*, *Country Life* and *Vanity Fair* as well as design groups. He now lives on the South Coast with his wife and two daughters and combines teaching photography with working on projects for exhibitions.
www.grahampiggottphotos.com

## Alan Newnham

Alan Newnham graduated with a degree in photography from the London College of Printing. In 1986, he established his own studio specializing in food. His portfolio includes editorial work, publishing and packaging. Since 1995 he has channelled his creative energies into a series of black and white photographs of flowers. Alan was one of the first studio-based photographers to shoot digitally.
www.newnhamphoto.co.uk

## Colin Thomas

Colin has been a photographer since his father gave him a box Brownie camera when he was seven years old and he started making his living by photography about 13 years after that. He now works from his London studio, making pictures for advertising, publishing and fashion clients. Most of his pictures have people in them and he often uses a computer to enhance what the camera originates. He shoots exclusively with digital cameras.
www.colinthomas.com

## Chris Cormack

Chris had a thorough grounding in the technique of photography at the London College of Printing and then worked as an assistant to a number of London photographers. His appreciation of the story-telling capabilities of the camera led him to work for all the major Sunday colour supplements and leading magazines around the world. Of late, he has been involved in long-term publishing projects as well as working for design groups and advertising agencies.

## Justin Pumfrey

Justin started as a photographer after he left Oxford. He assisted 'people' photographers and he has continued to photograph people for magazines, design groups and corporate clients. He now concentrates on working on assignment for Getty Images which he finds liberating as he is creating his own pictures.
www.justinpumfrey.co.uk

## Mark Hamblin

Mark has worked as a professional nature photographer since 1995, concentrating primarily on British wildlife. His photographs are regularly featured in national publications, books, calendars and other media and are available from his own extensive library. He has just published his first book, *Wild Peak*, and is working with Peter Cairns on another book documenting the wildlife of the Cairngorms National Park. Mark is also a partner in Wildshot Photographic Adventures (www.wildshots.co.uk), leading holidays in Scotland and overseas.
www.markhamblin.com

## Bob Martin

Bob has been a sports photographer for twenty years and has photographed every major sporting event from the winter and summer Olympics to elephant polo. Bob won Sports Photographer of the Year for the third time in 2001/02 and his work has appeared in *Sports Illustrated, The Sunday Times, Stern* and *Paris Match* and many other prestigious international magazines.
www.bobmartin.com

## Michael St Maur Sheil

An associate member of Black Star for over 30 years, Mike's work has covered everything from oil rigs to child slavery, for which he recently won a World Press Photo award. He lives in Oxfordshire and reckons that autofocus is the best thing since sliced bread as old photographers never die, but merely go out of focus.
www.sheilphoto.co.uk

## Paul Grundy

Paul studied sculpture and photography in Sheffield and has been based in London for the past twenty years photographing everthing to do with architecture.
www.paulgrundy.com

## Gary Knight

Gary has documented war, human rights issues and issues of crime and accountability in Southeast Asia and Indochina, the former Yugoslavia, Kashmir, Afghanistan, Iraq, Israel and elsewhere. He is a founding member and chairman of the board of the VII Photo Agency and a contract photographer for *Newsweek*.
www.viiphoto.com

## Denis Waugh

Denis Waugh has been one of the foremost British landscape photographers for the past twenty years. His work has appeared in many international magazines, in particular *Life* magazine and *The Sunday Times* magazine. His most recent book is *Searching the Thames; A Journey from the Source to the Sea*.
www.thames-search.com

## Kirsty McLaren

Kirsty shoots a wide variety of subject matter ranging from architecture and landscapes to people and still life. Her style encompasses hand-colouring techniques and image manipulation in the darkroom and on the computer.
www.kirstymclaren.com

## Tim Wren

Tim started his photographic career working for provincial newspapers where you had to be able to photograph every-thing. He then moved to Fleet Street as a staff photographer on the *Sun*. At weekends, he worked for the motoring press. Turning freelance, he mainly photographed for *Car* magazine and this led to advertising and direct commissions from car manufacturers. He now works mainly for the Ford Motor Company and for magazines.
Agent www.juliemetcalfe.co.uk

## Kim Sayer

Kim graduated from Brighton College of Art and has been a professional photographer for 25 years, working for advertising and editorial clients. He has produced several books and he recently moved from London to set up a studio in Totnes, Devon.
www.kimsayer.com

## Rob Lawson

Rob studied at Blackpool College of Art and assisted various photographers over five years shooting a wide range of subjects from celebrities (for *Hello!* magazine) to Jaguar cars in the south of France. Now working from his London studio, he mainly works for the drinks industry, either in the studio or on location.

## Tim Motion

Through several metamorphoses over 25 years, including portraits, fashion, house interiors and travel, Tim's professional activities now encompass architecture, aerial photography, landscape, travel and music. In 1988 he won the Gold Award in the Landscape Category of the Association of Photographers Annual Awards. He has exhibited in the UK, France, Tunisia, Spain, Portugal and the United States, and his photographs are held in private collections worldwide.
www.timmotion.com

## Robin Bell

In a 25-year career, Robin has worked with many exceptional photographers including Terry O'Neill, Eve Arnold, Don McCullin, John Swannell, David Bailey and the late Terence Donovan, Norman Parkinson and Linda McCartney – as well as many more whose work is instantly recognizable to the public even if their names are not. From folio images to editorial and documentary, from advertising and marketing to archives and historic collections, Robin has covered virtually every type of black and white printing work.
www.robinbell.com

## Genesis

From their London location Genesis offer a comprehensive range of services embracing the full spectrum of photographic and digital imaging requirements that a photographer may need.
www.genesis-digital.net

# Index

action shots 206, 209, 213
air photography 233
animals 194–9
aperture control 34, 37
architecture 180–3
  interiors 129, 184–5
  perspective 181, 182
autofocus 37, 38, 193, 201

birds 194, 198–9
black and white photography 11, 28–9
  film 70–1
  landscape 158
  papers 82–3
  street scenes 220
buildings see architecture

California sunbounce 119
cameras 30–61, 81
  see also aperture; exposure; lens; shutters
  batteries 66–7
  care of 66
  condensation 234
  weather proofing 230, 232, 235
car photography 123
celebrity photo-stories 212
centre-weighted metering 32
children 139, 148–51
cities 128, 174–9
  architecture 180–3
  locations 174
close-up 200–201
colour, de-saturated 122, 152, 193
colour balance 17, 24
colour control 24, 27
  digital photography 24
colour filtration 24
colour management 67, 91
colour transparency film, exposure 32
composition of picture 18–19
  rule of thirds 17
computer images see digital photography
contact sheets 83
cropping 20
cross-processing 74–5

detail 22
digital photography 10, 24, 32, 62–7
  see also flash; Photoshop
  advantages 63–5
  archiving 67
  cameras 30–1, 60–1, 66–7, 168

colour control 24, 67
double exposure 30
histogram 30
LCD screen 30
manipulation 90–1, 144
mobile storage 65
motor drive 31
portraits 142
printers 63–4
printing 67
RAW files 31
resolution 64
self-timer 31
stitching 61
wide-angle lenses 41
workflow 64–5
drum scan 129, 144

equipment 120–1, 189
expeditions 172–3
exposure 32–3
  black and white 28
  colour transparency film 32
  cumulative 114
  digital photography 32
  double exposure 30, 114
  metering systems 32–3
  to create movement 114

family 148–51
film 62, 68–73
  black and white 70–1
  in cold conditions 234
  colour film 69
  cross-processing 75
  effects 76–7
  grain 76
  infrared film 72
  negative film 69
  on safari 197
  security x-rays at airports 166
  special films 72–3
  transparency film 68–9, 74
  tungsten-corrected film 73, 77
filters 110–13
  close-up 200
  graduated 111
  home-made 112
  polarizing filter 110–11, 161, 181
  soft 113
  star 112
filtration, landscapes 110, 161
flash 98–103
  and candlelight 105

and daylight 104
exposure meters 33
flash blur 115
flash heads 101–2
and fluorescent 105
off-camera flash 103
ring flash 103
and tungsten 104
flowers photography 127, 192–3
focus 37–8
  Autofocus 37, 38, 193, 201
  close-up 201
  fixed focal length 40–1
  tracking 39
food photography 204–5

gardens 190–1

hand-colouring 91
holiday snaps 150, 164
hybrid print technologies 64

infrared film 72
infrared release 117
interiors 129, 184–5
  lens 184
  lighting 184

King's Troop photostory 224–9

landscape photography 156–63
  black and white film 158
  camera 59
  filtration 161
  nudes in 154–5
  sense of place 156
  sky 158–9
  square format 161
  time of day 157
  urban landscape 161
  weather 156
Lastolite reflector 118, 193
LCD screen 30
Leica 54
lens 40–9
  for air shots 233
  de-focus lens 44
  fixed focal length 40–1
  focus 37
  for interiors 184
  for landscape 158
  macro lens 45, 49, 201
  mirror lens 44
  for outdoors 193

range 40–1
on safari 197
sharpness 42
shift lens 45
tele-lens 44
tele-converter 48
wide-angle lens 41, 44, 48, 157, 200
zoom lens 17, 19, 40, 49, 200
light 92–109, 118–19
California sunbounce 119
daylight 92–3
difficult light 96–7
Lastolite 118
light source 126
natural light 92, 94–5
night 93, 96
reflector 118
spotlight 141
lighting 75, 104–5
beauty light 109, 195
buildings 183
cross 109
hero 107
interiors 184
nudes 152–3
portraits 107, 118, 135, 141
reflected 107
spotlights 108
studio 106–9
umbrella 109

magazine stories 212, 211
markets 221
matrix metering 33, 230
metering systems 32–3
mobile storage 65
model release form 221
motor drive
and auto winder 31, 38
in cold conditions 234
and remote release 116–17, 198–9
movement 114–15

nature 188–9
equipment 189
news pictures 11, 212–14
black and white 28
war 216–17
night photography 96
nudes 152–5

panning 115
papers 82
perspective control 43, 45
pets 194–5
photogram 80
photojournalism 212–18
big news stories 214

celebrity photo-stories 212
magazine stories 212
news photograph 212
Photoshop 60, 63, 74, 82, 87, 90, 104
adjustment layers 142
autoexposure 32
colour 91, 111, 170
contrast 160
de-saturated colour 122, 152, 193
double exposure 30
drum scan 129, 144
focus 65
movement 65, 114
posterization 90
retouching 140
sepia-tone facility 85
photostory 224–9
Polaroid 62, 78–81
cameras 81
image lift 79
image transfer 80, 145
proofing 78
portrait photography 11, 130–55
autofocus 38
computer enhanced portraits 144–5
cross-processing 75
digital format 142
exposure 32
lighting 107, 118, 135, 141
retouching 141
tripods 116
portraits
children 139, 148–51
clothes 141
family 148–51
groups 138, 145
nudes 152–5
pose of subject 141
The Queen 146–7
relationship with subject 134, 136
posterization 90
printing 67
black and white papers 82–3
contact sheets 83
prints 68–9
bromoil 89
cyanotype 87
hybrid print technologies 64
lith print 89
salt print 84
tone effects 85–8

reconstructed pictures 203
reflectors 118
releases 116–17
remote release 116–17
resolution 64
rig 123

safari 196–7
scale 22
sea 209, 232
security X-rays at airports 166
sepia tone 85
shutter speed 34–6
silica gel 231
solarization 80
sports photography 10, 206–11
action 206, 209
autofocus 38, 206, 209
camera 51
spot metering 32
square format 16, 58
still life 202–5
stitching 61
stories 224–9
street photography 166, 174, 220–1
light 97
studio lighting 106–9
see also portraits
studios 202

timers 31
travel photography 164–70
cities 174–9
digital cameras 168–9
equipment 173
expeditions 172–3
locations 166
tripods 116, 161, 235

underwater cameras 50, 53, 230

viewfinder 16–17
focusing 38
horizontal view 16
space around subject 17
viewpoint 14, 233

war pictures 216–17
weather 156, 230
wide-angle lens 41, 44, 48, 157, 200
wildlife 194–5
safari 196–7
tour companies 194
use of hides 198
work 222–3
workflow 64–5
working conditions
clothing 234
cold 234
desert 235
rain and snow 230
tropical humitity 231

zoom lens 17, 19, 40, 42
close focus 200

# Acknowledgements

A number of people have contributed to *Making Pictures,* and my thanks go to them all. Jinny Johnson and Mark Reynolds helped with the text and Louise Millar who designed the book so well. Ken Setha and Joe Thomas and all at Genesis and Robin Bell for the black and white prints; Lt Col Simon Hall who allowed me to use the pictures from the King's Troop. Special thanks also to Martin Brent, Adam Woolfit, Duncan Soar and all the other photographers who I badgered for pictures, some of whom have assisted me in the past and others who have made my life in photography so enjoyable. It's a slow business producing a book while being a full-time commerical photographer and particular thanks go to Gordon Wise and Ingrid Connell for their patience. This book has encroached on a lot of my family time, so my greatest thanks go to Clare, Sam and Rory. Without their help and understanding, I couldn't have done it.